A TASTE OF THE AVANT-GARDE
56 GROUP WALES 56 YEARS

WITHDRAWN

David Moore

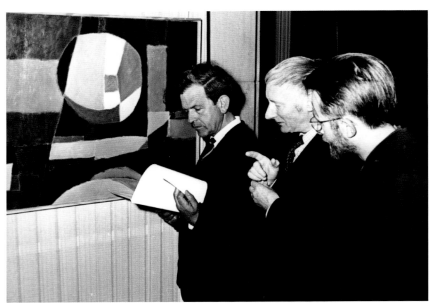

Members spanning the entire history of the 56 Group Wales. At the launch in 1969 of the exhibition *Breton Welsh Artists*, in which the Group took part, at University College Cardiff are (from left): Arthur Giardelli, founder member and chair from 1961 to 1998; Eric Malthouse, who, with two others, founded the Group and resigned in 1970; and Christopher Shurrock, a current member who has been exhibiting regularly since 1967. This was the first of many Group exhibitions at University College Cardiff. The 1965 oil painting by Jorj Morin, one of the visiting Breton artists, is titled *Star and Reflection.*

Contents

Preface

This book is a concise account of the professional artist exhibiting association 56 Group Wales. Founded in 1956 as the 56 Group, it is now fifty-six years old. Normally, tens of years are commemorated. The early Group wished to be radically different in advancing a modern exhibiting agenda. On occasions, it liked to play on the number fifty-six for exhibition titles and publicity.

Peter Wakelin originally planned to write the Group's history. He began the considerable preliminary task of cataloguing the Group's archive which, due to the diligence of successive Group secretaries and of Mary Griffiths in particular, is comprehensive and extensive. He would like to have seen the project through to its conclusion but, when commitments became greater, the task passed to me to complete. I am indebted to him for establishing the project, for significant groundwork and for allowing me to take over.

One day someone is likely to write a more comprehensive history of the Group. In the meantime, it is hoped that this account will help to stimulate wider awareness of its members and achievements. It has, over fifty-six years, played a significant, although not universally welcomed, role in the Welsh art world.

Membership of groups is a normal part of the structure of society. It is not surprising, therefore, that it is also part of the artist's world. As in other walks of life, not all artists wish to belong to a group, but, for those who do, membership may remain elusive. 'There are those who belong to 56 Group Wales,' a sage artist friend once confided in a portentous tone, 'and there are those who do not.' Reasons for leaving a group, too, may be social, economic, political, professional or geographic.

Artists group together for different purposes.[1] Some, such as the London Group and the South Wales Group (since 1974, the Welsh Group), focus on exhibiting.[2] The Rhondda Group coalesced, in the 1950s, from art students travelling to Cardiff College of Art. The radical and subversive Independent Group, on the other hand, had a mission in the early 1950s to advocate a media and consumer-based 'aesthetic of change and inclusiveness'.[3] Others, such as Beca, have been politically motivated. From the 1970s it wished to raise awareness of the destruction of Welsh communities and their language.[4]

This book emphasises the artists who, together, have determined the evolving character of 56 Group Wales. Each full member is discussed, focusing upon those who exhibited regularly, their period with the Group and, where possible, the type of work they showed. Other sections provide an overview of the Group at particular periods, exploring its exhibitions and concerns. Representative, unusual or outstanding exhibitions, including many on the Continent, are examined in more detail. Extensive use is made of the Group's archive, to which coded footnotes (references 'A' to 'V') are made throughout. The archive will be transferred to the National Library of Wales in Aberystwyth.

I should like to thank in particular Dilys Jackson, chair, and her predecessors, Robert Alwyn Hughes, Peter Spriggs and Glyn Jones, as well as other current members of 56 Group Wales, for the opportunity and support to complete cataloguing the archives and to write and publish this book. Sue Hiley Harris has worked prodigiously on picture research, design and layout, compiling appendices, checking information, preparation for printing and, not least, providing moral support. The Gibbs Trust and one of the Group's founders, Michael Edmonds, have also provided support, which is very much appreciated. I am most grateful to long-term members Glyn Jones and Harvey Hood for reading the manuscript and to Karin Hiscock and Amanda Renwick for proof reading. Members, past and present, and numerous other people and organisations who have very generously provided information, images and copyright permission are acknowledged in the footnotes and at the end of the book.

David Moore, Brecon, 2012

1 See: 'Artistic Communities in Wales' in Wakelin, Peter (1999), pp.10-19
2 Wakelin, Peter (1999); Redfern, David (2008); Thomas, Ceri (2008)
3 Robbins, David, ed. (1990)
4 Hourahane, Shelagh, 'Maps, Myths and the Politics of Art' in Bala, Iwan, ed. (1999), p.69

1956 and the Formation of the 56 Group

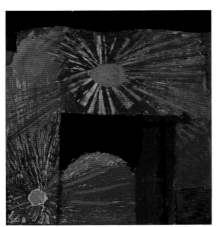

1 David Tinker *Insurgence I* 1956, 69 x 63 cm, oil on board

'Nineteen fifty-six was a turning point of a year,' reflected David Tinker, one of the 56 Group's founders. 'First of all there were the two major conflicts in the world, the last gasp of British colonial gunboat reaction, the Suez Canal fighting and, at the same time, the repression of the Hungarians by the Russians... The Hungarian Revolution made me want to convert the violent feelings which I felt into some visual art terms. The colour had to explode... From this point on I was a committed abstract artist.'[1]

Tinker was also influenced by the first major showing in Britain of abstract expressionist paintings from America as part of *Modern Art in the United States* at the Tate Gallery.[2] That same year another influential exhibition, *This is Tomorrow*, was staged at Whitechapel Art Gallery. It included constructed abstract art by Adrian Heath, who would later join the 56 Group Wales, and members of the influential Independent Group.[3]

Exhibiting opportunities for such art in Wales were limited. Public galleries were few and commercial galleries in their infancy. One of the earliest, Howard Roberts Gallery in Cardiff, opened in 1956.[4] Frustration was building at the limitations in space and selectivity of the annual exhibitions organised by the South Wales Group and the Welsh Committee of the Arts Council of Great Britain.

The appropriation of the year in the 56 Group name conveys a sense of this heady and turbulent period. It has been referred to regularly in general books about Wales. John Davies, in his *A History of Wales*, wrote: 'A desire to give prominence to the avant-garde made itself felt among them, and as a result the '1956 Group', the organisation which had taken upon itself the function of representing modern art in Wales, was founded.'[5]

Surprisingly little, however, other than material in the Group's own publications and in contemporary reviews, has been written about an association which has survived for fifty-six years, involved eighty-eight full members and staged over a hundred exhibitions with two hundred and twenty-five showings. Bryn Richards discussed members of the Group in 1971.[6] There is a useful essay in the twenty-fifth anniversary exhibition catalogue by David Fraser Jenkins, although this has a tendency to over-emphasise the significance of the original manifesto.[7] Eric Rowan, lecturer at Cardiff College of Art and a member of the Group, 1967-80, outlined its origins and early development in 1979 and 1985.[8] He experienced changes in the art schools, personally knew Group members as colleagues and refers to them extensively. This makes the latter part of his narrative useful first-hand testimony, although artists outside the Group, including those working in other traditions, have received less attention.

Peter Wakelin outines mid-1950s upheavals in the South Wales Group, founded in 1948, which precipitated the formation of the 56 Group.[9] He describes how Tinker felt that proposals to replace the South Wales Group with a South Wales Academy were elitist and likely to be dominated by conservative art societies.[10] In early 1956 John Petts, artist and arts council official, pressed for the South Wales Group's reconstitution as an association of artist members with no affiliated societies. That year, however, disillusioned progressive members and others formed the 56 Group. Intriguingly, nine of its twelve founders belonged to both groups.[11]

The 56 Group is referred to near the end of two volumes in Peter Lord's survey of *The Visual Culture of Wales*. Here, its establishment is seen partly as a reaction to both the movement for an academy and to the prevalence of painting characterised as 'Welsh environmentalism'. Concerned with everyday surroundings, cultural landscape and a compassion for humanity this was associated with efforts, at the time, to foster a Welsh tradition of painting.[12] The Group's past is also discussed by Jill Piercy in a general article and Arthur Giardelli refers to it in conversations with Derek Shiel.[13] An entry in an encyclopaedia of Wales is discussed on page 83.

The 56 Group was founded by three artists living in Cardiff - Eric Malthouse, David Tinker and Michael Edmonds. Tinker, who was a colleague of Malthouse at Cardiff College of Art, is clear that: 'The original idea was thought out by Eric Malthouse.' Edmonds, a young artist and architect, became a friend of Malthouse after attending his life classes. The three complemented each other well. Edmonds regards Malthouse as having been the driving force, with Tinker more of a thinker and Edmonds himself as an organiser.[14]

Tinker later wrote that: 'The need was felt to voice a clear radical point of view, radical in the *sense* of forward-looking... In both of the large scale exhibitions one painting by one painter was lost in a sea of pictures... Only a minimum of space was given to an artist who was aware of the rising tide of abstract art in New York and Paris. Not that the group was founded as an 'abstract' group. The net was widely spread.'[15]

Tinker recalled Malthouse, Edmonds and himself meeting in the Mitre Public House, Llandaff, when they decided to call the new association 'the 56 Group'. They discussed potential members. Edmonds recalls that Malthouse and Tinker did most of the selection. Tinker, however, describes how 'Eric Malthouse produced a list of artists and Michael Edmonds and I went over the list with him... We chose artists that we thought were aware of what was happening and who looked as if they were going to develop.'[16] It was decided to keep the number to around twelve so that everyone would be able to show several works. The following were invited to join and to indicate whether they agreed with a statement of purpose and aims: Trevor Bates, Brenda Chamberlain, Hubert Dalwood, George Fairley, Arthur Giardelli, Robert Hunter, Heinz Koppel, Will Roberts, John Wright and Ernest Zobole. Chamberlain was the only person who declined the invitation to join the Group (see page 32).[17]

There was no one style which applied to all the founder members. Their work was broadly modernist and, whilst abstraction was, for many, a major concern, figuration was also much in evidence. Ten members were art lecturers; only Roberts and Edmonds were not. The average age was thirty-six, although this conceals a range from Wright at twenty-five to Roberts at forty-nine. Only two, Roberts and Zobole, were born in Wales; Fairley was Scottish, Koppel was German and the others English.

Malthouse, Tinker and Edmonds formed the first loose Cardiff-based committee with Malcolm Ford as secretary. A friend of Edmonds, he was employed by the National Museum to arrange exhibitions for schools.[18] Their names were given equal prominence on circulars to members. The next step was to find somewhere to exhibit.

1 Tinker, David (c.1997), pp.266-67
2 Garlake, Margaret (1998), p.58
3 Whitham, Graham, 'This is Tomorrow', in Robbins, David, ed. (1990), pp.134-59
4 Roberts, Howard, 'Howard Roberts Gallery', *The Anglo-Welsh Review*, 18, 41, Summer 1969, pp.169-74
5 Davies, John (1994 ed.) *A History of Wales*, Penguin, p.658
6 Richards, Bryn (1971)
7 Fraser Jenkins, A.D. (1981)
8 Rowan, Eric, in Stephens, Meic, ed. (1979), pp.68-70; Rowan, Eric (1985), pp.125-29
9 Wakelin, Peter (1999), pp.39-47
10 Tinker to *The Western Mail*, 6 May 1955, quoted in Wakelin, Peter (1999), pp.38-39
11 Wakelin, Peter (1999), p.43. Only Dalwood, Edmonds & Koppel did not.
12 Lord, Peter (1998), pp.262-66; Lord, Peter (2000), p.405
13 Piercy, Jill, 'The Atrocities Over There', *Planet* 126, Dec. 1997, pp.88-94; Giardelli, A. & Shiel, D. (2001); see also details of forthcoming publication about the founder members on page 84, reference 3
14 Tinker, David (c.1997), pp.267-68; Interview with Edmonds, 14 August 2007
15 Tinker, David, 'Pioneers of self-help', *The Western Mail*, 7 December 1964
16 Tinker, David (c.1997), pp.267-69; Edmonds interviewed at National Museum Cardiff, 29 Sept. 2006
17 Chamberlain to Malthouse, 2 September 1956, Fii

2 The original statement of purpose and aims which was enclosed with the invitation to join the Group. Fairley, Giardelli, Hunter, Wright and Zobole wrote letters of acceptance.[19] In a circular, however, it was noted that they disliked it.[20] Fairley wrote: 'I should prefer that we issue as little as possible by way of a 'blurb' as indication of aims, policy, etc.'[21] Hunter felt the same: 'I personally think it unwise for a newly formed group to publish a 'manifesto' before they have their first exhibition...'[22] He was partly concerned that critics might expect works to exactly reflect the statement. Bates, Dalwood, Edmonds, Koppel, Malthouse, Roberts and Tinker are recorded as verbally welcoming the Group but also as being critical of the document.[23] The inclusion of the three founders might suggest a lack of conviction. Fraser Jenkins felt that: 'The prospect of exhibitions, without submission to a jury, was probably what made the circular attractive.'[24] Giardelli, indeed, confided: 'I doubt whether we need a manifesto. The reason for the Group's existence is that we wish to exhibit together...'[25]

18 Malcolm Ford's file, 1956-57, Fi; Interview with Edmonds, 14 August 2007
19 Malthouse file, Fii
20 Circular to 56 Group, October 1956, Fi
21 Fairley to Malthouse, 30 August 1956, Fii
22 Hunter to Malthouse, 22 September 1956, Fii
23 '56 Group: Replies to Memo - April '57', Fii
24 Fraser Jenkins, A.D. (1981)
25 Giardelli to Ford, 10 November 1956, Fi

The Three Founders

Eric Malthouse (born Erdington, Birmingham 1914; member 1956-70; chair 1961, publicity officer 1962-63; treasurer 1963-65; died 1997) was a painter and printmaker who studied at Birmingham College of Arts and Crafts and taught in schools before joining the Royal Armoured Corps in the Second World War. He was appointed a lecturer at Cardiff School of Art in 1944. His early work was figurative but, from 1952 for around six years, his painting was concerned with the transformation of movement, reflected in studies of pigeons, into abstract forms.[1] He often visited Cornwall and St Ives fishermen and rock pools also became the foundation for abstract work which showed the influence of Ceri Richards and Patrick Heron.[2] He closely analysed colour and spatial composition and, by 1959, when he had an exhibition at the National Museum of Wales, his work had become completely abstract. He produced murals for University Hall, Penylan, Cardiff, and for the Wales Gas Board.[3] In 1969 he explained that, for him: 'space is the surface of a painting; within the surface space, concern is with colour, not tone; design exploits fully the painting area... and paint lies on the surface, creating emphasis and depth within the colour space.'[4] Printmaking was important, notably his 1969 *Façade* series. He resigned from the Group in 1970, together with John Selway and Ernest Zobole, apparently in protest against the desire of some constructivists to exhibit together.[5] In 1972, long after unsuccessful attempts to persuade him back, he expressed an interest in 'a return to the fold' but relations were strained and this never occurred.[6] In 1973 he left Cardiff College of Art, his role having changed under the new régime, and moved to Cargreen, Cornwall. In 1981 he moved to Keynsham near Bristol and, in 1985, to Barry. He was also a founder member of the South Wales Group and, in 1959, of the Watercolour Society of Wales.[7]

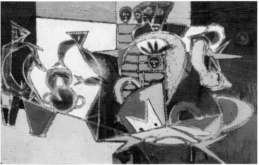

3 Eric Malthouse in his studio, late 1950s

4 Eric Malthouse *Sorting Fish I* c.1957, 50 x 75 cm, oil
Purchased by Sheila Gibbs from the first 56 Group
exhibition at the National Museum of Wales, 1957

David Tinker (born Charlton, London, 1924; member 1956-2000; treasurer 1961-63 & 1965-96; vice-chair 1977-96; died 2000) studied at Winchester and Bath schools of art and at the Slade School of Fine Art. During the Second World War he served in the Royal Naval Volunteer Reserve. He was appointed a lecturer at Cardiff College of Art in 1949 and moved to the art department at University College of Wales, Aberystwyth, in 1962. In 1973 he was promoted to director of its Visual Art Department. On retirement in 1986, he moved back to Cardiff.[8] In 1976 he had seen his paintings and uncommissioned sculpture as being concerned with poetic reactions and ideas about art. His stage design and commissioned sculpture, on the other hand, were a means of co-operating with others to present a public work.[9] Examples were work for Welsh National Opera and a 1970 cast aluminium mural for the Great Hall, University College of Wales, Aberystwyth. His paintings varied in style from early romantic figurative and mythological subjects, systems paintings in the 1960s and 1970s, to later abstract expressionism. In 1983 he exhibited terracotta heads and, in 1996, ceramic sculptures in a romantic style.[10] He wrote in 1973: 'The sight of colour, shape and form are marvellous to me. I have always felt that I must communicate to other people something of the excitement which I experience... Like most artists I am in perpetual war within myself. The protagonists are colour and form, free-handling or self-effacing control...'[11] He was much respected as a teacher and had wide-ranging concerns about the health of the art community in Wales.[12] He was also involved with the Arts Council of Wales, Contemporary Art Society for Wales, Welsh Sculpture Group, the general arts lobby for Wales for the National Assembly's arts policy review and the Welsh Group, of which he was chair between 1983 and 1998.

Michael Edmonds (born Bere Regis 1926; member 1956-65; associate 1963-65) attended the Royal West of England Academy School of Architecture in 1944. Studies were interrupted by the Second World War when he came to Monmouthshire as a Bevin Boy and worked in Bedwas Colliery until 1947.[13] He resumed his architectural studies from 1947 until 1951, when he was employed as an architect in Cardiff with the National Coal Board. He had painted from an early age and attended life classes with Malthouse who lived near him in Penarth.[14] In 1958 he was commissioned by the Medical Research Council and National Union of Mineworkers to design a ceramic mural at Llandough Hospital to show efforts to make mining safer, particularly the treatment of pneumoconiosis.[15] His 1960s artworks reveal a willingness to experiment and include abstract constructions, often in metal, resin and fibreglass, for churches and examples may be seen in Trinity Methodist Church, Penarth, and in the Methodist Art Collection.[16] He worked as an architect, 1957-80, in Kent and with the Greater London Council, as well as teaching part-time at Croydon College of Art in the late 1960s and early 1970s when George Fairley was head of foundation studies. Until 1967 he received many commissions for crosses, fonts, murals and furniture but, afterwards, architectural work tended to leave less time for these.[17] He retained contact with Group members and returned to Wales in 1984 to live in Montgomery. He has, since 2001, been a member of the Watercolour Society of Wales and has a long-standing interest in landscape painting.

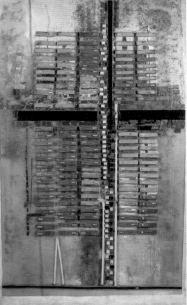

5 Michael Edmonds
photographed for *Coal News*, 1962

6 Michael Edmonds
The Cross over the City
1961, 150 x 90 cm
fibreglass, polyester, brass and mosaic
The Methodist Church
Collection of Modern Christian Art

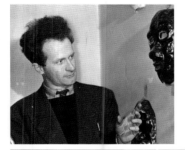

7 David Tinker, c. 1955

8 David Tinker *Beach Image*
c.1957, 114 x 183 cm, oil on canvas

Purchased by the National Museum of Wales
from the first 56 Group exhibition, 1957

1 Rowan, Eric (1985), p.125
2 Wakelin, Peter (1999), p.58
3 *Eric Malthouse: Paintings*, New Vision Centre Gallery, London, 1965
4 Malthouse, Eric, in *Art in Wales* (1969)
5 Conversations with John Selway, 13 and 27 April 2012
6 Giardelli to Elias, 18 December 1971; Malthouse to Giardelli, 30 October 1972; Giardelli to Elias, 1 November 1972; Giardelli to Griffiths, 15 November 1973, Fv
7 James, David, ed. (2009) *Fifty Years of Watercolour Painting in Wales, 1959-2009*, Watercolour Society of Wales, p.3
8 Meyrick, Robert, ed. (2002); Wakelin, Peter (2000) David Tinker obituary, *The Guardian*, 4 September, p.20
9 Tinker, David, in Giardelli, Arthur, ed. (1976), p.60
10 *Heads and Masks: An Exhibition of Sculpture by David Tinker*, University of Wales, Aberystwyth, 1983; *Dream Places: New Ceramic Sculpture by David Tinker*, Rhyl Library, Museum & Arts Centre, 1996
11 Tinker, David, in Stephens, Meic, ed. (1973), pp.81-82
12 Wakelin, Peter, 'David Tinker and the Art Community in Wales' and Whiteley, Nigel, 'The Hard-Edged Nurturing Tutor' in Meyrick, Robert ed. (2002)
13 Wakelin, Peter ed. (forthcoming) *War Underground*, The South Wales Record Society
14 Taped interview with Edmonds, 14 August 2007, and artist's curriculum vitae.
15 Notes by David Moore on Pneumoconiosis Unit Ceramic Mural, Llandough Hospital, 1958, prepared for Contemporary Art Society for Wales and Twentieth Century Society, 2008
16 Woollen, R. A., *Michael Edmonds*, Countryworks, 1997, pp 3-4; Wakelin, Peter (2004), pp.77-78
17 Taped interview with Michael Edmonds, 14 August 2007

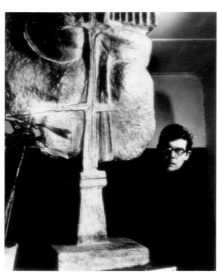

9 Trevor Bates with *Goat*
1958, 91 x 91 x 61cm, plaster for bronze

10 Hubert Dalwood with *Icon*
1958, 170cm high, aluminium

Nine More Founder Members

Trevor Bates (born Eltham, Kent, 1921; member 1956-68; associate 1963-68; died 2008) was a sculptor whose grandfather was the academic sculptor Harry Bates. Educated at Harrow School, he served as a Royal Air Force pilot in the Second World War and then attended the Slade School of Fine Art until 1951.[1] He spent a year in the studio of Ossip Zadkine, a Parisian sculptor of part-cubist, part-symbolic figures, and exhibited in the Salon de la Jeune Sculpture, Paris. His figurative, yet skeletal, metal sculptures have been associated with the anxiety identified by critic Herbert Read in an essay written for the 1952 Venice Biennale at the height of the Cold War as the 'geometry of fear.' Read applied it to artists such as Reg Butler, Lynn Chadwick and Kenneth Armitage.[2] Stylistic difficulties with the term have been discussed by Margaret Garlake.[3] Bates received an Arts Council award in a 1952-53 international sculpture competition organised by the Institute of Contemporary Arts to design a monument for *The Unknown Political Prisoner*. An exhibition of his bronze sculpture, mainly of birds and animals and associated drawings, was held at the Waddington Galleries in Cork Street, London, in 1959.[4] He was a lecturer at Newport College of Art until 1960 when he moved to become head of sculpture at Hornsey College of Art before emigrating to Canada in 1967.

Hubert Dalwood, known as 'Nibs' (born Bristol 1924; member 1956-70; associate 1963-70; died 1976) was a sculptor who had been an apprentice in the aircraft industry and an engineer for the Royal Navy in the Second World War. He studied at Bath Academy of Art with Kenneth Armitage and worked in a bronze foundry in Milan. He came to Wales as a lecturer at Newport School of Art, 1951-55, although he was 'near desperation to leave Newport' by 1954.[5] He was appointed to a Gregory Fellowship at Leeds University in 1955, which was extended until 1959. During this time he lectured part-time in Leeds. He wished to make sculpture free of the human figure. Henry Moore, one of the selectors for the Fellowship, bought his 1957 bronze *Tree*.[6] The 1959 egg-shaped aluminium *Large Object* won first prize for sculpture in the John Moores Liverpool Exhibition, establishing his reputation.[7] It resembled a ritualistic object from a vanished civilisation with a carefully worked surface of mysterious marks and symbols.[8] He was a prize-winner at the 1962 Venice Biennale. Becoming head of sculpture at Hornsey College of Art in 1968, he moved in 1974 to the Central School of Art. He often used aluminium with reflective surfaces in the late 1960s and 1970s, which mirrored the insides of works as well as their environment and played with perceptions.[9] Many of his later works reveal a fascination with Zen gardens.

1 Davies, Peter (2008) 'Trevor Bates: Sculptor of Distinctive, Spiky Forms' (obituary), *The Guardian*, 2 August
2 Burstow, Robert, 'The Geometry of Fear: Herbert Read and Modern British Sculpture after the Second World War' in Read, Benedict, & Thistlewood, David, ed. (1993) *Herbert Read: A British Vision of World Art*, Leeds City Art Galleries, pp.119-132
3 Garlake, Margaret (1998) *New Art, New World: British Art in Postwar Society*, Yale, pp.194-200
4 *Trevor Bates: Recent Sculpture*, Waddington Galleries, London, 1959
5 Stephens, Chris (1999) *The Sculpture of Hubert Dalwood*, The Henry Moore Foundation / Lund Humphries, p.16
6 Wood, Jon, *Hubert Dalwood: Landscape into Sculpture*, New Art Centre, East Winterslow, 2009
7 Stephens, Chris (1999), p.19
8 Stephens, Chris, in Curtis, Penelope, et al, ed. (2003) *Sculpture in 20th-century Britain: Volume Two, A Guide to Sculptors in the Leeds Collections*, Henry Moore Institute, p.64
9 Wood, Jon, 2009, as 6 above

Arthur Giardelli (born Stockwell, London 1911; member 1956-2009; chair 1961-98; president 1998-2009; died 2009), painter and construction artist, was one of the most dedicated and long-serving members of the Group, providing it with stability and direction.[1] He was educated at Hertford College, Oxford, where he read modern languages and attended the Ruskin School of Art. He taught languages at a school in Folkestone and frequently visited the Continent, meeting and collecting the work of artists. The school was evacuated to Dowlais near Merthyr Tydfil during the Second World War but, as a conscientious objector, he was dismissed from his post. He and his family were offered accommodation in a Quaker educational settlement and Giardelli taught art history and music. Here he met Heinz Koppel and Cedric Morris and would, later, attend the latter's East Anglian School of Painting. He became a tutor for the Extra Mural Department of the University of Wales, Aberystwyth, and made a large contribution to art appreciation in Wales. He lived in Pendine from the late 1940s and in Warren, Pembrokeshire, after 1969. His watercolour landscapes are distinctive but he is particularly associated, from the mid-1950s, with abstract constructions using found materials. These reveal a fascination with the rhythms of the sea and the enigmatic nature of man's relationship with time. They incorporate seashells, watch fragments, oar slices, pieces of tap and curled paper torn from old books. Giardelli served as a member of the committee of the Contemporary Art Society for Wales and, 1965-75, of the Art Committee of the Welsh Arts Council He also belonged to the South Wales Group and received an MBE for services to art in 1973.

11 Arthur Giardelli in his studio, 1967
12 Arthur Giardelli *Carmarthen Bay I* 1956 91 x 45 cm, sacking, wood & cork

13 Robert Hunter in his studio, 1960

Robert Hunter (born Liverpool 1920; member 1956-84; secretary 1959-61; honorary member from 1984; died 1996) was a painter and relief artist who received the Military Cross in the Second World War.[2] He attended Liverpool College of Art and, in 1952, became senior lecturer at Trinity College, Carmarthen, later head of art, then of creative arts, until 1983. Eric Rowan believed that 'Hunter is an artist whose personal development is inseparable from the fact that it has occurred largely in Wales.'[3] His earlier paintings were figurative and emphasised the Welsh landscape. He became fascinated by dry stone walls and the sound and rhythms of the Welsh language, seeking to make visual equivalents for them.[4] By 1960 his paintings had become completely abstract.[5] He then returned to an abstraction co-existing with content. In 1965 he explained that 'paradox or tension is present in the type of art that I admire most - the Byzantine period, Paul Klee, cromlechs, Celtic crosses…'[6] 'My work is made up of signs and symbols,' he wrote in 1976. 'These are either personally fashioned or adapted from ancient and modern cultures. I believe that the pictorial sign or symbol is capable of the most variable means and modes of communication and possesses the necessary degree of ambiguity to promote wonder.'[7] The quality of his craftsmanship made his work particularly effective.[8] He was also a member of the South Wales Group.

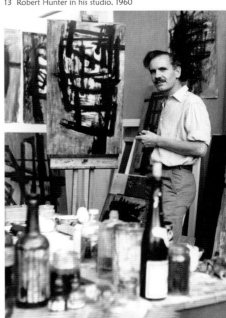

1 Giardelli, A. & Shiel, D. (2001); Obituaries by Stephens, Meic, *The Independent*, 6 November 2009,& Moore, David, *The Guardian*, 12 November 2009; Interview in Curtis, Tony, ed. (1997) *Welsh Painters Talking*, pp.17-28
2 *56 Group in 1981: 25th Anniversary Exhibition*, National Museum of Wales, 1981, pp.24-25
3 Rowan, Eric (1985), p.127
4 Lord, Peter (2000), p.406, refers to remarks by Hunter in Stephens, Meic, ed. (1973) about the Welsh language and Celtic crosses.
5 Jones, J Gareth (1965) 'The Paintings of Robert Hunter', *The Anglo-Welsh Review*, Autumn, p.73
6 *2 Artists: David Tinker, Robert Hunter*, Welsh Committee of the Arts Council of Great Britain, 1965
7 Hunter, Robert, in Giardelli, Arthur, ed. (1976), p.33
8 Stone-Jones, Gareth, in *Robert Hunter & David Tinker: Paintings*, University College Cardiff, 1979

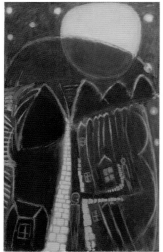

14 Ernest Zobole *Rhondda Street with Moon and Stars* c. 1964
126 x 76 cm oil on canvas. University of Glamorgan Art Collection Museum

Ernest Zobole (born Ystrad, Rhondda, 1927; member 1956-70; died Ystrad 1999) was a painter, the son of Italian immigrants. His National Service was spent as a clerk in the Army and, from 1948, he attended what would shortly be renamed Cardiff College of Art. He travelled daily with fellow students who, together, have become known as the Rhondda Group.[1] Zobole painted the familiar environment of the Rhondda Fawr. He had been much impressed by Heinz Koppel's dedication to painting. In 1963 he became a lecturer at Newport College of Art and took part in a touring exhibition with Brenda Chamberlain. Two exhibitions at the Piccadilly Gallery, London, followed. Whilst involved with the Group his work evolved from representation, through expressionism, towards flat surface pictures with multiple viewpoints and a more restricted palette.[2] 'I think,' he wrote, 'it is a case of painting myself through the material around me.'[3] He resigned from the Group in 1970 in protest against the desire of some of the Group's constructivists to exhibit together.[4] He continued to lecture at Newport until 1984 and remained a member of the Welsh Group.

John Wright (born London 1931; member 1956-67; publicity officer 1963-67) is a painter and film-maker. He first came to Wales as an evacuee in 1939.[5] He studied art in Carmarthen, Kingston and Swansea and became a lecturer at Hereford School of Art in 1955. Although his painting at this time was partly abstract, it was often figurative and romantic, revealing a strong interest in the Welsh landscape.[6] In composition, it featured recurrent circles and rectangles, a structure against which narrative might occur, and colour was carefully restricted in range and tone.[7] In paintings such as his 1960 *Hill Farmer* he responded to the poetry of R.S.Thomas. He moved to Newport College of Art and Design in 1959 as head of graphic design, becoming principal, the youngest in Britain, in 1964.[8] He resigned from the Group in 1967, a time of restructuring when many new artists with constructivist interests were being recruited (see page 24). He was, he told the press, a narrative rather than an experimental painter.[9] Wright became vice-principal of Gwent College of Higher Education in 1975 and moved to Spain in 1989.

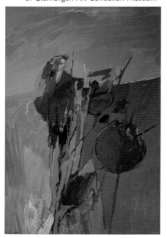

15 John Wright *Hill Farmer*
1960, 75 x 49 cm, gouache

Will Roberts (born Ruabon, Denbighshire, 1907; member 1956-64; died 2000) studied at Swansea School of Art. He served as a technician in the Royal Air Force during the Second World War and attended Bath School of Art part-time for nine months.[10] He then worked as a jeweller and clock repairer. He came to prominence in the 1950s at the same time as his friend Josef Herman, who, for several years, had mentored him in Ystradgynlais.[11] Roberts drew and painted the gentler aspects of men and women at work and leisure around his home town of Neath.[12] His work was expressionist in style with colours and shapes reflecting his feelings towards his subjects.[13] In 1954 he held his first one-man show in Cork Street. BBC Wales television presented a film about him in 1964. That year he withdrew from exhibiting with the Group after a review of his work was requested at the annual general meeting.[14] Under the constitution a letter to the secretary was required. Jeffrey Steele, motivated by the contemporary debate between figuration and abstraction, provided this.[15] Roberts later said: 'My role in the 56 Group was not important to me at all. In fact I left them very soon ... The 56 Group was set up by art school teachers who wanted to sell their work.'[16] When he sold an oil painting in 1957 to the National Museum, however, he had written: 'I am pleased also that the exhibition from which the purchase was made is the 56 Group.'[17] He was also a member of the Artist's International Association and the South Wales Group.

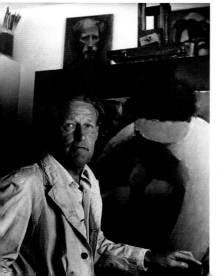

16 Will Roberts in his studio, 1964

Heinz Koppel (born Berlin 1919; member 1956-79; associate 1963-69; died 1980) was a painter who received private art tuition. With the rise of the Nazis, his family fled Germany in 1933 for Prague, where he attended the Academy of Fine Arts.[18] Later, in London, he studied at the Contemporary School for Painting and Drawing with Martin Bloch, another émigré from Berlin. He taught at Burslem School of Art, Stoke-on-Trent, moving to south Wales in 1944. Introduced to Cedric Morris, he taught for Merthyr Art Society.[19] He was the principal at Dowlais Art Centre, 1948-56. His figurative work was derived from the German expressionist tradition emphasising strong non-naturalistic colour for emotional effect. David Fraser Jenkins emphasises the importance of wit and that it was 'minutely to do with place and incident, but considered beyond this it was not local but international.'[20] Reflecting psychological turmoil, the work poses riddles and is often surreal. In 1956 he moved to Highgate, lecturing in art part-time at Hornsey and Camberwell in the early 1960s. He showed work at the Beaux Arts Gallery. He lectured at Liverpool College of Art, 1964-74. In 1969 he acquired a farmhouse in mid-Wales, where his family moved in 1974. He held an exhibition of more abstract paintings, drawings and constructions in 1978 at Oriel, Cardiff.[21]

George Fairley (born Dunfermline, Fife, 1920; member 1956-66; associate 1963-66; died 2003) was a painter and sculptor who attended Edinburgh College of Art. He studied in Paris with Fernand Léger. During the Second World War he became a radar technician with the Royal Air Force. He was appointed a lecturer in painting at Swansea School of Art in 1947 and moved to Croydon College of Art as head of foundation studies, 1962-81.[22] Giardelli describes how, after earlier surrealist landscape leanings and being influenced by Josef Herman's expressionism, Fairley became interested in the non-figurative language of colour, line and texture. Wakelin feels that his work may, stylistically, be related to the sculpture of Moore and Hepworth.[23] His paintings are the result of constant reworking.[24] From his Welsh studio overlooking Caswell Bay, he produced work shown at Gimpel Fils, London, and Bear Lane Gallery, Oxford, and theatrical designs for his friend the poet Vernon Watkins' *Ballad of the Mari Lwyd*. He was also a member of the South Wales Group.

17 Heinz Koppel in his studio, c.1950
18 Heinz Koppel *Sari* 1959
153 x 102 cm, tempera & oil on canvas

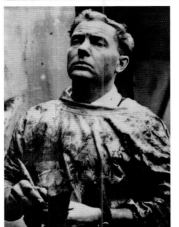

1 Interview with Ernest Zobole in Curtis, Tony, ed. (1997); Thomas, Ceri (2007) *Ernest Zobole: A Life in Art*, Seren; Obituaries, 1999, by Stephens, Meic, *The Independent*, 7 December, & Wakelin, Peter, *The Guardian*, 23 December
2 Thomas, Ceri (2004) *Ernest Zobole: A Retrospective*, University of Glamorgan, p.9
3 Quoted in Cross, Tom, *Two Painters: Brenda Chamberlain / Ernest Zobole*, Welsh Committee of the Arts Council, 1963, p.7
4 Conversations with John Selway, 13 April 2012 and 27 April 2012
5 Wright, John, in Stephens, Meic, ed. (1971) *Artists in Wales*
6 Rowan, Eric (1985), p.147
7 Jones, J. Gareth (1966) 'The Paintings of John Wright', *The Anglo-Welsh Review*, Vol.15, 36, pp.46-54
8 Brown, Peter (2009) *No More World's to Conquer: The Story of Newport's University*, pp.48-55
9 'New Blood', *The Western Mail*, 13 December 1967
10 Roberts, Will, in Stephens, Meic, ed. (1977) *Artists in Wales 3*, pp.106-07
11 Roberts, Phillis, in Joyner, Paul, ed. (2001) *Will Roberts RCA: Drawings*, The National Library of Wales, p.27; Crawford, Alistair (1993) *Will Roberts: A Retrospective, 1927-1992*, Oriel Mostyn, Llandudno, pp.3-11
12 Will Roberts (obituary), *The Times*, 18 March 2000
13 Roberts, Will, in Stephens, Meic, ed. (1977), p.105
14 AGM, 24 October 1964, Ci; Griffiths to Roberts, 26 October 1964, & Roberts to Griffiths, 5 November 1964, Giiia
15 Steele to Griffiths, undated, Giiia; Conversation with Steele, 16 May 2012
16 Roberts, Will, in Curtis, Tony, ed. (1997), p. 93
17 Roberts to Ford, 22 July 1957, Fii
18 Monk, Anna Canby, in Schütz, Chana, & Hermann, Simon, eds. (2009) *Heinz Koppel: Ein Künstler zwischen Berlin und Wales*, verlag für berlin-brandenberg, pp.128-35
19 Lord, Peter (1998), p.229
20 Fraser Jenkins, David, in Schutz, Chana, & Hermann, Simon, eds. (2009), p.88
21 *Heinz Koppel: New Paintings, Drawings and Constructions*, Oriel, Cardiff, 1978
22 Buckman, David (2003) George Fairley (obituary), *The Independent*, 8 December
23 Wakelin, Peter (1999), p.68
24 Giardelli, Arthur (1962) 'The Work of George Fairley', *The Anglo-Welsh Review*, Vol.12, 29, pp.32-39

19 George Fairley *Out of the Sea* 1955-59, 99 x 122 cm, oil on board. Aberystwyth University, School of Art Gallery & Museum, gifted by the Arts Council of Wales, 2002

20 George Fairley in his studio, 1962

21 Catalogue cover for the first 56 Group exhibition, 1957, designed by Eric Malthouse.

exhibiting
artists:

Trevor Bates *
Michael Edmonds
George Fairley
Arthur Giardelli
Robert Hunter
Heinz Koppel
Eric Malthouse
Will Roberts
David Tinker
John Wright
Ernest Zobole

* (not Tenby)

The First Exhibition: From England to Wales, 1957

The 56 Group's first exhibition took place at Worcester Museum and Art Gallery, 6th to 22nd June, 1957. An often expressed although misleading view, even by members, is that the Group was unable to find a gallery prepared to show its work in Wales.[1]

Curators were, not surprisingly, intrigued yet wary of what was an unexhibited new association with radical intentions, even though individual members' work would have been known. Giardelli wrote to David Bell at Swansea's Glynn Vivian Art Gallery in September 1956. There was a prompt, although probably standard, reply: 'I see no reason why my Committee should not consider favourably the request for accommodation for the exhibition. I think my Committee, however, would wish me to see the work before giving me authority to make a firm booking.'[2] Giardelli urged Malthouse and Fairley to let Bell know if they wanted him to take the first show.[3] Will Roberts later remarked that: 'It seems somewhat deplorable that those in charge of gallery space in S.Wales show such a cautious attitude toward the new Group.'[4]

The first showing occurred outside Wales because Giardelli 'knew a man who was working in Worcester, a civil servant Jim Phelips, a good friend from Hertford College, and he offered to get us an exhibition...'[5] He was in a position of influence as deputy clerk for Worcestershire. Giardelli visited the curator and librarian and was offered an exhibition, confirmed in writing on the 9th October. Edmonds and Tinker made further arrangements.[6] Tinker later reflected that: 'It is an interesting irony that we had to wait less than a year for our first exhibition because we used the Old Boy network.'[7]

The Worcester exhibition included sixty-six works by eleven artists as Dalwood, then working in Leeds, did not exhibit.[8] It was opened on Thursday 6th June by Rollo Charles, keeper of art at the National Museum of Wales, and coffee and snacks were served.[9] Mr and Mrs Phelips held a drinks party in the gallery that Friday and around three hundred and forty visitors signed the visitors' book in seventeen days.[10] There were no sales, although a Malthouse oil, *Walking on Rocks*, sold afterwards.[11] *The Manchester Guardian* referred to the works as 'a challenge more solid, various, and audacious than usually troubles the walls of our county towns.'[12] As a participant, however, John Wright felt disappointed by the standard of the exhibition.[13]

There were signs of internal tension by spring 1957. 'Unless we do this Worcester show properly,' Giardelli wrote to Malthouse in early May, 'the 56 Group will fail.' He was anxious to firm up arrangements in Wales and wrote in mid June: 'Of course

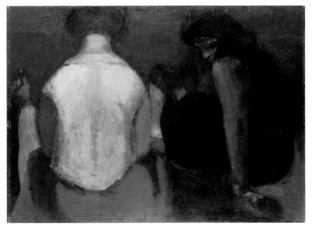

From the first exhibition the National Museum of Wales bought three works: Malthouse's *Rock Pool III*, Roberts's *Two Women on a Beach* and Tinker's *Beach Image*,[14] the latter illustrated on page 9. Tinker recalls that his painting was slightly damaged by lipstick during the showing, although he was able to repair it.[15]

John Wright's *Amroth* was bought by the Contemporary Art Society for Wales and he also sold *The Town*.[16] Sheila Gibbs bought Malthouse's *Sorting Fish I* (see page 8) which would, as Wakelin points out, have been 'partly with the educational aim of showing how forms could be abstracted from figures and objects.'[17] All works sold were oil paintings.

22 Will Roberts *Two Women on a Beach*
1955, 91 x 122 cm, oil on hardboard
Purchased by the National Museum of Wales from the first 56 Group exhibition, 1957.

you want to get out of organising this Group as soon as possible - organising is lousy. The trouble is most people who like organising are a menace… Can't you be content with the fact that the Group is a wonderful idea, has got a good first show, that several people are helping and that it <u>must</u> live.'[18]

After the opportunity to see the exhibition in Worcester, firm offers of showings in Wales were received at short notice. These included one from Bell although, frustratingly, it was not possible to accept it because a similar period had just been arranged at the National Museum.[19] Bell came to appreciate the artistic significance of the Group because, after the 1958 exhibition, he wrote to Malthouse: 'I did indeed like your show enormously and would be very glad to show it here.'[20] Nevertheless, forty years later, Tinker seemed convinced that Bell 'didn't like us - in fact he had an exhibition of us down there and then bad-mouthed us.' The context for this remark, however, is uncertain because the Group did not exhibit at the Glynn Vivian Art Gallery until 1960 and Bell died in 1959.[21]

The National Museum of Wales accepted the entire exhibition for its Pyke Thompson Gallery with a private view on 6th July.[22] It ran until 6th August and over a thousand people signed the visitors' book.[23] *The Western Mail* considered it 'a significant event.'[24] *The Times* felt that 'we must congratulate the authorities of the National Museum on giving South Wales this appetizing taste of avant-garde contemporary art.'[25] *The Western Mail* later noted a healthy level of sales although 'many an artistic eyebrow was raised in surprise when the National Museum of Wales decided to stage the current exhibition of mainly abstract pictures…'[26]

A reduced version of the exhibition, consisting of thirty-eight works without sculpture, was shown by arrangement with Tenby Arts Club in the Council Chamber Annexe of Tenby Civic Centre from 17th to 31st August.[27] Giardelli oversaw arrangements. It was opened by Philip Jones, assistant director in Wales of the Arts Council of Great Britain. In peak holiday time, over eight hundred people signed the visitors' book in fifteen days.[28]

The Tenby Observer believed that: 'The exhibition as a whole has a stimulating vitality which is most refreshing,' although one of its readers 'came away wondering why otherwise intelligent people do these things and expect ordinary folk like myself to appreciate what I can only describe as monstrosities and travesties.' William Wilkins responded: 'The artists of the '56 Group' are not incomprehensible; 'One of the Old School' is uncomprehending.'[29]

What is surprising is that the 56 Group, whilst only formed the previous autumn, was able to secure three exhibitions in 1957, two of which *were* in Wales. This does not suggest a lack of interest, although the notion that there was may have suited the Group's political purpose. It is worth reflecting, too, that the Arts Council Welsh Committee provided a grant towards the cost of the first exhibition.[30]

1 Rowan, Eric (1985), p.125; Giardelli, A. & Shiel, D. (2001), p.108; Jones, Huw David (2012), p.11
2 Bell to Giardelli, 20 September 1956, Fi
3 Giardelli to Malthouse, 21 September, 1956, Fii
4 Roberts to Ford, Malcolm, 18 November 1956, Fi
5 Giardelli, A. & Shiel, D. (2001), p.108
6 Letters, 1 October - 14 November 1956, Fi & Fii
7 Tinker, David (c.1997), p.267
8 56 Group, Worcester, 1957
9 Phelips to Ford, 14 May 1957, Fi
10 Communiqué 6 from Malthouse, September 1957, Fii
11 Keen, E.A.F., to Malthouse, 24 June 1957, Oi; 'Paintings sold 1957', 56 Group notebook, p.7, Ei
12 *The Manchester Guardian*, 13 June 1957
13 Conversation with Wright, 3 February 2012
14 Ford to respective artists, 20 July 1957, Fi
15 Tinker, David (c.1997), p.270
16 Malthouse to Ford, 14 August 1957, Fi
17 Gibbs, Sheila, to Malthouse, 21 July 1957, Fi; Wakelin, Peter (2004), p.47
18 Giardelli to Malthouse, 2 May & 13 June 1957, Fii
19 Bell to Giardelli, 26 June 1957 & 1 July 1957, Fi
20 Bell to Malthouse, 10 June 1958, Oiii
21 Quoted in Lord, Peter (2000), p.406
22 Remarks by Tinker attributed to Lord Raglan were, presumably, those made at the National Museum of Wales in 1960 and not 1957 as indicated in Lord, Peter (2000), p.406. See press report, page 16
23 Notes on accounts, September 1957, Fii
24 Powell, Geronwy, 'Significant Welsh art exhibition', *The Western Mail*, 8 July 1957
25 'Wales Gets a Taste of the Avant-Garde', *The Times*, 11 July 1957
26 Powell, Geronwy, 'Modern art shocks - but paintings sell', *The Western Mail*, 25 July 1957
27 56 Group, Tenby, 1957, Ni; 'Art gets blessing of Tenby Town Council', *The Tenby Observer*, 14 June 1957
28 Notes on accounts, September 1957, Fii
29 Letters in *The Tenby Observer*, 23 August, 30 August & 6 September 1957
30 Owen, Myra, to Ford, 24 May 1957, Fi. The grant was for £59.

ARTISTS HAVE A WORD FOR IT

23 Photograph in *The Western Mail*, 19th August 1957, at 56 Group exhibition in Tenby. From left: Fairley, Philip Jones (assistant director, Welsh Committee of the Arts Council), Giardelli, Hunter and Wright with *Sorting Fish* by Malthouse.

24 Catalogue cover, 1958 exhibition, designed by Malthouse.

25 Invitation to the opening, National Museum of Wales, 1960.

Atrocities at the Museum, 1958 - 61

An ambitious first year of exhibiting seems to have put the Group under strain. By autumn, Ford had left the committee and Edmonds had moved to London to practise as an architect. A draft 'communiqué' in Malthouse's writing suggests that Edmonds, Tinker and Malthouse were resigning from the executive.[1] Presumably this did not occur because both Malthouse and Tinker were handling administration throughout 1958. By early 1959, however, Hunter is secretary and, with Malthouse, handling arrangements for the 1960 exhibition.[2]

The Group's character at this time derived from the founder members' work, ideals, ambitions and distinctive publicity material. The second exhibition, at Turner House, Penarth, in May 1958, was supported with an Arts Council Welsh Committee grant.[3] The venue was described to members as 'an intimate setting for works with a charming full-time 'attendant' who provides a continual decor of flowers.'[4] Alan Bowness, then a young lecturer at the Courtauld Institute, gave a lantern lecture on abstract art. In addition, Giardelli agreed to help with a discussion about the work, advising that 'members of the audience (if any) should be invited to ask questions (or throw tomatoes).'[5] The exhibition was advertised widely in the national press.[6]

The next exhibition opened in the Pyke Thompson Gallery at the National Museum of Wales in early 1960.[7] Remarkably, with Dalwood's first appearance, this was the only time that all twelve founder members exhibited together. The launch seems to have been a dramatic occasion, with the vandalism of artworks being reported in the press (see right). The exhibition was toured by the Arts Council to Swansea's Glynn Vivian Art Gallery.

26 Report by David Mathias on 56 Group exhibition opening at the National Museum of Wales. *Cardiff District News* Thursday 3rd March, 1960

Giardelli secured three year support to meet the costs of planning exhibitions and for a secretary from the Calouste Gulbenkian Foundation.[8] This led to an extraordinary general meeting in April 1961 at which the Welsh Committee's assistant director, Tom Cross, was present.[9] Committee roles and procedures were formalised. Patricia Cross became secretary, Malthouse chair and Tinker treasurer. The Group opened its first bank account and subscriptions were raised to three pounds.

A constitution was drawn up to clarify the Group's aims which were: regular exhibitions; a membership of twelve; future members to be Welsh or to live and work in Wales; those not exhibiting for two years to lose membership; members able to request a review of another member's work in writing; non-members to be invited to exhibit if space was available; and new members to be invited, supported by two existing members.[10]

That October at the annual general meeting, however, Malthouse resigned as chair and was replaced by Giardelli, a position which he would hold until 1998.[11]

1 Communiqué 6, September 1957, Fii
2 Exhibition file, 1960, Oiv
3 Owen, Myra, to Malthouse, 16 May 1958, Oiii. Grant was £25
4 Malthouse to members, 1957, Oiii
5 Promotional card, *56 Group*, Turner House, 1958, Oiii; Giardelli to Malthouse, 4 April 1958, Oiii
6 Advertisements appeared in *The Studio, The Observer, The New Statesman* and *Art News & Review*; Turner House file, 1958, Oiii
7 Exhibition file, 1960, Oiv
8 Calouste Gulbenkian Foundation granted £100 a year, 1961-63, EGM, 22 April 1961
9 EGM, 22 April 1961, Ci; Arts Council granted £50 in 1961, Accounts 1962, Eii
10 1961 Constitution, Ai
11 AGM, 21 October 1961, Ci

Extended Tours, 1962 - 64

With a more effective administrative structure and security of funding in place, extensive tours around Wales and England were planned and implemented in 1962 and 1963-64. This was supported by what was becoming regular Arts Council Welsh Committee annual funding.[1] At the 1962 annual general meeting a hanging committee of three, to be selected by postal vote, was authorised to control exhibition quality.[2] At the following annual general meeting the constitution was amended to permit members living outside Wales to become associates.[3]

The 1962 *Paintings and Sculpture* tour opened at University College North Wales in Bangor, visiting eight venues over twenty-two weeks. Guest artists - Ronald Carlson, Glyn Jones, Jeffrey Steele and Anthony Stevens - were invited to exhibit for the first time. All but Carlson would become members and play a significant role in the Group.[4] Roger Webster, director for Wales with the Arts Council of Great Britain, opened the show at Cardiff's Howard Roberts Gallery. The Group's usual commission was waived as it was a commercial gallery.[5] Unfortunately, in Bangor, Bates's sculpture was snapped off its stem and work by Anthony Stevens was also damaged. It is not known how these incidents occurred.[6]

That year Malthouse was shocked to discover that Giardelli was exhibiting watercolour landscapes in non-Group exhibitions.'We cannot include anyone who can in one exhibition produce supposedly sincere experiments,' he felt, 'and then in the same gallery a month afterwards exhibit a number of blatantly executed pot-boilers… views of Paris etc.'[7] Wisely, the matter was not pursued.[8]

For the 1963-64 *Drawings and Gouaches* tour, Jeffrey Steele and Anthony Stevens were invited to replace Edmonds, who was ill, and Dalwood.[9] Displayed in a remarkable fifteen venues, it was one of the longest tours ever held by the Group, Midlands Federation of Museums and Galleries arranging six of the showings. Standard framing by Robert Sielle enabled works to be crated easily. There were many sales and writer Saunders Lewis bought a work by Zobole. It was opened at Swansea's Dillwyn Gallery by Vernon Watkins, who recited a poem which played upon members' names:[10]

This is a FAIRLEY comprehensive exhibition. ZO BOL(D)LE I HUNTER ound for something to say about it, before you STEELE yourselves to look at the pictures. The artists have done their job, and what WRIGHT have I to TINKER with it? I'm shaking like a GIARDELLI as it is. What with a KOPPEL at the MALTHOUSE, I'm like a fish out of water.

Now, you other fish, look at these attractive BATES. Snap them up. WILL ROBERTS be yours, or which? It mu STEVEN Seem I can't talk properly, but I know them all, and they're all here. I declare the exhibition open.

At the 1963 annual general meeting, held at the Arts Council's Cardiff offices, Patricia Cross resigned when her husband, Tom Cross, was appointed to a post in Reading. Mary Griffiths took over in an honorary capacity. In her first term of office she would serve until 1971 helping to provide stability to the Group.[11]

1 The Arts Council provided £100 a year, 1962-64, Accounts 1963-64, Eii
2 AGM, 10 November 1962, Gi
3 1963 Constitution, Ai
4 Annual Report, 1961-62, Di. Glyn Jones became a member in 1972.
5 AGM, 21 October 1961, Ci
6 Correspondence with members, 1962, Gii
7 Malthouse to Cross, 13 June 1962, Fiii
8 Cross to Malthouse, 19 October 1962, Fiii
9 Annual Report 1962-63, Di; AGM 1962, Ci
10 Typescript in press cuttings file, 1963, Vviia
11 Annual Report, 1963-64, Di

exhibiting artists
1962 tour:

Trevor Bates
Ronald Carlson (guest)
Michael Edmonds
George Fairley
Arthur Giardelli
Robert Hunter
Glyn Jones (guest)
Heinz Koppel
Eric Malthouse
Will Roberts
Jeffrey Steele (guest)
Anthony Stevens (guest)
David Tinker
John Wright
Ernest Zobole

27 Catalogue cover, 1962 tour, designed by George Fairley

28 Combined catalogue and poster, 1963-64 tour, designed by Robert Hunter to be overprinted for each venue.

exhibiting artists
1963 - 64 tour:

Trevor Bates
George Fairley
Arthur Giardelli
Robert Hunter
Heinz Koppel
Eric Malthouse
Will Roberts
Jeffrey Steele (guest)
Anthony Stevens (guest)
David Tinker
John Wright
Ernest Zobole

Newport Op & Pop, 1963 - 64

Three artists employed by Newport College of Art, whose work reflected new preocccupations, joined the Group in the early to mid 1960s: Jeffrey Steele, Anthony Stevens and John Selway. They had already been guest exhibitors, replacing founder members who had left Wales. Peter Nicholas, a painter and sculptor also working at Newport, was a guest during 1964 and 1965.[1]

Jeffrey Steele [born Cardiff 1931, guest 1962-63; member 1963-74; 'permanent' member 1969; life / honorary member 1974] attended both Cardiff and Newport schools of art and, after independent study and travel, obtained a French Government scholarship to the École des Beaux-Arts, Paris. His systematically painted geometric work tends to create optical effects in the mind of the viewer. It was included in *The Responsive Eye*, an influential 1965 exhibition of predominantly optical art, originated by the Museum of Modern Art, New York.[2] He was appointed a lecturer at Newport College of Art that year, remaining until 1967. He wished 'to exploit the area of tension between a given idea as a concept in the mind and the experience of it as a sensation.'[3] The op art effect, which he described as 'a battery of optical nuances or flickering overtones in the eye and mind of the spectator,' was virtually a by-product of a rigorous attempt to eliminate traces of the artist's touch from the picture surface. He moved in 1968 to Portsmouth to head the fine art department and, although he still lives there, is conscious of 'the inescapably Welsh origin of my project, especially in my 'role/assignment' as untypical Welsh subject.'[4] He took part with David Saunders in the 1972-73 Arts Council *Systems* exhibition.[5] He has recently been included in a review of systems-based art at Southampton Art Gallery.[6] Steele believed that the Group should focus upon abstract rather than figurative work and, in 1967, he proposed the recruitment of Tom Hudson and other Cardiff lecturers.[7] This was to have a profound influence on the Group.

Anthony Stevens [born Shirenewton, near Chepstow, 1928; guest 1962-63; member 1963-84; honorary member 1985; died 2000] attended Newport School of Art and the Institute of Education, London University. After school teaching, he became, in 1960, a lecturer in sculpture and then head of fine art at Newport College of Art before moving to Wimbledon in 1979 as head of fine art. In the late 1960s he made what has been characterised as 'funk pop art', rendering objects such as telephones and televisions in *ciment fondu*.[8] By the mid 1970s he turned to materials such as fibreglass, resin, latex and aluminium to make subjects such as birds,

29 Jeffrey Steele *Hecuba*
1964, 122 x 91 cm, oil on cotton

Image used on the back cover of the 1965 *Painting & Sculpture* exhibition catalogue.

Amgueddfa Cymru -
National Museum Wales

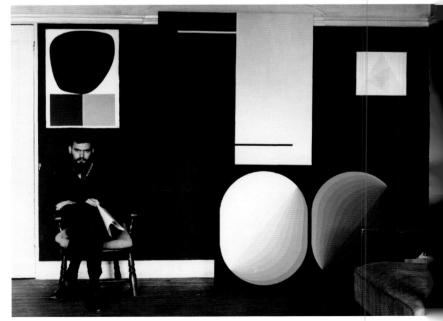

30 Jeffrey Steele in his
Cardiff studio, 1961

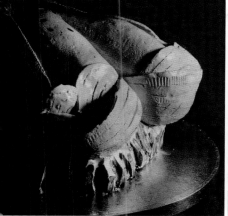

31 John Selway *Cake*
c. 1969, 20 x 25 x 25 cm, ceramic

32 John Selway in his studio, 1966

33 Anthony Stevens working on *Adam*
1974, 66 x 33 x 33 cm, glass fibre, wood and latex

houses and clouds. Starting with clay, he would then make a plaster mould.[9] These include the 1974/5 fibreglass *Kate's Bears*, a Welsh Arts Council commission for St Dials Infants School in Cwmbran.[10] For a 1982 exhibition he explored primitive-looking human figures using modelled and fired, yet unglazed, clay. Eric Rowan, in the catalogue essay, remarked that: 'There is no identity, no personality to the individual figures, there is no relationship between them.'[11] He was also involved in the Association of Artists and Designers in Wales.

John Selway [born near Doncaster 1938; guest 1964; member 1964-70 & from 2004; vice-chair from 2011], whilst primarily a painter, also made sculpture.[12] He is one of the few members to have rejoined the Group, in his case after a break of thirty-six years. Having been brought up in Abertillery since the age of two, Selway attended Newport and the Royal colleges of art, with National Service in between. 'Pop Art was just coming into fashion,' writes Osi Rhys Osmond, 'and although John Selway could never be said to have been a disciple, his work at this time often referred to everyday incidents and the world of consumption.'[13] He returned to Wales, which has been important to him, becoming a lecturer at Newport from 1964-91.[14] Figurative painting and a combination of imagination with reality have been major preoccupations.[15] His subjects are often disturbing and include memories of places, circuses, beach life or landscapes. He also draws upon history, literature and religion, as in the liberation of Auschwitz or the poetry of Dylan Thomas.[16] All his work is notable for skilful use of colour. He originally resigned from the Group in 1970 in protest against the desire of some of its constructivists to exhibit together. Malthouse and Zobole resigned with him, following a meeting at his house.[17] His recent paintings in the Church of St Michael, Abertillery, have Christ's Passion as an underlying structure.[18] Intriguingly, 'these were inspired not by faith but by his political convictions, although he acknowledges that his political thought is probably conditioned by growing up in a culturally Christian climate.'[19] He belongs to the Welsh Group and has been a member of Ysbryd / Spirit - Wales.[20]

1 Carlson and Jones in 1962, Nicholas in 1964.
2 Seitz, William, ed., *The Responsive Eye*, Museum of Modern Art, New York, 1965, p.4
3 Steele, Jeffrey (1967) 'Cicerone', *The Anglo-Welsh Review, Vol. 16, No 38, Winter 1967*, pp.56-58
4 Letter from Steele, 13 May 2012
5 *Systems*, Arts Council, 1972-3, pp.52-56
6 Fowler, Alan (2008)
7 Conversation with Steele, 16 May 2012
8 Rowan, Eric (1979), p.76
9 Stevens, Anthony, in Giardelli, Arthur, ed. (1976), pp.56-59
10 Public Monuments & Sculpture Association (TOR003), www.pmsa.org.uk, 2012
11 Rowan, Eric, *Anthony Stevens: The Assembling of Parts, An Exhibition of Sculpture from the Human Figure*, Oriel, Welsh Arts Council, Cardiff, 1982, p.5
12 'John Selway, Painter' in Bala, Iwan (2003), pp.113-21
13 Osmond, Osi Rhys (2001) 'Illuminated From Within: Osi Rhys Osmond on the Art of John Selway', *Planet 147*, p.18
14 Griffiths, Sarah in *John Selway: A Retrospective, 1953-2007*, Newport Museum & Art Gallery, 2007, p.28
15 Selway, John, in Hughes, Robert Alwyn, ed. (2011)
16 Griffiths, Sarah, *John Selway: A Retrospective - An Exhibition of Paintings, Drawings & Prints*, Newport Museum & Art Gallery, 2007 (leaflet)
17 Conversations with John Selway, 13 & 27 April 2012
18 Selway, John, & Meek, Julian (2010) *A Paraphrase on Christ's Passion and Other Images*, Church of St Michael, Abertillery
19 Lloyd-Morgan, Ceridwen, 'Decline or Transformation? Modern Welsh Artists and the Welsh Biblical Heritage', in O'Kane, Martin, & Morgan-Guy, John (2010), p.313
20 Selway, John, in Lynton, Norbert, et al (1998), pp.10-11

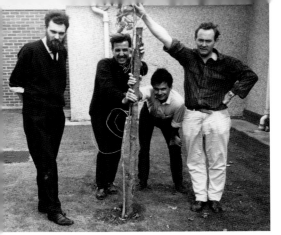

34 Two recent recruits, Steele (left) and Stevens (right), flanking two founder members, Zobole (centre left) and Wright at Barry Summer School, 1963.

Radicals are the Establishment, 1964 - 66

This period saw the continuation of an intensive touring exhibition programme focusing upon Wales and England, the raising of the Group's establishment status and the replacement of certain founder members. Steele and Stevens joined in 1963, Selway in 1964 and Terry Setch in 1966. Roberts would leave in 1964 (see page 12) with Edmonds resigning in 1965 and Fairley in 1966.[1]

The Group's 1964 *Oils and Constructions* exhibition was opened by Aneirin Talfan Davies of BBC Wales at the Dillwyn Gallery, Swansea, and travelled to three other venues. Selway and Peter Nicholas were invited artists. Three pictures were sold, bearing out Tinker's assertion that 'sales of paintings have always been small. Most of them went to a very few collectors in South Wales…'[2]

The 1965 *Painting and Sculpture* show opened at Bear Lane Gallery, Oxford, and toured to four other venues. Marina Vaizey praised 'a model of catalogues and a fitting souvenir of an extremely good exhibition.'[3] Seventeen works were sold, which must have surprised Tinker. An expanded version, with additional artists, was taken by the Welsh Committee to Newtown National Eisteddfod as its *56/65* exhibition.[4]

Giardelli was appointed to a new art subcommittee of the Arts Council Welsh Committee in 1965. Malthouse was the buyer for the Contemporary Art Society for Wales and Giardelli would be in 1967.[5] As Huw David Jones indicates: 'The Welsh avant-garde who had once faced a battle to get their work shown in Wales now found themselves part of the Welsh arts establishment.'[6] Griffith Williams reflected, 'Now it exhibits regularly each year in Wales, moving from North to South with the apparent ease of an accomplished ambassador of artistic trends.'[7] J.E. Ross wrote that 'the 56 Group have changed from revolutionaries advancing into new territory to reconnaissance squads of varying audacity.'[8]

```
F I F T Y - S I X
I F T Y - S I X     S
F T Y - S I X       S I
T Y - S I X         S I X
Y - S I X           S I X T
- S I X             S I X T Y
S I X               S I X T Y -
I X                 S I X T Y - F
X                   S I X T Y - F I
                    S I X T Y - F I V
                    S I X T Y - F I V E
```

35 Catalogue, designed by Steele, for the Group's 1965 touring *Painting & Sculpture* exhibition.

The Dillwyn Gallery was supportive of both the Group and its artists. Enterprisingly, it showed modern Welsh art in Cambridge in 1963 and London in 1964.[9] In 1965, with Welsh Committee funding, it took an exhibition, *11 Painters from Wales*, to Jefferson Place Gallery, Washington DC. Britain's ambassador to the United States, opened it. Nine of the 56 Group's members, together with John Elwyn and Tom Nash, took part. Whilst it was not organised by the Group, and no mention, indeed, is made of the Group in the catalogue, the inclusion of so many of its members reflects well on the Group's standing at the time.[10]

Relations were less good with the Howard Roberts Gallery, Cardiff. Although the Group had exhibited there in 1962, plans for an exhibition in 1966 to celebrate their joint tenth anniversaries unravelled over charges and the Group's unwillingness to compromise its relationship with the Welsh Committee of the Arts Council by requesting an additional grant.[11]

In 1966-67 the Group, again with the Midlands Federation of Art Galleries, organised another record fifteen-venue tour of Wales and England, this time of graphic work. Terry Setch was an invited artist and Giardelli designed the catalogue. 'The current display, full of colour and vigour,' wrote Williams, 'not only confirms the need for their continuance but also points to a resurgence of vitality.'[12]

36 Hunter (left), Malthouse and Stevens with Steele's *Scala* at the opening of the graphic exhibition at the Dillwyn Gallery, Swansea. *The Western Mail*, Monday 16th May 1966.

56 Group 'Wales', 1967

The decision to add 'Wales' to the Group's name appears to have arisen pragmatically. In the summer of 1966 Giardelli wrote simply in a letter to Griffiths: 'I think we should call ourselves 'The 56 Group, Wales' and I shall propose this at our next AGM.'[13] Indeed, at the annual general meeting that October, 'it was decided to add the word 'Wales' to the name of the Group.'[14] Whether there was opposition to the proposal is unknown. 'With so many of the Group's exhibitions going across the border,' explained the introduction to a new booklet about members, 'it was felt that its Welsh origins ought to be re-affirmed.'[15]

The name change, as a marketing device for the Group's purposes, would seem to have been successful. As aspirations to exhibit further afield and on the Continent became a reality, the inclusion of 'Wales' signified that the Group, whilst it had been pursuing an avant-garde agenda, also wished to be more strongly associated with its homeland. This would be helpful in obtaining exhibitions abroad. Celtic connections were made with Scotland, Ireland and Brittany. Diplomacy through the British Council and embassies to exhibit in both western and eastern Europe would, undoubtedly, have been assisted by implied national status.

The new name was also likely to have helped reinforce public funding from the Arts Council. 'The Welsh Committee may have regarded exhibitions of abstract art as the symbol of a 'new' Wales,' reflects Huw David Jones, 'but to some they also represented the dominance of Anglo-American values over Welsh culture and identity.'[16] The Committee had, indeed, provided a grant to the Group in 1967-68 and its continued support was very important to its activities.[17] Such art, however, was not widely appreciated by the general public and what was, that year, renamed the 'Welsh Arts Council' would, coincidentally, pursue a more populist agenda.[18]

56 Group Wales produced two exhibitions in early 1967. One was in Amsterdam, the Group's first venture to the Continent, and this is discussed on pages 22-23. A concurrent touring exhibition of Wales and England was, as two years earlier, launched at Oxford's Bear Lane Gallery. Eric Rowan and David Saunders were guest exhibitors. It was shown at seven other venues with the Welsh Arts Council touring it to three in Wales. A modern '56 Group Wales' logo was used for exhibition publications that year. Malthouse liaised with the Council on a booklet with separate catalogue inserts and 2 Design Associates are credited with the design.[19]

Vaizey felt that: 'The 56 Group Wales is an important collection of artists, of diverse and expanding interests, united by their admirably high standards and their continuing, exciting growth.'[20] Of the Whitworth Art Gallery showing, at which five hundred catalogues were sold, M.G. McNay believed 'the group, though far from extreme, has kept its vigour.'[21] F.W. Fenton, however, noted that 'The age of the group is belied by the fragile charm of the abstracts…'[22]

exhibiting artists
1967 tour:

Trevor Bates
Hubert Dalwood
Arthur Giardelli
Robert Hunter
Heinz Koppel
Eric Malthouse
Eric Rowan (guest)
David Saunders (guest)
John Selway
Terry Setch
Jeffrey Steele
Anthony Stevens
David Tinker
John Wright
Ernest Zobole

37 Cover of the Group's 1967 booklet by 2 Design Associates

1 Edmonds to Griffiths, 16 December 1965, Giiib; Annual Report, 1965-66, Di
2 Tinker, David, 'Pioneers of self-help', The Western Mail, 7 Dec. 1964
3 Vaizey, Marina, 'The Fifty-Six Group, Bear Lane Gallery, Oxford', The Arts Review, January 1965
4 56/65, 1965
5 Recent Purchases: An exhibition of works purchased for the Contemporary Arts Society for Wales, 1964-67, Welsh Arts Council, 1967. Malthouse bought 4 works, & Giardelli 8, by Group members.
6 Jones, Huw David (2012), p.13
7 Williams, Griffith, 'Along an abstract road', The Western Mail, 23 January 1965
8 Ross, J. E., 'The 56 Group at the Dillwyn Gallery, Swansea', The Guardian, 23 March 1965
9 The Western Mail, 2 January 1965; Thomas, Ceri, 'The Early Years' in The Attic Gallery at Fifty, 1962-2012, Attic Gallery, 2012
10 11 Painters from Wales, Jefferson Place Gallery, Washington DC, 1965. Group members were: Giardelli, Hunter, Koppel, Malthouse, Steele, Selway, Tinker, Wright and Zobole.
11 Correspondence with Griffiths, 1963-66, Fiva; Exhibitions, 1966, Oxi; The Welsh Committee grant increased to £150 in 1965 and 1966, Accounts 1965-66, Eii
12 Williams, Griffith, 'Group's exhibition shows resurgence of vitality', The Western Mail, 26 April 1966
13 Giardelli to Griffiths, July 1966, Fiva
14 Annual Report, 1966-67, Di
15 56 Group Wales, 1967
16 Jones, Huw David (2012), p.15
17 Accounts, 1967, Eii. Welsh Arts Council granted £300 in 1967
18 Jones, Huw David (2012), p.15. WAC remained funded by ACGB until 1993 (Lord, Peter, 1998, p.266)
19 Griffiths to Crossley-Holland, Joan, 10 November 1966, Pi; Annual Report 1966-67, Di
20 Vaizey, Marina, '56 Group Wales, Bear Lane Gallery, Oxford', Arts Review, 21 January 1967
21 McNay, M. G., '56 Group Wales at the Whitworth Art Gallery, Manchester', The Manchester Guardian, 29 April 1967
22 Fenton, F. W. '56 Group Wales', The Daily Telegraph (Manchester Edition), 8 May 1967

Continental Exposure: Amsterdam, 1967

38 Cover of invitation to the launch of the Group's Amsterdam exhibition at Bols Taverne, 5th January 1967.

The ambition to exhibit on the Continent was due, in large part, to the vision and determination of Arthur Giardelli. This was backed up by the tenacious administrative skills of secretary Mary Griffiths. Giardelli read modern languages at Oxford University and, being well versed in the cultural history of Italy and France in particular, was European in outlook. The Continent, too, was where many members' modernist roots lay. 'The visual arts, like music, create no barrier of language,' Giardelli emphasised: 'Every exhibition abroad gives us more confidence about being accepted internationally…'[1]

The first exhibition on the Continent was of prints, drawings, watercolours and gouaches at Bols Taverne, Amsterdam in 1967, just over a decade after the Group's formation. Located in Rozengracht, a formerly run-down area characterised by cafés, studios and bookshops, the venue had a reputation for showing contemporary art.

In early 1966 Griffiths contacted the British Council's representative in the Netherlands, H.G. Wayment: 'I write on behalf of a group of Welsh artists to ask your help in sending an exhibition of their work to the Netherlands.'[2] He wrote back advising her to contact a Dr. L. Gans at Bols Taverne, 'a gallery under the patronage of the big liquor firm of Bols.'[3] Gans was described as 'a most energetic person who is trying to persuade ordinary middle-class people of quite modest means to buy originals. He told me some time ago that he would be interested in securing an exhibition from Britain.' Wayment let Griffiths know that he had asked Bols Taverne to send her a copy of the prospectus of their current exhibition 'so that you can see something of their standards.'[4] Giardelli recalls that his friendship with the Dutch fabric designer maker Hans Polak Leiden helped to secure the venue.[5]

Ten members of the Group and one guest, Eric Rowan, exhibited forty-two works in Amsterdam.[6] Robert Sielle framed the works uniformly in silver.[7] One thousand two hundred copies of a four-page black and white catalogue, designed to complement the Group's new booklet, were printed and many were distributed by post.[8]

The administration involved in sending exhibitions abroad was considerable. Apart from diplomacy and the need to understand different procedures, it involved the complexities of customs entry, transport and insurance. Fortunately, on this occasion, Bols Taverne covered the latter two items.

There was a lively opening on 5th January by Sir Peter Garran, Britain's ambassador to the Netherlands. As one of two buyers, he acquired a lithograph by Malthouse.[9] Giardelli attended the event. Wayment, in a letter to Griffiths enclosing translations of press cuttings, felt that: 'On the whole, as you will see, I think the exhibition made a pretty favourable impression.'[10]

An anticipated exhibition in Wales of contemporary Dutch art did not occur and several later attempts by the Group to visit the Netherlands were unsuccessful.[11]

1 Giardelli, A., & Shiel, D. (2001), p.111
2 Griffiths to Wayment, H.G., British Council, 30 March 1966, Pii
3 Wayment, H.G., to Griffiths, 26 April 1966, Pii
4 Wayment, H.G., to Griffiths, 9 May 1966, Pii
5 Giardelli, A., & Shiel, D. (2001), p.109
6 *56 Group: Graphics*, Bols Taverne, 1967
7 Sielle, Robert, to Griffiths, 1 February 1967, Pii
8 Gans, Dr L., to Griffiths, 10 December 1966, Pii
9 Gans, Dr L., to Garran, Sir Peter, 25 February 1967, Pii
10 Wayment, H.G., to Griffiths, 8 March 1967, Pii
11 Correspondence re. Netherlands, 1976-2000, Kiii

42 At the launch of the exhibition at Bols Taverne are (centre, with spectacles, facing) Sir Peter and Lady Garran and (right, foreground) Giardelli.

Three of the graphic works shown in Amsterdam. Clockwise, from top left, dimensions unknown:

39 Eric Malthouse *Wha Wha*
intaglio print

40 David Tinker *Eden*
indian ink drawing

41 Anthony Stevens
Sculpture Drawing 2 charcoal

exhibiting
artists:

Arthur Giardelli
Robert Hunter
Heinz Koppel
Eric Malthouse
Eric Rowan (guest)
John Selway
Jeffrey Steele
Anthony Stevens
David Tinker
John Wright
Ernest Zobole

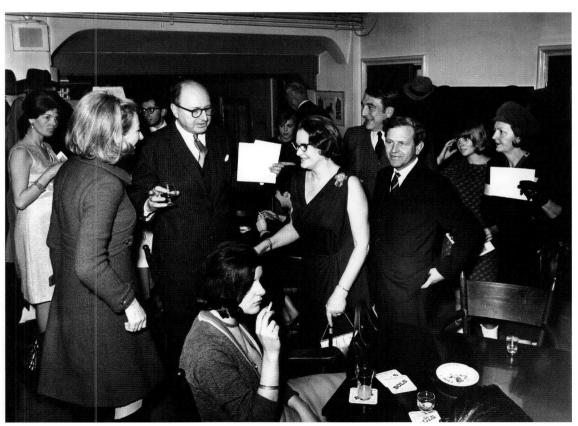

New Blood from the Art Schools, 1967

In October 1967, at the annual general meeting, Steele assessed the state of the Group. His view was that there was a malaise, that the reason for the Group's creation no longer applied and that it did not represent the best artists in Wales. It was decided that a substantial number of artists should be asked to join enabling them to influence the Group's development. Mervyn Baldwin, Laurence Burt, Tom Hudson, Keith Richardson-Jones, Eric Rowan, David Saunders, Christopher Shurrock, Norman Toynton, Michael Tyzack and Alan Wood were invited. They represented new approaches to painting and sculpture, embracing pop and op art, minimalism, hard-edged abstraction and constructivism. Most of them had recently exhibited at the Howard Roberts Gallery, notably in the 1966 *Undefined Situation* exhibition. There was a willingness to look afresh at the Group's aims, although it was hoped that it would continue to exhibit 'without a platform or aesthetic programme.'[1]

The invited artists were all art college lecturers at Newport or Cardiff, mostly recruited from outside Wales in recent art education reforms. At Newport, Wright appointed Richardson-Jones, Saunders, Steele and Bryan Macdonald. At Cardiff, Hudson appointed several lecturers from his previous art school at Leicester - Setch, Burt and Toynton - and a former student, Baldwin.[2] Burt, Hudson and Setch had exhibited together as part of the Leicester Group at London's Grabowski Gallery in 1964.[3] Hudson also appointed Tyzack and Wood. Many of these artists taught at the Barry Summer School which had a reputation for stimulating courses.[4]

The National Diploma in Design had been replaced by 1963 with a new Diploma in Art and Design. A rigorous assessment of standards was implemented to award this and, in Wales, only Newport was found to be acceptable.[5] Hudson, at the forefront of Bauhaus-inspired 'basic design' developments in art education, was recruited in 1964 as director of studies at Cardiff to upgrade courses.[6] In basic design, writes Mark Hudson, 'the student was stripped of preconceived ideas and taught, not specific craft skills, but visual literacy in the use of colour, establishment of form and construction of space.'[7] Ken Elias experienced the new foundation studies course at Cardiff and describes how it was 'taught in an almost scientific manner.'[8]

Six weeks after the October meeting the Group held an extraordinary general meeting at the Welsh Arts Council offices. Peter Jones represented the Council.[9] Those invited, with the exception of Hudson, Toynton and Tyzack, attended and were joined by Giardelli, Malthouse, Setch, Steele, Stevens and Tinker. Wright resigned before the meeting, writing: 'I do not feel that I can any longer take part in it.'[10] He advised the press 'that he thought the group had succeeded in making its point,' although 'it was right in what it continued to do' (see page 12).[11]

Key constitutional changes were: freedom to hold activities other than exhibitions; a lifting of the limit on twelve members; the abandonment of associate membership for those living outside Wales; and those no longer living or working in Wales to be members for two further years, after which they would become honorary members.

All invited artists were elected at the meeting and Macdonald was added by December. The Group nearly doubled in size. Griffiths later reflected that when the Group was smaller it had been 'more of a club'.[12] Shurrock felt that 'it was quite brave as it was also a risk to cast the net wider stylistically.' Institutionally, though, he felt that it was limited.[13] The press noted that new members were 'all male.'[14] Twelve bottles of claret provided by Giardelli to end the meeting must, after this, have been welcome.[15]

1 AGM, 14 October 1967, Ci; Letter from Shurrock, 19 March 2012
2 Hudson, Mark (2011), p.12
3 *The Inner Image*, Grabowski Gallery, London, 1964; Hudson, Mark (2011), p.10
4 *Glamorgan Summer School, Barry, 25 July - 19 August, 1966*. The prospectus included as tutors: Hudson, Burt, Baldwin, Setch, Tyzack, Wood, Zobole, Steele and Tinker. Other members took part on different occasions.
5 Rowan, Eric (1985), p.152; Brown, Peter (2009), p.48
6 Rowan, Eric, in Stephens, Meic, ed. (1979), p.66
7 Hudson, Mark (2011), p.5
8 Thomas, Ceri, ed. (2009) *Ken Elias: Thin Partitions*, Seren, p.26
9 EGM, 24 November 1967, Ci; 1967 Constitution, Ai
10 Wright to Griffiths, 9 November 1967, Fivb
11 'New Blood', *The Western Mail*, 13 December 1967
12 Annual Report, 1967-68, Di; Conversation with Griffiths, 23 March 2009
13 Letter from Shurrock, 19 March 2012
14 'New Blood', as above
15 Giardelli to Griffiths, 8 November 1967, Fivb

43 Tom Hudson *Industrial Rainbow* 1968, 76 x 122 x 30 cm, aluminium, polyester and glass fibre
Amgueddfa Cymru-National Museum Wales, gifted by the Arts Council of Wales, 2002

Newport Constructed Abstract Art, 1967

Keith Richardson-Jones [born Northampton 1925; member 1967-73; died Abergavenny 2005] was a constructivist painter, relief sculptor and printmaker who exhibited regularly with the Group. He studied at Northampton School of Art and the Royal Academy Schools, became a lecturer at Derby and, in 1965, a senior lecturer in fine art at Newport College of Art. In 1966 he exhibited in *Soundings Three* at London's Signals Gallery, a show which pioneered kinetic art. In 1969 he wrote that 'I'm looking for a format that allows maximum colour / light vibrance.'[1] For him, art was a dialogue with his work. From 1969 into the 1970s 'he experimented with additional dimensions of colour with ... objective rigour, positioning each colour on a notional three-dimensional map according to its hue, its lightness or darkness, and its density or saturation.'[2] Structures of music, both classical and jazz, were an influence and led to serial works. There could also be humour in his work. He had a one-person exhibition at the Lisson Gallery in 1970.[3] A retrospective exhibition toured Wales from Wrexham Arts Centre in 1996. He retired from Newport in 1987 and lived at Tintern.

44 Keith Richardson-Jones
Counterpoint 2 1970
96 x 62 cm, serigraph

David Saunders [born Southend, Essex, 1936; guest 1967; member 1967-70] was conscripted into the Army but did not see active service. A painter, he attended St Martin's School of Art and the Royal Academy Schools. He became a lecturer at Derby and, in 1965, Newport College of Art.[4] That year he held a solo exhibition at Artists International Gallery, London. Saunders produced early constructive work in 1967 and went on to study the relationship between systems-based art and experimental serial music.[5] He moved to polytechnics in Portsmouth in 1968 and Liverpool in 1971. He founded the Systems Group in 1969 with Steele and others. This was concerned with abstraction constructed from individual elements in a process predetermined by a logical system.[6] 'System', he wrote for the 1972 Whitechapel Art Gallery *Systems* exhibition, 'denotes sharing of information, the unity of ethics, aesthetics and logic, and the rejection of individual expressionism.'[7] The Systems Group dissolved in the late 1970s, in part due to political differences.[8] He gave up teaching in 1988 and now lives in France.[9]

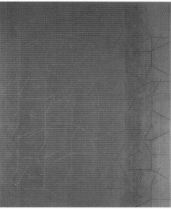

45 David Saunders *Gulf Stream* 1968
190 x 152 cm, polymer on canvas
Bodelwyddan Castle Trust,
gifted by the Arts Council of Wales, 2002

46 Bryan Macdonald working on a painted aluminium sculpture *Purple Suspension*, 1968, for the Gulf Oil refinery at Milford Haven.

Bryan Macdonald [born Singapore 1932; member 1967-70; died Darwin 1990] was a sculptor who studied at the University of Durham and Leeds Institute of Education. He became a lecturer at Salford and a Gulbenkian Fellow at the University of Keele before being appointed a senior lecturer in sculpture at Newport College of Art. A large epoxy resin construction of his was included in the *Structure 1966* exhibition at Cardiff Castle.[10] In 1969 he wrote: 'The sculpture is organised according to strict and actual physical relationships, but by the use of artificial lighting values are altered, creating visual ambiguities and apparent contradictions... The sculptures are not meant specifically to be seen in galleries but are created for natural situations... where they may surprise the onlooker all the more for their qualities...'[11] He used materials such as stainless steel, glass and perspex. Having moved in 1968 to Sheffield Polytechnic as head of sculpture, he exhibited in *Three Towards Infinity* in 1971 at Whitechapel Art Gallery and created a mural representing cancer cells for Weston Park Hospital, Sheffield, in 1972. In 1986 he became head of fine art at Darwin Institute of Technology, Australia.

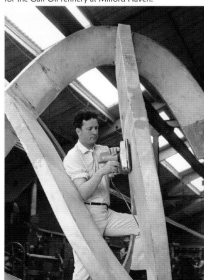

1 Richardson-Jones, Keith in *Art in Wales* (1969)
2 Harrison, Michael (2005), 'Keith Richardson-Jones: Self-effacing constructive artist' (obituary), *The Independent*, 25 April
3 *56 Group Wales*, Newport Museum & Art Gallery, 1971
4 Saunders, David, in *Art in Wales* (1969)
5 Fowler, Alan (2007), p.9
6 Fowler, Alan, ed. (2008), p.12
7 Saunders, David, in *Systems*, Arts Council, 1972, p.40
8 Fowler, Alan, ed. (2008), p18
9 www.davidsaunders.info, 2012
10 *Structure 1966*, Welsh Committee of the Arts Council
11 Macdonald, Bryan, in *Art in Wales* (1969)

From Leicester to Cardiff, 1966 - 67

Terry Setch [born Lewisham, 1936; guest 1966; member 1966-79] is a painter and relief artist who attended Sutton and Cheam Art School and, after National Service, the Slade School of Fine Art where he developed a strong interest in abstraction.[1] Hudson appointed him as a lecturer at Leicester where, assimilating its constructivist ethic, he began to use a variety of materials and showed with the Leicester Group.[2] Following Hudson, he became a senior lecturer at Cardiff in 1964 and an organising tutor for the Barry Summer School, 1963-69. He returned to painting, responding visually to stone walls, works which set up 'complex channels of colour between the units like two layers of imagery.'[3] After moving to Penarth, and particularly from 1971, the beach became his main subject as well as workplace and source of materials.[4] This reflected a concern with environmental issues such as pollution and recyling. Around the mid 1970s he coated carpet in dyes, oil and wax to suggest a sensation of landscape. By the end of the decade he included scraps of upholstery and springs from wrecked cars. Whilst exhibiting regularly with the Group, he held exhibitions at London's Grabowski Gallery and at Cardiff's Oriel and Chapter Arts Centre. He resigned from the Group to become more self-reliant as an artist, feeling that it had become too risk averse, closed and resistant to expansion as well as part of the establishment.[5] Howard Gardens Gallery, Cardiff, toured a retrospective exhibition in 2001, the year he retired from the College. He was elected to the Royal West of England Academy in 2002 and became a Royal Academician in 2009.

47 Terry Setch *Brick upon Brick*
1968, 122 x 244 cm, acrylic on canvas with plastic form units
48 Hudson, Burt & Setch at Kibworth Rectory, Leicestershire, c.1963

Tom Hudson [born Horden, County Durham 1922; member 1967-78; life / honorary member 1978; died Bristol 1997] was a painter, constructivist and influential art educator who attended Sunderland College of Art before serving in Burma during the Second World War. He then studied at the University of Durham and the Courtauld Institute. He became painting master at Lowestoft School of Art, lecturer at Leeds and head of foundation studies at Leicester, exhibiting with the Leicester Group.[6] He moved in 1964 to Wales as director of studies at Cardiff College of Art (see page 24).[7] He was involved in organising the Barry Summer School, 1959-70, which explored open approaches to creativity. His art educational ideas, forcefully advocated, were influenced by Herbert Read, the Bauhaus and the constructivist and de Stijl movements.[8] Hudson's artwork, perhaps overlooked in relation to his teaching achievements, found regular exposure in the Group's exhibitions. Rowan observed that: 'Experimenting with fibreglass and synthetic resins, Hudson stretched the potential of these materials, and created a medium as fluent as paint and as durable as bronze.'[9] Mark Hudson describes how his 'reliefs set machine-tooled steel against exuberantly coloured and textured fibreglass, plastic and resin - in forms that had the ruthless sheen of the commercial objects they lampooned and paid homage to.'[10] He was commissioned to produce a mural for Cardiff's Heath Hospital, made a series of creative maps of Wales and showed at London's Grabowski Gallery. In 1965 he was appointed to the Art Subcommittee of the Arts Council Welsh Committee. He stayed in Wales until 1977, when he felt his academic freedom curtailed in a college reorganisation.[11] He moved to Canada as dean of instruction, Emily Carr College of Art, Vancouver, until 1995.

1 Holman, Martin (2009) *Terry Setch*, Lund Humphries; Setch, Terry, in Curtis, Tony, ed. (2000)
2 *The Inner Image: Paintings by the Leicester Group*, Grabowski Gallery, London, 1964
3 Holman, Martin, in Tooby, Michael, & Holman (2001) *Terry Setch: A Retrospective*, Howard Gardens Gallery, p.47
4 'Terry Setch, in conversation with Michael Sandle', *Terry Setch - Lavernock, Paintings 2010*, Art Space Gallery, 2010, p.7
5 Email from Setch to Jackson, 6 July 2012; Conversation with Setch, 28 July 2012

6 *The Inner Image: Paintings by the Leicester Group*, Grabowski Gallery, London, 1964
7 Obituaries to Tom Hudson in *The Independent* by Mark Hudson, 8 January 1998, & *The Times*, 27 January 1998
8 Hudson, Mark (1998) 'Obituary: Tom Hudson', *The Independent*, 8 January 1998
9 Rowan (1985), p.164
10 Hudson, Mark (2011), p.8
11 *The Times* obituary, 27 January 1998

Laurence Burt [born Leeds 1925; member 1967-69] is primarily a sculptor, but also a painter. He worked as an industrial metalworker, becoming an evening student at Leeds College of Art. Studying sculpture, he progressed, 1956-60, from studio assistant to lecturer, working with both Hudson and Dalwood.[1] He became a lecturer at Leicester College of Art and a member of the Leicester Group with Setch and Hudson.[2] Earlier work included a series of distinctive helmet heads. He followed Hudson to Cardiff as a principal lecturer in fine art, 1964-66. Although only a member of the 56 Group Wales for two years, he took a full part in its shows. He also exhibited at Howard Roberts Gallery, Cardiff, at the Drian Gallery, London, and in the Arts Council's *Structure 1966* show at Cardiff Castle. Rowan felt that: 'During his Welsh period, Burt gave full rein to his taste for the fantastic, the bizarre, and the surreal.'[3] Perhaps his most striking work from this time is the nihilistic five foot high steel and bronze *Machine AD 1965: Function: Depopulation of the World and the Degradation of Man*. A group of works created under the generic title *'Nothing'* followed, interrupted by hospitalisation from a serious road accident. He made a series of smaller works and paintings immediately afterwards.[4] From 1966 he lectured at Leeds and Wolverhampton, moving to Falmouth School of Art, 1975-80.

Norman Toynton [born London 1939; member 1967-71] is a painter and relief maker who studied at Hornsey College of Art and the Royal College of Art and became a lecturer at Leicester and then Cardiff College of Art, 1965-70.[5] He showed his work at Howard Roberts Gallery. Whilst in Wales his form of pop art 'used a rebarbarative technique derived from graffiti, with imagery from the urban environment and the world of mass-communication.'[6] He moved to north America, lecturing at universities in Ohio and Massachusetts in the United States and Victoria in Canada. In 1976 he held a solo exhibition at the Whitechapel Art Gallery, London, and currently lives in Norfolk.

Mervyn Baldwin [born Immingham, Lincolnshire, 1934; member 1967-80] is a painter and sculptor who attended Grimsby School of Art, Leicester College of Art and the British School at Rome and, in 1965, became a senior lecturer at Cardiff College of Art. In 1973 he transferred to Newport College of Art as a principal lecturer, where he remained until 1975, when, disillusioned with the structure of art education, he resigned to take up painting full-time. His sculpture, using resin and fibreglass, often used a Grecian column motif and, from the early 1970s, a pyramid, as ironic symbols for society. 'His works are parables to illuminate the dual nature of man,' wrote Bryn Richards, '...they combine within one form strength, rigidity and the virtues of civilisation with weakness, flaccidity and decay.'[7] 'Baldwin,' explains Rowan, 'was able to create a column that was bent, twisted, torn, limp and deflated, and sometimes metamorphosed into pink, bleeding flesh.'[8] The Welsh Arts Council commissioned the multiple *That's the Way the Column Crumbles* in 1969. He exhibited at the Grabowski Gallery, London, and held a show of 'pin-up' women at Oriel, Cardiff, in 1978.[9] He now lives in Scotland.

1 Burt, Laurie (2008) *The Mandela and the Machine: An Autobiographical Story of the 1960s*, STEIP
2 *The Inner Image: Paintings by the Leicester Group*, Grabowski Gallery, London, 1964
3 Rowan, Eric (1985), p.153
4 Measham, Terry, 'A Twentieth Century Romantic', *The Anglo-Welsh Review*, Volume 18, 41, Summer 1969, pp.56-62
5 *Art in Wales* (1969)
6 Rowan, Eric (1979), p.74
7 Richards, Bryn (1971), p.191
8 Rowan, Eric (1985), p.166
9 *Private Enterprise: Pictures by Mervyn Baldwin*, Oriel, Welsh Arts Council, 1978

49 Laurence Burt *CAM Model - Propaganda for Control System Mk I*
Shown in and out of the box
1969, 16 x 66 x 17 cm, boxed prototype wood, letraset and paint
Arts Council Collection

50 Norman Toynton *Interior I*
1967, 91 x 102 cm, acrylic on canvas

51 Mervyn Baldwin working on the design for a tiled mural at Crymych swimming pool, Pembrokeshire, 1975.

Five More Cardiff Lecturers, 1967 - 69

Eric Rowan [born Liverpool 1931; guest 1967; member 1967-80 publicity officer 1974-77] is a painter and etcher who attended Liverpool College of Art and the Accademia di Belle Arti, Florence. He was the art director at the New Shakespeare Theatre in Liverpool, lived in Italy for a year and lectured at Liverpool before being appointed to Cardiff College of Art in 1963.[1] He exhibited regularly with the Group. 'I seem to have been concerned,' he wrote in 1969, 'with the signs and symbols of the urban environment, with the increasing speed at which we have to apprehend these information signals and with the problem of transposing this contemporary mode of seeing into a formal metaphor of colour, shape, space, etc. Probably, this also accounts for the device of pictures within pictures, which is analogous to the space complexity of the city scene...'[2] He has exhibited etchings with Victor Vasarely at Clark Gallery, New York, and work with Glyn Jones at University College, Swansea. He left his lecturing post at Cardiff in 1978, becoming a freelance artist, art historian and documentary film maker.

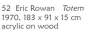

52 Eric Rowan *Totem* 1970, 183 x 91 x 15 cm acrylic on wood

53 Eric Rowan c.1974

54 Michael Tyzack *Madigan* 1969, 244 x 279 cm, acrylic on cotton duck

55 Alan Wood *Yellow Duo* 1970, 102 x 127 cm, PVA on canvas

Michael Tyzack [born Sheffield 1933; member 1967-72; died 2007] was a hard-edged abstraction painter with a fascination for colour and form. He studied at Sheffield College of Art and the Slade School of Fine Art, received a French government scholarship and became a lecturer at Cardiff in 1964. He was a main prize winner in the 1965 John Moores Liverpool Exhibition.[3] He took part in influential exhibitions: *Trends and Trend-setters* at Howard Roberts Gallery, Cardiff, in 1965; *New Shapes of Colour*, Stedlijk Museum, Amsterdam, in 1966; and *Documenta 4*, Kassel in 1968.[4] Panels commissioned for the Heath Hospital, Cardiff, were completed in 1971.[5] 'Tyzack used brilliant colours,' writes Rowan, 'juxtaposed in startling contrasts and applied in flat areas with clear, precise edges.'[6] Nature and jazz were influences and he played jazz trumpet professionally. He held exhibitions at Axiom Gallery, London, and moved to Hornsey College of Art in 1968. In 1971 he emigrated to the United States to teach at Iowa University before becoming professor of fine arts at College of Charleston, 1976-2005.

Alan Wood [born Widnes 1935; member 1967-75] is a painter and sculptor who attended Liverpool College of Art. He was a school teacher, then lectured in Leeds, Lancaster and Falmouth, establishing a studio in St Ives, before becoming a principal lecturer at Cardiff in 1966.[7] Malthouse had encouraged him to work there.[8] Rowan writes that he 'preserved some of the influences of the St Ives type of abstraction derived from landscape and natural forms.'[9] His work at this time was much concerned with suggesting, through ribbon-like forms, the depth and layers of movement in water. These, Bryn Richards writes, 'create a shallow space in which one level of rhythmic activity is overlapped with another.'[10] He exhibited in Edinburgh at Richard Demarco Gallery and in London at New Art Centre as well as at Grabowski Gallery with Setch. He moved to Vancouver, Canada, in 1974, much attracted by the mountains and water. A retrospective exhibition of his work was held in 1982 at the Art Gallery of Greater Victoria.[11]

Christopher Shurrock [born Bristol 1939; member from 1967] is a sculptor, painter and printmaker with a particular concern for optical construction. He studied lithography and painting at the West of England College of Art in Bristol and took an art teachers' diploma at Cardiff College of Art. Art adviser to the University Settlement, Bristol, 1961-62, he was appointed a lecturer at Cardiff in 1962. A contributor to the creation and development of the foundation course in art and design, he became director of foundation studies, retiring in 1991. He co-ordinated Cardiff Open Art School, 1994-98. 'When structural systems are combined,' he wrote in 1969, 'each system affects every other, interactions result which are more than the sum of the components.'[12] Optical art, Rowan wrote, 'took simple principles of perceptual psychology and extended them to produce either ambiguous visual patterns or, as is the case with Shurrock's work, to create disturbing effects on the eye and the mind of the spectator.'[13] He exhibited constructions at London's Axiom Gallery in the 1960s and multiples at the Whitechapel Art Gallery in 1970.[14] He showed in *Kinetic Art* at the Glynn Vivian Art Gallery in 1972. In complete contrast, he was exhibiting small expressionistic acrylic and mixed media panels from the mid 1980s.[15] He held an exhibition, *Studies, Chance & Intention*, at Howard Gardens Gallery in 2007. He was first invited to exhibit with the Group as a guest in 1966 at Howard Roberts Gallery. Although this exhibition was cancelled he has, nevertheless, become the longest continual full member and has exhibited consistently.[16] With Geoffrey Davies, he designed many 1970s Group catalogues and he has organised Group exhibitions including *Art in the Making* with Barrie Cook, 1978-79.[17] He was a member of the South Wales Group, 1963-68, a member of the Printmakers' Council, 1970-76, and is a Royal West of England Academician.

56 Christopher Shurrock with '*…do you feel surrounded by things…?* c.1975. Photographic print from double exposed negative including a copy of Welsh Arts Council 1974 postcard.

Geoffrey Davies [born St Albans 1944; associate 1969-71; member 1971-85] is a painter and printmaker who studied at Goldsmiths' College and the Royal College of Art. Appointed as a lecturer at Cardiff College of Art in 1966, he remained full-time until 1995, then part-time until his retirement in 2003. He was a regular exhibitor with the Group.[18] In 1982 he wrote: 'These drawings are a return to the fundamental issues that concern me: flat, 'theatrical' space, pattern and a sense of mannered selectivity.'[19] His home environment at Porthcawl has been important in his work, particularly the wind, sea, light, cloud, tides and pools. 'I absorb,' he writes, 'and try to use the many sensations this landscape forces me to notice.'[20] He produced a self-destructive screen print for the World Congress of Art, Coventry, in 1970. Theatre sets for Welsh Drama Company productions of plays by Harold Pinter and Tom Stoppard followed in 1971-73.[21] He also produced a mural for University College Swansea in 1976.

1 *56 Group Wales: A Rainy Day*, National Museum of Wales, 1973
2 *Art in Wales* (1969)
3 *Michael Tyzack: Recent Paintings*, Axiom Gallery, London, 1966
4 Buckman, David (2009) *Michael Tyzack*, Portland Gallery, p.8
5 Rowan, Eric (1985), p.162
6 Rowan (1979), p.74
7 *56 Group Wales*, Newport Museum & Art Gallery, 1971
8 Conversation with Sue Hiley Harris, Vancouver, 5 March 2012
9 Rowan (1985), p.164
10 Richards, Bryn (1971), p.194
11 *Alan Wood*, Heffel Gallery, Vancouver, 1994
12 Shurrock, Christopher, in *Art in Wales* (1969)
13 Rowan, Eric (1985), p.167
14 *56 Group Wales*, Newport Museum & Art Gallery, 1971
15 *Life & Landscape: Scotland & Wales*, Newport Museum & Art Gallery, 1985
16 Griffiths to Shurrock, 19 November 1965
17 Letter from Shurrock, 19 March 2012
18 Giardelli, Arthur, ed. (1976), pp.14-15
19 *Glasgow Group / 56 Group Wales*, Edinburgh, 1982
20 *Life & Landscape: Scotland & Wales*, 1985
21 *Drawn Together: New Work by Four Artists with the 56 Group Wales*, Howard Gardens Gallery, 1983

57 Geoffrey Davies *Birdland* 1982, 122 x 91 cm, pastel

No Turgid or Murky Pictures, 1968 - 71

exhibiting artists
Ireland, London,
Scotland & Cardiff:

Mervyn Baldwin
Laurence Burt
Hubert Dalwood *
Arthur Giardelli
Tom Hudson
Robert Hunter
Heinz Koppel
Bryan Macdonald
Eric Malthouse
Keith Richardson-Jones
Eric Rowan
David Saunders
John Selway
Terry Setch
Christopher Shurrock
Jeffrey Steele
Anthony Stevens
David Tinker
Norman Toynton
Michael Tyzack
Alan Wood
Ernest Zobole

* (London only)

The Welsh Arts Council continued to provide financial support and took a keen interest in the Group.[1] Peter Jones, its art director, often attended meetings, many of which were held at the Council's headquarters.[2] The Council consulted the Group in 1971 when re-considering its support for visual artists. Proposals, including one from Tinker for extending patronage and enabling the artist to reach a wider public, were discussed.[3] The Council also underwrote the expenditure of the South Wales Group.[4] Generally, however, the Council steered a more popular course, placing abstract designs on commercial poster sites and encouraging an appreciation of the social context of art through its *Art and Society* exhibitions.[5] The Group valued its support and, in 1969, threw a party for guests from the Welsh Arts Council, the National Museum and media.

A substantial tour of the Republic of Ireland and Northern Ireland occurred in 1968-69. Arranged by their respective arts councils, it was launched at the Municipal Gallery of Modern Art in Dublin. Brian Fallon praised 'excellent and unpretentious painting.'[6] Bruce Arnold, on the other hand, felt that 'there is an uneasy balance between good, original and exciting work, and paintings which are mediocre and imitative.'[7] Dorothy Walker praised 'a certain clarity and crispness,' and was thankful that 'there are no turgid or murky pictures.'[8] In Northern Ireland the exhibition opened at the Arts Council's Gallery in Belfast. Rowan persuaded *The Times* to publish an article about the Group.[9] Earlier that year, too, it showed at the Little Theatre and Arts Centre in Newport to coincide with a visit by Princess Margaret and Lord Snowdon.

58 Catalogue cover for the 1969 Arts Council of Northern Ireland to

Every member took part in an exhibition at London's Grosvenor Gallery in 1969. Lord Harlech opened this and seven of the sixteen works sold were acquired for the Welsh Arts Council's collection. Steele recalls unstructured Harlech Television coverage hosted by actor Kenneth Griffith. Intriguingly, he also felt that the appearance of James Callaghan at the launch 'completely distorted the ambience and cultural significance of the occasion.'[10] Hansi Bohm remarked that 'the subtle overtones and undercurrents of Welshness escape me,' but acknowledged that it was, 'good, clean, professional and contemporary.'[11]

The exhibition formed the basis of a tour to three Scottish venues as well as to Nottingham. 'Another Welsh invasion of Edinburgh,' reported *The Edinburgh Evening News*, 'will follow Saturday's Rugby international at Murrayfield - this time by artists.'[12] *The Nottingham Evening Post* excitedly heralded that: 'Opening to the public tomorrow is the most up-to-date collection of contemporary art ever to be seen in Nottingham.'[13]

59 Christopher Shurrock *Construction Serial No 22/A/3/66* 1966, 91 x 91 x 15 cm, acrylic sheet, acrylic paint, wood and aluminium. Purchased by the Welsh Arts Council from the Grosvenor Gallery exhibition, 1969. Bristol City Museum & Art Gallery, gifted by the Arts Council of Wales, 2002

Also in 1969, Cardiff University's Art Group, led by Raymond Eyquem, organised an exhibition, *Breton-Welsh Artists*.[14] Work was drawn from the Museum of Fine Arts, Nantes, contemporary Breton artists and 56 Group Wales. Much support was received from the Cardiff-Nantes Fellowship Committee.

That year, too, the Welsh Arts Council organised a three-part exhibition, *Art in Wales: The Twentieth Century*, in which the Group's perceived significance was explicit.[15] The first part, *The Early Years*, covered the period from 1900 until 1956; the second, *Today*, was represented by both the Group and, separately, another twenty-five invited artists; the third, *Tomorrow?*, consisted of student work displayed in a converted furniture showroom in Cardiff's St Mary Street. Huw David Jones refers to a survey of visitors to *Today* at the National Museum which revealed 'much ill-considered prejudice and downright hostility to 'modern art'.'[16] There was at least one fan, however, as Toynton's portrait of William Featherston was stolen from the Glynn Vivian Art Gallery.

Edward Lucie-Smith identified reasons for the Group's vitality as: whilst standing for modern art of a high international standard, it had never attempted to narrow this down to a particular style; its capacity for self-renewal; and that it was based in Wales and had added 'Wales' to its title.[17] Advantages for artists in Wales, he felt, were relatively easy social contacts, small and flexible arts organisations and imaginative arts council policies. Disadvantages were that movements and styles often originated and spread from metropolitan centres where the press tended to be located. He later reflected that: 'Compared with any recent mixed exhibition in London, the 56 Group show in Cardiff offered the visitor a remarkable range of experiments in different media, and suggested perhaps more clearly than any other show of the year, the degree of technological involvement now possible to the modern artist.'[18]

Other exhibitions included a 1969-70 tour of graphic work in England. Myfanwy Kitchin wrote: 'it is all working notes: experiments with colour, drawings, diagrams, a few works on silkscreen, some written statements, some small photographs of finished works.'[19] The 1970-71 *Two Foot Square Show* visited Birmingham before Wales. It included work by Geoffrey Davies and William Featherston, who were a new type of short-term associate member introduced at the 1969 annual meeting. Lectures were given by Rowan in Merthyr Tydfil and Tinker in Haverfordwest. A 1971 exhibition at Bristol's Arnolfini Gallery stimulated Griffith Williams to write: 'Precision and a quality of intense colour, expertly controlled and disciplined, predominate throughout.'[20] Exhibitions in Newport, Swansea and Cardiff that year included Geoffrey Davies as a full member.

By 1971 eight of the Group's twelve founder members had left. Bates, now in Canada, resigned in 1968.[21] Burt resigned in 1969 and Dalwood in 1970.[22] Both had left Wales. Giardelli had earlier remarked 'that nearly everybody thinks Dalwood is more important than any of the rest of us.'[23] Selway, Malthouse and Zobole, resigned together in 1970.[24] They objected to the wish of the Group's constructivists to exhibit together as a sub-group. Richardson-Jones wrote that 'it is difficult to reconcile the understandable wish of some to exhibit as a total group with the desire of others to show in compatible sub-divisionings.'[25]

The loss of the person who had the original idea to form the Group was keenly felt. Hudson was asked to enquire whether Malthouse would like to rejoin (see page 8).[26] Macdonald and Saunders, who had also left Wales, resigned in 1970.[27] Toynton's membership lapsed in 1971 whilst in the United States.

At the 1971 annual general meeting, Griffiths, who had been the Group's tenacious and hard-working secretary for nine years, stood down. She was made vice-chair, presented with members' work and, with her husband Bruce, held a party for the Group. Elisabeth Elias, another trained barrister, became secretary.

60 Activities were widened with two events at the National Museum's Reardon Smith Lecture Theatre. Yoko Ono was invited in 1968. She wrote: 'I'm sorry I have no idea what I will be doing, but I will be there.'[28] Later described as 'a happening that didn't quite happen,' a chauffeur driven limousine arrived containing only a signed photograph of the artist and a one-word poem called 'Fly'.[29] The Group sent her a photograph of a torn up cheque for the agreed fee. At the instigation of Steele and Saunders, a programme of trans-disciplinary experimental *All-in-Music* by Gavin Bryars and John Tilbury occurred in 1969 with around fifty art students attending.[30] *The Western Mail* reported that: 'The first piece... consisted of these two 'musicians' wandering around the auditorium with objects such as a suitcase which emitted a clicking sound...'[31]

1 Annual Reports, 1968-71, Di; AGM, 1967-71, Ci; The Welsh Arts Council provided: £275 in 1968-69 & a guarantee against loss of £50; £300 in 1969-70 & a guarantee against loss of £100; £400 in 1970-71; and £130 in 1971-72.
2 Executive committee minutes, 1963-69, Bi
3 Tinker, David, 'Extending Patronage', Memorandum to Art Committee of the Welsh Arts Council, 1971, Bii
4 Wakelin, Peter (1999), p.49
5 Jones, Huw David, 'War Declared! Art and Society in Wales, 1969-77', Planet 196, 2009, pp.47-56
6 Fallon, Brian, 'Vital Welsh paintings on show', Irish Times, 16 Nov.1968
7 Arnold, Bruce 'A with-it view of Wales', (Irish) Sunday Independent, 17 November 1968
8 Walker, Dorothy, 'Nearest Neighbours', Hibernia, 12 December 1968
9 Rowan, Eric, 'Adventures of a Welsh art group', The Times, 3 Dec 1968
10 Letter from Steele, 13 May, and conversation, 16 May 2012; Radyr, Nicholas, 'Harlech's Experiment', The Times, 25 January 1969
11 Bohm, Hansi, '56 Group Wales', Arts Review, 18 January 1969
12 'Welsh Art', Edinburgh Evening News, 29 January 1969
13 'Works of 22 artists on view', Nottingham Evening Post, 9 May 1969
14 Breton-Welsh Artists, Cardiff University Art Group, 1969
15 Measham, Terry, 'Wales in the Twentieth Century', Art & Artists, September 1969, p.10
16 Jones, Huw David (2012), p.14
17 Lucie-Smith, Edward, 'Preface' in Art in Wales (1969)
18 Lucie-Smith, Edward (1970) Art in Britain, 1969 / 70, Dent, p.139
19 Kitchin, Myfanwy, 'Group 56', The Guardian, March 1970
20 Williams, Griffith, 'Age takes edge off protest', The Western Mail, 13 February 1971
21 Bates to Griffiths, 1 October 1968, Giiic
22 Griffiths to Burt & Dalwood, 10 October 1970, Giiie
23 Giardelli to Griffiths, undated, June 1964, Fiva
24 Malthouse, Selway & Zobole to Griffiths, March 1970, Giie; Interviews with John Selway, 13 & 27 April 2012
25 Richardson-Jones to Griffiths, 2 October 1970, Giiie
26 Hudson to Griffiths, 21 October 1971, Giiie; AGM, 1971, Ci; Giardelli to Elias, 18 December, Fv
27 Macdonald to Griffiths, 29 September 1970, & Saunders to Griffiths, 9 November 1970, Giiie
28 Ono, Yoko, to Griffiths, 6 June 1968, Vii
29 Rogers, Ken, in Mirror, 8 July 1968
30 Letter from Steele, 18 May 2012
31 Holliday, Jon, 'Very tasty, that tomato sonata,' The Western Mail, 4 July 1969

61 Mary Lloyd Jones, 1976

Breaking up the Boys' Club, 1971

Mary Lloyd Jones [born Devil's Bridge 1934; associate 1971-73; member 1973-86] was taught by Malthouse and Tinker at Cardiff College of Art. She then taught at Swansea and Dyfed colleges of art, as well as from her home near Llandysul.[1] Three men elected associate members with her in 1971 were made full members the following year but Jones had to wait until 1973, despite playing a full role in Group exhibitions. In 1976 she wrote: 'My work is the result of living in this part of Ceredigion and has to do with the changing seasons, weather conditions and light. Colour has always for me been an important medium of expression… My time is now shared between using paint on canvas or paper and using textile techniques, particularly tapestry weaving.'[2] West Wales Association for the Arts commissioned her to weave a tapestry, *A Theme from the Mabinogi*, for Carmarthen Library. Shelagh Hourahane explains how Jones used a family quilt as a metaphor for the way in which her work relates to rural women's traditions and to cultural impressions in her local landscape. Later, her appreciation of landscape deepened through an interest in earlier cultures and their remaining traces. 'The patches and the formalism of the quilt still linger in her work,' writes Hourahane, 'transformed into areas of colour overlaid with lines, signs and symbols that sketch in a faint archaeology.'[3] She left the Group shortly after being appointed visual arts officer for Dyfed in 1985. Since then she has worked prolifically exploring themes relating to her identity, Celtic languages and archaeology in oils, watercolours and, in collaboration with Tom Piper and Virtually-6 printmakers, digital imaging.

Jones was the first woman artist member, despite there having been notable non-artist women secretaries. Presumably this was, in part, due to dominance by men recruited to teach in art schools through the 1950s and 1960s. She comments that 'it is well known that the world of fine arts is one of the most male-dominated fields.'[4] Steele has reflected on the 'boys'club' nature of both the 56 Group Wales and the Barry Summer School 'with definitely-assigned gender roles and exploitative systems, of all of which we (the boys) were entirely unconscious (='innocent') at the time, but for which there can be no real ethical justification.'[5]

Brenda Chamberlain had been invited to be a founder member in 1956 and had given as her reason for turning the Group down: 'I cannot quite understand why my name was put down on the list of the 56 Group as I had heard nothing of it previously: certainly, I am not one who has 'expressed a wish that a group be formed' etc.'[6] The London Group had women members since its formation in 1913, although, generally, men have been the dominant gender.[7] The South Wales Group had many woman members including Joan Baker and Esther Grainger.[8] Baker was not part of the influx of Cardiff lecturers to join the 56 Group Wales in 1967, presumably because her work did not reflect the favoured international and experimental style.[9]

1 Ropek, Eve, ed. (2001) *The Colour of Saying: The Work of Mary Lloyd Jones*, Gomer / Aberystwyth Arts Centre; Jones, Mary Lloyd, et al (2006) *First Language: Mary Lloyd Jones*, Gomer / National Library of Wales
2 Jones, Mary Lloyd, in Giardelli, Arthur, ed. (1976), pp.38-39
3 Hourahane, Shelagh, 'The Layers of a Landscape' in Bala, Iwan, ed. (1999) *Certain Welsh Artists: Custodial Aesthetics in Contemporary Welsh Art*, pp.54-55
4 Jones, Mary Lloyd, 'Between two worlds' in Aaron, Jane, et al (1994) *Our Sisters' Land: The Changing Identities of Women in Wales*, UWP, pp.273-74
5 Letter from Steele, 18 May 2012; for numbers of the Group's women members see reference 18, page 86
6 Chamberlain (Bardsey Island), to Malthouse, 2 September 1956, Fii
7 Redfern, David (2008). Of its founder members, 19% were women. In the mid 1920s there was near equal gender selection. In the 1950s, 91% of the total intake were men. Since the 1980s the gender ratio has been around 35% women.
8 Wakelin, Peter (1999), pp.94-99
9 Thomas, Ceri (2009) *Joan Baker: A Retrospective. 65 Years of Painting Since 1944*, pp.22-23

62 Mary Lloyd Jones *Llyn-y-Fan* 1984, 152 x 366 cm, dyes on cotton

The New Men, 1971

Jack Crabtree [born Rochdale 1938; associate 1971-72; member 1972-75] is a figurative painter who attended Rochdale College of Art, St Martin's School of Art and the Royal Academy Schools. He taught at art colleges in Salford and, 1966-74, Newport. The following year, supported by Bill Cleaver who was a senior director of the National Coal Board in south Wales and secretary of the Contemporary Art Society for Wales, Crabtree recorded the changing face of the coalfields above and below ground. He developed studies of heavy industry as a Gregynog Fellow in 1975-76 and on a Ruhr Arts Fellowship, 1977-78. 'Whereas Herman's figures were archetypal labourers,' writes Tony Curtis, 'Crabtree's have both that force and the sense of each being an individual.'[1] Margaret Richards feels that: 'Crabtree is a social realist who works in a natural style that is neither didactic nor over-emphatic,'[2] Crabtree's work in the mines attracted considerable media attention. He became a senior lecturer at Gwent College of Further Education in 1978 and, in 1984, head of fine art at the University of Ulster. In 1987 he moved to France, although he retains a base in north Wales.

David Shepherd [born Wigan 1944; associate 1971-72; member 1972-79] attended Wigan School of Art and Goldsmiths' College, became an art teacher and joined Cardiff College of Art as a lecturer in 1971 until his retirement.[3] An installation artist making largely ephemeral works, he held exhibitions at London's Serpentine Gallery and Birmingham's Ikon Gallery in the early 1970s. 'Stemming from the American roots of environmental pieces and Minimal Art,' writes Rowan, 'his work has gradually acquired a personal, poetic form of expression.'[4] 'Existing in time as much as in space,' Rowan later writes, 'Shepherd's sculpture is often created while it is on exhibition; changing and developing and so becoming almost a performance piece... (His) favourite basic ingredients ...are a set of plaster slabs - cast like paving stones - which appear in successive installations, each time changing their context and meaning and each time bearing more marks of their experiences.'[5]

Andrew Walton [born Oxford 1947; associate 1971-72; member 1972-75] is a painter who attended Oxford School of Art and Cardiff College of Art, becoming a lecturer and junior fellow in fine art at the latter, 1970-72. His drawings and paintings submitted to Group exhibitions in this period reveal a fascination with the power and enduring nature of primitive imagery and of symbolism.[6] In the Group's 1973 catalogue to the exhibition *A Rainy Day* he quotes Carl Jung: 'Whoever speaks in primordial images speaks with a thousand voices...'[7] He exhibited in a two-person show at the Welsh Arts Council's gallery in 1972. He returned to live in Oxford and his recent work is concerned with landscape and the urban environment.[8]

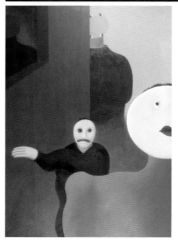

1 Curtis, Tony, 'The Last Shift: The Welsh mining industry in art since 1970' in Bala, Iwan, ed. (1999), pp.34-36
2 Richards, Margaret (1978) *Jack Crabtree: Face to Face*, London, SVR Essen & Welsh Arts Council, Cardiff, p.12
3 Shepherd, David, in Giardelli, Arthur, ed. (1976), pp.48-50
4 Rowan, Eric (1985), p.157
5 Rowan, Eric, in Stephens, Meic, ed. (1979), p.81
6 Photograph of artist's work in Group exhibition, Oriel, Welsh Arts Council Gallery, 1974, Miva
7 *56 Group Wales: A Rainy Day*, 1973
8 www.andrewwaltonartist.org.uk, 2012

63 Jack Crabtree
Landscape with Derelict Pithead
1974, 116 x 116 cm, oil on panel

64 David Shepherd *Untitled*
(installation at Ibis Gallery,
Leamington Spa), 1977
approx 10 x 610 x 91 cm
cast plaster, pigment and rope

65 Andrew Walton *The Watcher*
1971, 175 x 124 cm, oil on canvas

66 Mervyn Baldwin *The pillars of society are rotten at the top* 1967, 147 x 122 x 30 cm steel, epoxy & polyester resin Bürgermeister-Ludwig-Reichert-Haus, Ludwigshafen am Rhein, West Germany

exhibiting artists
West Germany:

Mervyn Baldwin
Jack Crabtree (associate)
Geoffrey Davies
Arthur Giardelli
Tom Hudson
Robert Hunter
Mary Lloyd Jones (associate)
Eric Rowan
Terry Setch
David Shepherd (associate)
Christopher Shurrock
Jeffrey Steele
Anthony Stevens
David Tinker
Andrew Walton (associate)
Alan Wood

GROUP WALES

67 Logo produced for the German and Nottingham exhibition catalogues by Design Systems, Cardiff. They also designed printed material for *A Rainy Day*.

68 (right) **Tom Hudson** *Rainy Day Wales* 1973, drawing & screenprint

Exhibitions at Home and Abroad, 1972 - 73

After the 1971 annual general meeting, four artists accepted an invitation to become associate members - Jack Crabtree, Mary Lloyd Jones, David Shepherd and Andrew Walton. They were included in a 1972 exhibition at Newport Museum and Art Gallery, which was expanded and taken to West Germany. They also showed at Nottingham's Midland Group Gallery. All except Mary Lloyd Jones became full members that year. She remained an associate, together with newly invited Glyn Jones, until they were both elected full members in 1973. The Welsh Arts Council continued to support the Group and were represented at annual general meetings. Hunter was elected to the Council in 1973.[1]

In autumn 1972 the Group exhibited on the Continent for the second time. Eighty works - sculpture, paintings and graphic work - were shown at the art gallery in Bürgermeister-Ludwig-Reichert-Haus, Ludwigshafen am Rhein, West Germany.[2] Contact had been established by Baldwin, who had sold a sculpture to the Gallery.[2] Giardelli reported that the presentation of works was excellent and many works were sold, a British Council representative spoke at the opening, it had been well received in the press and he was interviewed on local radio. *Die Rheinpfalz* headlined its piece: 'Art Group from Wales shows work of International Standard.'[3]

In 1973 the Group exhibited with the Glasgow Group, at their invitation, in Glasgow's extensive McLellan Galleries. It was opened by Douglas Hall, director of Edinburgh's Museum of Modern Art. A newspaper strike affected press coverage and Mary Lloyd Jones was the only one to sell work. Rowan reported that the Group's contribution 'did not do us justice... and there was no sculpture. I think we could have made a greater impression if more of our people had contributed, and that those who did, had sent more and possibly larger works.'[4]

The suggestion of holding a subject-themed exhibition, particularly one reminiscent of a school exercise, might have been expected to be greeted with disdain. Instead, an exhibition entitled *A Rainy Day* was readily accepted, possibly for its ironic potential, by both the Group and the Welsh Arts Council. In 1973 it was toured by the Council to the National Museum of Wales, the University College of North Wales, Bangor, and Newport Museum and Art Gallery. Five works were acquired for the Welsh Arts Council's collection and the Council provided a grant to include hiring fees for members' work.[5]

Giardelli received an MBE in 1973 for services to art in Wales including his work with the Group. Tyzack, who moved to London and then the United States, left the Group in 1972. Richardson-Jones resigned early in 1973, no longer wishing to belong to a group, and Tom Gilhespy became an associate member that year.[6] Elisabeth Elias resigned as secretary. She was made an honorary member and held a party for the Group, making way for the return of Griffths in January 1974.[7]

1 Annual Reports, 1971-73, Di; AGM 10 November 1973, Ci. WAC grant was £523, 1971-72, and £100 in advance for 1972-73
2 Giardelli's Report on West Germany exhibition to the Welsh Arts Council, 27 Sept. 1972, Qvi; Letter from Pat & Mervyn Baldwin, 25 April 2012
3 'Artist Group from Wales Shows Work of International Standard', *Die Rheinpfalz*, 15 August 1972
4 Rowan to Elias, 22 June 1973, Qix
5 Annual Report, 1972-73, Di. WAC Grant was £1,700
6 Richardson-Jones to Elias, 13 February 1973, Giv
7 AGM 10 November 1973, Ci; Annual Reports, 1972-74, Di

New Members, 1972 - 73

Glyn Jones [born Tynewydd, Rhondda Valley, 1936; guest 1962; associate 1972-73; member from 1973; vice-chair 1996-97; chair 2003-06; past-chair 2006-08] attended Cardiff College of Art and the Slade School of Fine Art. He became a lecturer in Warwickshire and Coventry and, in 1972, head of the school of fine art at Cardiff. He was first chair of the Association of Artists and Designers in Wales, 1974-76. He served on the Art Committee of the Welsh Arts Council, 1985-87. Writing of his work in 1976, he referred to the significance of an awareness of his cultural roots and of the coal-mining environment in the Taff Vale and Rhondda Valley.[1] It was only after returning to Wales after fifteen years in England that he had the perspective to relate effectively his experience of the past to the Welsh present. He began to paint black abstract works from industrial materials such as PVA, pitch, scrim and rope. Strongly spiritual, these were often monumental in scale.[2] His 1979 mural *Lifelines*, installed in the refectory of University College Swansea, revealed a change in mood and technique and reflected his Christianity with Celtic symbolism and glowing colour.[3] His interest in the art and craft of India, Africa and the Far East as well as in improvisation contribute to his work. 'I see this process of improvisation,' he writes, 'as similar to that used by many composers and musicians, particularly in jazz and the music of India.'[4] He has exhibited widely, including with Ysbryd / Spirit - Wales, and retired from the University of Wales Institute Cardiff in 2001.

69 Glyn Jones, 1974

70 Glyn Jones *Rhondda* 1973-74, 290 x 442 cm PVA, pigment & scrim

Tom Gilhespy [born Ferryhill, Durham 1944; associate 1973-74; member 1974-92] attended Leicester College of Art. He became a lecturer in Cardiff in 1967 and at Newport College of Art, 1968-80, moving to Birmingham as head of sculpture, 1981-90, and as head of MA studies, 1990-96. 'Most of the work I produce is assemblage or construction in mixed media,' he wrote on joining the Group. 'I make no fetish of technical virtuosity. The most important thing is not how the work is made but whether it has the correct balance of materials and authority of visual handling.' He did not see the traditional division into painting, sculpture and drawing as important but used them together. 'My work refers to personal experience and is usually narrative or allegorical. It is not intended to be problematical, but to involve and entertain the spectators in the story, fantasy, joke or even nonsense.'[5] David Briers wrote in 1986 that: 'There is much more air than metal in Gilhespy's sculptures, and they are almost like drawings in three dimensions, with linear grids of steel rods intersecting with planes of cut and welded flat steel sheet.'[6] He has connections with Russia and a particular interest in Soviet monumental sculpture. He now lives in mid Wales.

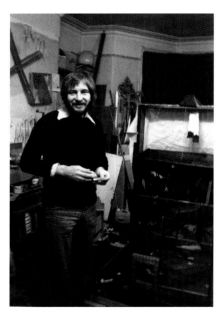

71 Tom Gilhespy in his studio, 1974

1 Jones, Glyn, in Giardelli, Arthur, ed. (1976), pp.36-37
2 Jones, Glyn, in Bala, Iwan, ed. (1999), pp.113-29
3 Spencer, Charles, in *Glyn Jones: Peintiadau / Paintings, 1980-81*, Oriel, Cardiff, 1981, p.4
4 Jones, Glyn, in Jones, Glyn, ed. (2006); see also Glyn Jones in Hughes, Robert Alwyn, ed. (2011)
5 Gilhespy, Tom, in Giardelli, Arthur, ed. (1976), pp.23-25
6 Briers, David, in *Tom Gilhespy: Lluniau / Drawings*, Oriel, Cardiff, 1986

Oriel: A Window on Art in Wales, 1974

exhibiting
artists:

Mervyn Baldwin
Jack Crabtree
Arthur Giardelli
Tom Gilhespy (associate)
Tom Hudson
Robert Hunter
Glyn Jones
Mary Lloyd Jones
Eric Rowan
Terry Setch
Christopher Shurrock
Anthony Stevens
David Tinker
Andrew Walton

In May 1974 the Welsh Arts Council opened Oriel, an art gallery and bookshop in Charles Street, Cardiff. It was, the Council explained, 'intended primarily for the showing of work by Welsh artists to the public of Wales.'[1] There were few galleries specialising, promoting and selling in this field, the Howard Roberts Gallery in the city having closed in 1970.[2] Not surprisingly, and at a time of recession, Giardelli believed that Oriel 'promises to be of crucial importance to the professional artist in Wales.'[3]

Setch had suggested in 1972 holding a Group exhibition where works were given to interested members of the public.[4] At a meeting with the Welsh Arts Council in July 1973 the Group, as a way of thanking the Council for its support, offered an unusual exhibition to open its new gallery. One work from each exhibiting artist would be given away to a member of the public in a free raffle. Each visitor would receive a numbered card on which to write their first three choices of artwork. There would be a draw at end of the show. A folder of information about each work would be presented to winners with an undertaking to keep them informed of future shows. In addition, on each day, a member of the Group would work in the gallery.[5]

The Group's dramatic offer seems to have disconcerted the Council's staff. Isabel Hitchman, the officer appointed to run the new gallery, wrote to Griffiths anxiously in February 1974: 'Do you think that those who are willing to take part fully understand that the works to be given away are to be of value… The idea after all is to make the exhibition sensational in as many ways as possible.'[6]

The exhibition took place in May 1974. The presentation of artworks to the fourteen winners was held during Oriel's next exhibition, a retrospective by painter

56 Group Wales at Oriel, Cardiff. Welsh Arts Council 1974

72 Catalogue cover for the exhibition

73 The exhibition at Oriel showing: string, foil and oil panels by Hunter, far left; freestanding sculptures by Stevens; and, on the wall, Hudson's aluminium, resin and glass fibre give-away work, *Red and Green Spectrum*.

The two large mixed-media sculptures by Stevens are *Rain Cloud, Wet Roof and Birds* and *Present from Egypt*. The small sculpture, bottom left, is his ciment fondu give-away work, *'Hellow' Telephone*.

Ray Howard-Jones who, at the time, was working in the gallery. Peter Jones presented the works and it was an opportunity for winners to meet the artists.[7] 'Whatever doubts might have been in the minds of the Group,' he wrote afterwards, 'must have been dispersed by the presentation ceremony on Saturday.'[8]

Director Aneurin Thomas emphasised that Council members 'were highly appreciative of the gesture made by the 56 Group Wales towards the opening exhibition and arrangements.'[9] The Group would be invited back for the tenth anniversary of Oriel and, over the years, many individual members exhibited in the gallery.

At this time there was a wider trend towards the grouping of professional artists, which was encouraged by the Welsh Arts Council. The Association of Artists and Designers in Wales was formed in 1974 with substantial Council support.[10] Links between local art societies and the South Wales Group, renamed in 1975 the Welsh Group, had ceased by the end of the decade, the separate exhibiting of professional artists and societies having been encouraged in the early 1970s by the Council.[11]

1 Press release, Oriel, May 1974, Qxi
2 Fraser Jenkins, A.D. (1981); Lord, Peter (1998), p.265
3 Giardelli, Arthur, 'Introduction' in 56 Group Wales at Oriel, Cardiff. Welsh Arts Council, 1974
4 AGM, 14 October 1972, Ci
5 Elias to Tinker, 22 July 1973, Fv; Press release, Oriel, May 1974, Qxi
6 Hitchman to Griffiths, 25 February 1974, Qxi
7 'Unique End to First Exhibition', press release, Oriel, May 1974, Qxi
8 Jones to Giardelli, 20 May 1974, Qxi
9 Thomas to Griffiths, 8 July 1974, Qxi
10 AADW Records, National Library of Wales website, 2012
11 Wakelin, Peter (1999), pp.49-51

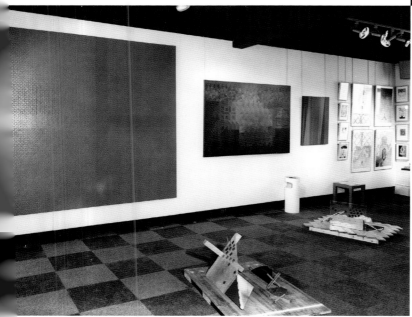

74 Newspaper photograph showing Baldwin discussing his 1971 lithograph *Wood's Pyramid* with Susan Singleton, who won this work in the draw. *South Wales Echo*, Tuesday 21 May, 1974.

75 Tom Gilhespy *Construction of a Memory* 1974, 30 x 135 x 93 cm, mixed media. Gilhespy's give-away work was the working drawing for this sculpture.

76 The exhibition at Oriel showing sculpture by Gilhespy including *Construction of a Memory* in the foreground. On the wall, from the left: PVA and pigment panel *Overlap Centre* by Glyn Jones; acrylic paintings *Sonic Changes* and *Rainy Day II* (the latter a give-away work) by Mary Lloyd Jones; and a group of watercolours by Walton.

56 GROUP WALES
musée des beaux arts
NANTES

74/75

77 Nantes catalogue cover. On the version provided at the launch, the Group's name was incorrect. It was immediately reprinted.

Musée des Beaux-Arts, Nantes, 1974 - 75

Since 1962, various attempts had been made by the Group to exhibit in France.[1] Cardiff's twinning with Nantes in 1963, however, provided fertile ground for cultural exchange. This had already led to the 1969 *Breton Welsh Artists* exhibition at University College Cardiff.[2]

'Our exhibition in Nantes,' explained Giardelli, 'arose from the fact that Cardiff is sister city to it..'[3] The invitation to exhibit at the Musée des Beaux-Arts, Nantes, in 1974-75 developed from links made during the 1969 Cardiff exhibition. Fourteen members took part.[4] Raymond Eyquem considered that it was: '…an event which should make history because it is the first exhibition of Welsh art ever to be held in France.'[5] The director, Claude Souviron, came to Wales twice to make arrangements. He was made an honorary member of the Group, 'such has been his enthusiasm and tireless concern to meet every artist in his studio and select works for the exhibition.'[6] HTV Wales supported the exhibition.[7]

Thirty people from Wales attended the launch including eight of the artists, the chair and an officer of the Welsh Arts Council, as well as representatives of University College Cardiff, the British Council, the National Museum of Wales and Newport Museum and Art Gallery. The journey by bus and boat was described as 'a testing experience' but the exhibition was regarded as well worth the temporary discomfort. The wife of the principal of University College Cardiff, Elizabeth Bevan, opened it in fluent French.[8] Sir William Crawshay, chair of the Welsh Arts Council, also spoke in French at the launch.[9]

Sadly and inexplicably, Stevens' sculpture *Rain Cloud, Wet Roof and Birds* was damaged beyond repair on the return journey, a reminder of the potential hazards of taking art exhibitions abroad.[10]

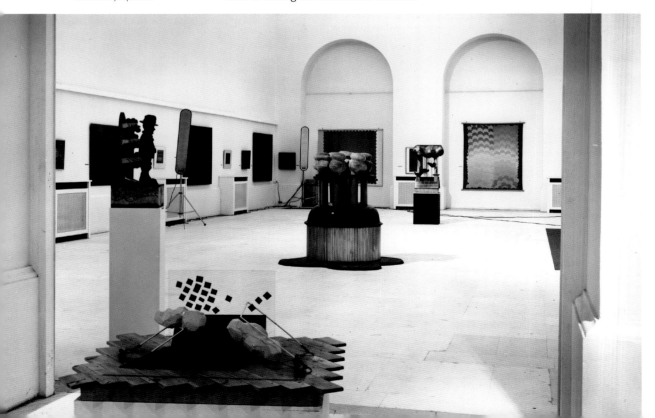

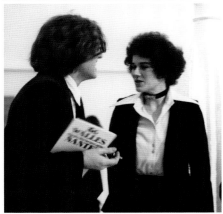

78 At the launch, a group including, centre left, Hudson next to Glyn Jones.

79 Gallery director Claude Souviron, left, with Giardelli.

80 Sally Hudson, right, with a French official, next to Hudson's maps of Wales.

81 Henry Meyric Hughes, British Council, with Isabel Hitchman, Welsh Arts Council.

1 Correspondence, 1962-84, Ki
2 *Breton Welsh Artists*, Cardiff University Art Group, 1969; Griffiths to Eyquem, 1 May 1969, Pviii
3 *Giardelli, A. & Shiel, D.* (2001), p.109
4 Annual Report, 1974-75, Di
5 Eyquem's introduction to catalogue, 56 Group Wales, Musée des Beaux-Arts, Nantes, 1974-75, Qxiia
6 Giardelli's preface to catalogue, 56 Group Wales, Musée des Beaux-Arts, Nantes, 1974-75
7 Accounts for 1974-75 show that HTV Wales granted £100, Fii. It would fund the Group regularly until the early 1990s. The Group, intermittently, referred to HTV as Harlech Television, the name not used by the company since 1970.
8 Annual Report, 1974-75, Di
9 Conversation with Isabel Hitchman, 26 January 2012
10 Correspondence between Griffiths, Souviron & carrier, 10-20 March 1975, Qxiib

82 (left) The exhibition at Nantes. This shows Gilhespy's mixed media sculpture *I Remember Henri*, foreground, and three sculptures by Stevens *(Adam, Crow Wood* and *Rain Cloud, Wet Roof and Birds)*. *Summer*, one of Tinker's hangings representing the four seasons, may be seen in the alcove at the end of the gallery.

83 David Tinker
Autumn 1970
244 x 244 cm
acrylic on canvas hanging

New Members, 1975

Four 1974 associate members - William Wilkins, Barrie Cook, Michael Punt and Robert Mitchell - were invited to become full members in 1975. Mitchell declined, 'after careful consideration... since my output is limited,'[1] but the others would make, in different ways, significant contributions to the Group. Much to his surprise, Wilkins was soon offered the opportunity, through the Group, to exhibit in a one-person show at University College Swansea.[2] An invitation was received from the University to show members' work over three terms. With the Group's support, Glyn Jones and Rowan exhibited there in Autumn 1974, followed in 1975 by Wilkins and, then, Mary Lloyd Jones and Tinker.[3] Cook was one of many fine art fellows at Cardiff College of Art encouraged to join the Group and Punt had just been recruited as a lecturer at Newport.

William Wilkins [born Kersey, Suffolk, 1938; associate 1974-75; member 1975-99; publicity officer 1978-86] was brought to Llandeilo at the age of two and attended Swansea College of Art and the Royal College of Art. After a period teaching he became an architectural journalist in London but, two years after joining the Group, he concentrated on painting. He has also been heavily involved in historic garden projects in Wales. A painter particularly interested in the human figure, still-life and landscape, his work may be seen as postmodernist in its use of art-historical themes, poses, designs and techniques, notably *pointillisme*.[4] 'There may be six to ten layers of dots and dabs,' he writes, 'as the right balance of colour and tone is finally established.'[5] Precise use of colour, line and architectural space are characteristic of his work. Whilst a member he held four one-person shows in New York, three at Robert Schoelkopf Gallery. He has also exhibited at the Glynn Vivian Art Gallery in Swansea, the Piccadilly Gallery in London and, more recently, at Martin Tinney Gallery, Cardiff.

84 William Wilkins
The Artist 1974, pencil

85 William Wilkins
Still Life: Three Lucie Rie Bowls
1986, 94 x 125 cm, oil on canvas

Barrie Cook [born Birmingham 1929; associate 1974-75; member 1975-79] studied at Birmingham College of Art and, after teaching for a number of years, became a senior fellow in fine art at Cardiff College of Art, 1974-77. During this period he had an exhibition at London's Whitechapel Art Gallery. Since the mid-1960s he has painted with an industrial spray gun and, sometimes, he has used more than a hundred coats of paint.[6] David Briers writes that 'Cook describes the way he makes his paintings as not wanting to 'bully' them into existence.'[7] In Cardiff he worked in an old warehouse overlooking the docks, a studio he retained until 1992. His large canvases were recognisable for their distinctive vertical parallel spray marks in carefully textured colours, often dark blue or black. 'Barrie Cook sees his paintings as inspiring meditation and contemplation, a form of spiritual discipline,' reveals Tom Cross, continuing: 'His paintings are to do with the illusion of space.'[8] On a 1977-78 fellowship, he responded to the environment around the University of Wales' residential mansion at Gregynog, near Newtown.[9] Although reluctant to leave Wales, he became head of fine art at Birmingham Polytechnic in 1979, a post he left in 1983 to devote himself to painting. A passionate socialist, he resigned from the Group over a perceived lack of commitment to the aims of the exhibition *Art in the Making* and some disappointment at what he felt to be a lack of conviviality in the Group.[10] Living in Cornwall since 1992, his spray paintings now have a different character with brighter colours and new shapes which often intersect.

Michael Punt [born London 1946; associate 1974-75; member 1975-93; honorary member 1993] attended Bath Academy of Art and worked as a designer before becoming a lecturer in sculpture. In 1974 he moved to Newport, rising to course director in fine art at Gwent Institute of Higher Education. By 1980 he was living near the Forest of Dean. Later in his time with the Group he studied for an MA at the University of East Anglia and was a senior research fellow at the University of Amsterdam. 'In my work,' he wrote in 1976, 'I indulge in two separate but related activities, drawing and object making. They compete for my attentions and constantly borrow from and refer to each other.'[11] His drawings, consisting of very fine lines on board painted over with white emulsion, are painstaking copies from flat materials such as photographs or illustrations which may include images of people. Very little colour is used. David Fraser Jenkins described in 1980 how: 'The images arrive from some personal and emotional iconography which is a closed world to anyone but the artist, for whom there is the greater commitment of personal emotion in-so-far as the object is vulnerable.'[12] His sculpture is different. Fraser Jenkins reveals that 'Punt was intrigued by the emotional impact of apparently purposeful objects which in fact had no purpose.' Geometrical solids appearing on a conjuror's table in a painting by Bosch, for example, had the power to deceive and to seem significant. He was, later, to become very interested in video and digital art and specialises in these areas at the University of Plymouth, where he moved in 2004.

86 Michael Punt *The Hogarth Stone*
1975, 122 × 127 cm, wood & cement

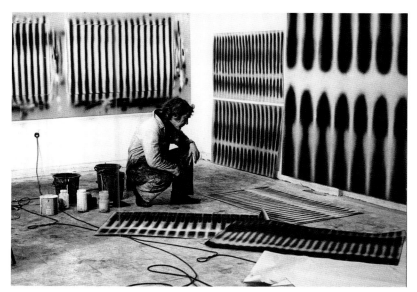

87 Barrie Cook in his studio, 1975

1 Mitchell to Griffiths, 6 January 1976, Gvc
2 Wilkins to Griffiths, 2 November 1974, Gva
3 Annual Report, 1974-75, Di
4 Dipple, Elizabeth, in *William Wilkins: Recent Paintings*, Robert Schoelkopf Gallery, New York, 1981, p.2
5 Wilkins, William, in Giardelli, Arthur, ed. (1976), p.62
6 Cook, Barrie (1976), in Giardelli, Arthur, ed. (1976), p.12
7 Briers, David, in *Barrie Cook, John Mitchell*, Howard Gardens Gallery, Cardiff, 2006
8 Cross, Tom, in *Barrie Cook: Presence of Painting*, Lemon Street Gallery, Truro, 2003, p.2
9 Walker, Ian, in *Barrie Cook, Gregynog Fellow*, Welsh Arts Council Touring Exhibition, 1978
10 Conversation with Cook, Ruan Minor, Cornwall, 8 January 2011
11 Punt, Michael in Giardelli, Arthur, ed. (1976), p.42
12 Fraser Jenkins, A.D., in *Michael Punt: New Sculptures and Drawings*, Oriel, Cardiff, Welsh Arts Council, 1980, p.3

88 An advance publicity photograph for the cancelled New York exhibition. Taken at Cardiff College of Art it includes, from left: Glyn Jones, Hudson (seated), Setch (standing), Rowan, Hunter and associate member Mitchell (front).

89 The work behind is Setch's *In the Twilight of the Gods*, 1974, 335 x 419 cm, dye and acrylic on cotton duck, shown at the National Museum of Wales in 1975 and reproduced above.

exhibiting artists Cardiff:

Mervyn Baldwin
Barrie Cook (associate)
Jack Crabtree
Arthur Giardelli
Tom Gilhespy
Tom Hudson
Robert Hunter
Glyn Jones
Mary Lloyd Jones
Robert Mitchell (associate)
Michael Punt (associate)
Eric Rowan
Terry Setch
Christopher Shurrock
Anthony Stevens
David Tinker
William Wilkins (associate)

Wales Week in Cardiff, 1975

Griffiths recalls that it was one of the Group's biggest disappointments 'that we did not go properly to the United States.'[1] The 1965 Dillwyn Gallery exhibition in Washington DC, which included many Group members, has been discussed on page 20. The Group received an invitation from the Development Corporation for Wales to provide an exhibition in 1975 for 'Wales Week' in New York. Extensive discussions included the Welsh Arts Council.[2]

Unfortunately, the New York show had to be cancelled because of a misunderstanding.[3] Tinker realised the problem. 'I saw the photographs of the exhibition area of the Union Carbide Building yesterday evening for the first time,' he wrote to Giardelli, 'I am sorry to say that I think the premises are not suitable for the kind of work which is done by the Group, nor is the anticipated back-up organisation of the kind that we need or the quality we require.'[4]

This may, in the end, have been fortunate as the planned dates, in late August and early September, were later described as 'probably the three deadest weeks of the entire year in the art world in New York.'[5] Difficulties had also arisen over financial responsibility for transport.[6]

The exhibition was to be previewed in July at the National Museum of Wales. The catalogue noted that 'we are glad that the museum regards it as worthy of showing on its merits, and we thank them for their renewed invitation.'[7] Wynford Vaughan-Thomas, chair of the Contemporary Art Society for Wales, opened the exhibition 'with an optimistic speech.'[8]

90 1975 National Museum of Wales exhibition catalogue featuring *Banner for Pwyll and Rhiannon* by Hunter.

91 Opening of exhibition by Wynford Vaughan-Thomas, with arms folded; Hunter, in denim jacket, foreground.

The Group also exhibited that year at Leeds University and sponsored a one-person show by Giardelli at University College Cardiff. Glyn Jones would follow in 1976 and Shepherd in 1977. The Italian Department had devoted an edition of its journal *Lettera*, edited and introduced by Raymond Eyquem, to the Group's graphic work.[9]

Both the Welsh Arts Council and HTV Wales continued to support the Group with regular funding.[10]

1 Conversation with Griffiths, 2 April 2009.
2 Annual Report, 1974-75, Di; Minutes of meeting with WAC, 5 May 1975, Qxv
3 Griffiths to Duncan, Alan, Development Corporation for Wales, 13 June 1975, Qxv.
4 Tinker to Griffiths, 12 June 1975, Fvib
5 Ralph, Colin, New York, to Griffiths, 23 June, 1975, Qxv.
6 Annual Report, 1974-75, Di
7 Note in *An Exhibition of Painting and Sculpture by the 56 Group Wales*, National Museum of Wales, 4-27 July 1975
8 Annual Report, 1974-75, Di
9 Annual Report, 1974-75, Di; *Lettera*, Quaderno 1, June 1975
10 AGM, 11 October 1975, Ci; Annual Report, 1974-75, Di

The Artist and How to Employ Him, 1976

'The purpose of this book,' Giardelli explained in a preface to the twentieth anniversary publication which he edited, 'is to show where the artists' works can be seen, what are their many and various artistic skills, and how to get in touch with them.'[1] *The Artist and how to employ him* established a high standard in 1976 for the promotion of the professional artist in Wales. Hudson, in support of the project, explained that: 'Many of the artists who would readily accept commissions for public spaces, of an architectural or environmental scale, feel inhibited by lack of opportunity from demonstrating still further their professional abilities and dedication in any work they might be called upon to do.'[2]

David Fraser Jenkins would later describe the book as 'a notable attack on the problem of public and private patronage… This promotion of the Group as a kind of business firm is probably unique, although,' he reflected, 'the Group does not seem to have the kind of management to sustain this approach.'[3]

The Artist and how to employ him included a background to the Group, an account of the previous twenty years by Raymond Eyquem and an article entitled 'How to purchase and how to commission work from an artist' by Stevens. There were sections on each member with career details, statements and illustrations of artwork, including commissions. Koppel had different ideas: 'Anybody who wishes to become acquainted with the fabric of my daily curriculum and the pictures I paint is very welcome at Lettycaws. A curriculum vitae cannot be offered as substitute.'[4]

Griffiths noted that 'the book should be comfortable in the hands of an architect.'[5] At A4-size and sixty-four pages long, it had seventy-four black and white halftone illustrations and twelve colour plates.[6] Designed by Roger Fickling, a striking wrap-around cover suggested a parcel tied up with string. A thousand copies were printed, with two hundred and sixty complementary copies being distributed. With a covering letter from Peter Jones of the Welsh Arts Council, these were sent not just to architects but to official organisations, local government, members of parliament, librarians, industrialists, banks, hospitals, colleges and galleries.[7] The colour plates doubled as postcards used by the Council, which supported the project.[8]

1 Giardelli, Arthur, ed. (1976), p.1
2 Hudson, Tom, 'Grŵp 56 Cymru - 56 Group Wales: The Artist and how to employ him', Llais Llyfrau, Gaeaf, 1976, Welsh Books Council, p.21
3 Fraser Jenkins, A. D. (1981)
4 Giardelli, Arthur, ed. (1976), p.40
5 Griffiths to Giardelli, 11 April 1976, Fvi
6 Invoice from Fickling Seaward, 29 May 1976, Viva
7 Recipients for Book: Giving Away List, 1976, Vivc
8 Treasurer's Report, October 1976, Cii; WAC granted £2,500. The Group also received a grant of £930 from the Council in 1976 and £100 from HTV.

featured artists:
Mervyn Baldwin
Barrie Cook
Geoffrey Davies
Arthur Giardelli
Tom Gilhespy
Tom Hudson
Robert Hunter
Glyn Jones
Mary Lloyd Jones
Heinz Koppel
Michael Punt
Eric Rowan
Terry Setch
David Shepherd
Christopher Shurrock
Anthony Stevens
David Tinker
William Wilkins

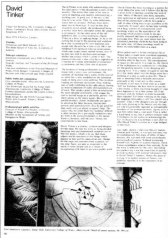

93 The cover and a representative artist page from *The Artist and how to employ him.* Tinker's page illustrates his recent cast aluminium sculpture in the Great Hall, University College of Wales, Aberystwyth.

92 Robert Hunter
Banner for Pwyll and Rhiannon
1974, 122 x 122 cm, acrylic on canvas
Carmarthenshire County Museum, gifted by the Arts Council of Wales, 2002

Featured in *The Artist and how to employ him* and in the Group's 1976 Retrospective Exhibition.

exhibiting artists
National Museum of Wales:

Mervyn Baldwin
Trevor Bates *
Laurence Burt *
Barrie Cook
Hubert Dalwood *
Geoffrey Davies
Michael Edmonds *
George Fairley *
Arthur Giardelli
Tom Gilhespy
Tom Hudson
Robert Hunter
Glyn Jones
Mary Lloyd Jones
Heinz Koppel
Bryan Macdonald *
Eric Malthouse *
Michael Punt
Keith Richardson-Jones *
Will Roberts *
Eric Rowan
David Saunders *
John Selway *
Terry Setch
David Shepherd
Christopher Shurrock
Jeffrey Steele *
Anthony Stevens
David Tinker
Norman Toyton *
Michael Tyzack *
William Wilkins
Alan Wood *
John Wright *
Ernest Zobole *

* past members

Twenty Year Celebration and Criticism, 1976

In Cardiff the Group's twentieth anniversary was marked by a three-venue summer exhibition. A retrospective including all present and all but two past members, Crabtree and Walton, was held at the National Museum of Wales.[1] Each artist showed three works, including one from when they joined the Group and another which had recently been produced. Opened by Barry Jones, parliamentary under secretary of state at the Welsh Office, it was followed by a party at the art college. Seven members gave lunchtime talks. An exhibition of graphic work was held at the Sherman Theatre and installations and large works were shown at Chapter Arts Centre. The strikingly designed red, green and white catalogues and posters by Roger Fickling played on the numbers '56' and '20'. It was the first time that a Welsh version of the Group's name, *Grŵp 56 Cymru*, was used on exhibition publicity. Ignored by London critics and turned down for a tour by the Arts Council of Great Britain, it was concluded that the Group's aims were different from those fashionable in London. 'The path,' they felt, 'lay abroad and in Wales.'[2]

Rollo Charles, keeper of art at the National Museum, contributed what transpired to be a provocative foreword in the catalogue. 'The Group has always been exclusive', he wrote, 'and has been confined to those of whom the individual members have approved as professionals as well as artists.'[3] The remark elicited censure from critic Bryn Richards: 'I believe that their proud boast of exclusiveness is a disguised claim to infallibility.'[4] Giardelli pointed out, in the Group's defence, that 'our aim is to give every member enough space in our exhibitions to demonstrate the character of his art…'[5] Richards also, rather disapprovingly, felt that it 'must be considered more of an exhibition club for teachers who pass through the local Art Colleges than the spearhead of revolutionary art in Wales.' Nevertheless, he acknowledged that 'a tripartite exhibition of this magnitude… is a major artistic event in Wales.'[6]

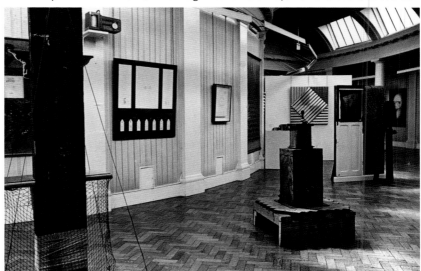

94 Retrospective exhibition in the Circular Gallery at the National Museum of Wales, 1976, showing mixed-media sculptures: Gilhespy's *The Lost Weekend*, left, and *Drinking Alone*, centre, and Punt's *The Broken Tryst*, right. Prominent wall-hung works are: Punt's drawing *Polyptych*, left, and polished & matt aluminium *Untitled* by Richardson-Jones, far screen.

95 (top left) Retrospective exhibition at the National Museum of Wales, 1976, showing one of Cook's *Continuum* acrylic paintings and mixed-media sculptures: *Malekula* by Stevens, centre left; and *Wave Construction* by Macdonald, right.

Of another comment in the catalogue foreword by Charles that the Group 'is now generally regarded as the official avant garde of Welsh art,' Richards mused: 'This must seem to those who founded the group, with such hope, as a veritable kiss of death.'[7] The same remark incensed Harry Holland in a notably disparaging review of the exhibition in *Link:* 'To have an 'official' avant garde (if the words mean what I think they do) would be exactly like having an official revolution, which is no revolution at all.'[8] A further assertion by Charles that the Group had 'proclaimed its Welshness' also stirred a rebuke to which Giardelli responded: 'All of us live and work in Wales; some of us were born here; and many of us have spent the greater part of our working lives in Wales and have sought to express our sense and understanding of the culture and the land in our work… We are the 56 Group Wales because no art that is not evidently of a particular place and of a particular time is of any value.'[9] Although this was the eleventh time in twenty years in which the Group had exhibited with the National Museum, it would not show there again until 1981.

The anniversary was also celebrated with an exhibition of work by current members toured by the arts councils of the Republic and Northern Ireland. Launched at Dublin's Bank of Ireland, it travelled to Cork and Belfast. Glyn Jones attended the Dublin opening and reported difficulties, largely overcome, with the venue. It would have been desirable if a member had visited beforehand to advise both organisers and artists. The publicity, however, was good and the launch well-attended.[10] The exhibition returned to Wales for a final showing at Aberystwyth Arts Centre where, *Link* reported, the poet 'R.S Thomas gave great lustre to the last of anniversary exhibitions by assisting at the celebration.'[11]

The Ireland catalogue noted, a little undiplomatically, that the Group 'is unchallenged as the representative of contemporary Welsh art.'[12] *The Irish Times* observed that: 'As a group it is heterogeneous, without any obvious *Leitmotiv;* as quality it is variable, but always interesting.'[13] *The Cork Examiner* felt that 'whilst it holds points of interest and some things of real beauty, it is on the whole a disappointment.'[14] *The Evening Herald* believed that: 'Art as a whole has gone past the concepts which dominate this exhibition.'[15] *The Irish Tatler*, on the other hand, felt that 'the group's exhibitions are varied and lively and show a remarkable cross-section of ideas.'[16]

1 *56/20: Grŵp 56 Cymru / 56 Group Wales: Twentieth Anniversary Retrospective Exhibition, 1956-1976*, 1976. Crabtree, Malthouse & Walton are not recorded in the catalogue. An inserted slip, however, gives details of three works by Malthouse, presumably added later.
2 AGM, 23 October 1976, Cii
3 Charles, Rollo, 'Foreword', *56/20: Grŵp 56 Cymru / 56 Group Wales: Twentieth Anniversary Retrospective Exhibition, 1956-1976*, 1976, p.1
4 Richards, Bryn, '56 Group Wales. Twentieth Anniversary Exhibition 1956-1976', *The Anglo-Welsh Review*, Vol. 26, No. 57, Autumn 1976, pp.274-76; see also Thomas, Ceri (2012) *Bryn Richards: a retrospective. 75 years of painting since 1937*, University of Glamorgan
5 Giardelli, Arthur, letter to editor, *The Anglo-Welsh Review*, Spring 1977
6 Richards, Bryn, as 4 above
7 Richards, Bryn, as 4 above
8 Holland, Harry, 'Anniversary Exhibition of the 56 Group Wales', *Link* 4, Association of Artists and Designers in Wales, Summer 1976
9 Giardelli, Arthur, letter, 1977, as 5 above
10 *56/20*, Ireland tour catalogue, 1976; AGM, 23 October 1976, Cii
11 '56 Group Wales', *Link* 6, AADW, Winter 1977
12 'Introduction', Ireland tour catalogue, 1976, p.3
13 Fallon, Brian, '56 Group Wales at the Bank of Ireland', *The Irish Times*, 18 September 1976
14 Neeson, Geraldine, 'Interesting Welsh group exhibition', *The Cork Examiner*, 2 November 1975
15 'As Down the Glyn', *The Evening Herald*, 18 Sept. 1976
16 'Contemporary Welsh Art', *The Irish Tatler & Sketch*, October 1976

exhibiting artists
Sherman Theatre:

Mervyn Baldwin
Geoffrey Davies
Arthur Giardelli
Tom Gilhespy
Tom Hudson
Robert Hunter
Glyn Jones
Mary Lloyd Jones
Michael Punt
Eric Rowan
Christopher Shurrock
Anthony Stevens
William Wilkins

exhibiting artists
Chapter Arts Centre:

Barrie Cook
Tom Hudson
Terry Setch
David Shepherd

96 Catalogue covers for the related Twentieth Anniversary exhibitions.

97 Larger works at Chapter Arts Centre:
Shepherd's mixed media installation *Construction*, foreground, and a distant view of a second of Cook's *Continuum* acrylic paintings.

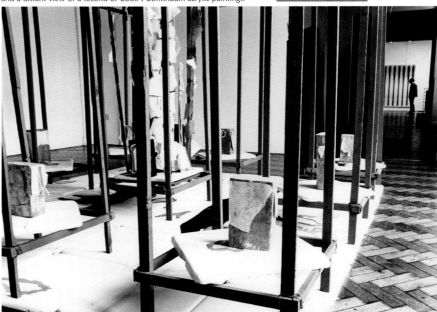

98 Paul Beauchamp *Foxbat*
1978, 107 x 152 x 15 cm, glass, poly/paint and blockboard

99 Adrian Heath *Monkton No.2*
1980, 117 x 91 cm, oil on canvas

1 Nash to Griffiths, 12 August 1977, Gvd
2 Rowan, Eric (1979), p.82
3 Rye, Jane (2012) *Adrian Heath*, Lund Humphries
4 Heath, Adrian, in Alloway, Lawrence, ed. (1954) *Nine Abstract
Artists: Their Work and Theory*, Alec Tiranti, pp.25-26
5 Grieve, Alastair (2005) *Constructed Abstract Art in England*, Yale, p.180
6 Rowan, Eric (1985), p.159
7 *Adrian Heath: Peintiadau Newydd / New Paintings*,
Oriel, Welsh Arts Council, 1979
8 Robertson, Bryan, 'Obituary: Adrian Heath',
The Independent, 21 September, 1992
9 Heath, Adrian, in *56 Group Wales in 1981: 25th Anniversary
Exhibition*, National Museum of Wales, 1981
10 Redfern, David (2008)

New Members, 1976 - 77

Paul Beauchamp and David Nash became associate members in 1976. Nash exhibited with the Group once, ex-catalogue, in Aberystwyth in 1977 but decided not to continue. 'The context, where my work is, how it is, is delicate,' he wrote, 'and I am unhappy with mixed exhibitions on this point.'[1] Adrian Heath and Alistair Crawford were the last to be elected associate members of the Group in 1977, Crawford continuing until 1978.

Paul Beauchamp [born Barrow upon Soar, Leicestershire, 1948; associate 1976-77; member 1977-78] is a sculptor and photographer who studied at Loughborough and Hornsey colleges of art and then, as a postgraduate, at the Slade School of Fine Art. He became a lecturer at Cardiff College of Art in 1974. His work, at the time, used 'glass and metal in severe, geometrical configurations, relying on the quality of the materials and their intrinsic aesthetic appeal.'[2] He exhibited in three Group exhibitions and was also a member of the Association of Artists and Designers in Wales. He moved in 1988 to College of Charleston, South Carolina, returning to Cardiff Institute of Higher Education as course director, 1990-2006. He still lives in Cardiff and photography is now his main medium, although drawing is an integral part of his work. He has been chair of Ffotogallery in Cardiff.

Adrian Heath [born Maymyo, Burma, 1920; associate 1977-78; member 1978-82; died 1992] was a painter whose work had evolved from 1950s constructed abstract art.[3] When young he studied with Newlyn artist Stanhope Forbes, then attended the Slade. He served in the Royal Air Force and was a prisoner of war. London became a base for travelling. In the 1954 *Nine Abstract Artists* he wrote: 'It is the process, the method of development that is the life of the painting, and this that absorbs my interest rather than the attractions of any particular form or colour.'[4] He exhibited in *This is Tomorrow* at the Whitchapel Art Gallery in 1956. Chair of the Artists International Association, 1954-64, he joined the London Group in 1962. From then until 1977 he was a visiting lecturer at Bath Academy of Art, Corsham. Alastair Grieve considers that, from around 1960, he no longer made constructed abstract art, adopting a more intuitive approach.[5] In 1977 he followed Cook as senior fellow in fine art at South Glamorgan Institute of Higher Education, Cardiff, remaining until 1980.[6] He showed at Redfern Gallery, London, and exhibited work in 1979 at Oriel, Cardiff, the titles of which alluded to place-names in Wales.[7] Despite this, Bryan Robertson noted that: 'Heath was far more concerned with reconciling the character of geometric shape with the nature of organic form than with making any recognisable references to the natural, verifiable, physical world.'[8] Ideas were drawn on paper with little resemblance to the finished picture.[9] He became a lecturer at Reading College of Art, 1980-85, and resigned from the Group, as well as from the London Group, in 1981.[10]

Exhibitions Realised and Unrealised, 1977 - 79

University College Cardiff continued to be receptive to the Group's work. After Shepherd's 1977 exhibition, the whole Group showed there in January 1978. In the spring, paintings, constructions and drawings by Giardelli, Glyn Jones and Setch were shown, highlighting their south Wales connections and interest in unusual materials.[1] This was also shown at University College Swansea. Early in 1979 Hunter and Tinker showed at University College Cardiff.

A substantial exhibition of paintings and sculpture, including some individual large works, took place in July 1978 at the Royal West of England Academy. Gerda Roper in *The Western Mail* proclaimed that 'much is excellent and memorable.'[2] Ian Walker in *The Guardian*, however, wrote damningly: 'A couple of blunt questions need to be asked. Is a group such as this necessary, and secondly, is it desirable?... It's all too predictable, utterly unadventurous and slack.'[3] *The Bristol Evening Post* felt that 'although this exhibition has several fine works, that original break-away zeal seems to have been lost.'[4] The Group also exhibited at the new Wyeside Arts Centre in Builth Wells.[5] The year ended with the launch of the more didactic *Art in the Making*, discussed on page 48.

In spring 1979, with support from the British Council, the Welsh Arts Council and HTV Wales, the Group exhibited in France at the Musée de la Poste, Amboise, a town on the River Loire.[6] The Giardellis had befriended abstract artist Olivier Debré at the Nantes exhibition launch in 1974. Debré, in 1976, became an international fellow of the Welsh Arts Council and exhibited at the National Museum of Wales in 1977.[7] His brother, Michel, a former prime minister of France and now mayor of Amboise, invited the Group.[8] Around a hundred people attended the opening and there was a reception afterwards at the home of Olivier Debré.

The Group exhibited in parallel to this at Newport Museum and Art Gallery and, with the support of West Wales Association for the Arts, at the Glynn Vivian Art Gallery, Swansea. The exhibition, reflecting a new policy from the Group, was selected by critic Charles Spencer who commented that: 'The overall quality - both technically and imaginatively - eliminated nervousness in decision-making...'[9] The Welsh Arts Council bought five works.[10]

The Continental ambition of the Group is reflected in unrealised projects to exhibit in Eastern Europe despite cultural, political and bureaucratic difficulties. Initial attempts to show in the German Democratic Republic were made on the back of a proposed Welsh National Opera tour.[11] The director of the British Council's Fine Art Department was not optimistic. He suggested a formal proposal through the British cultural attaché in East Berlin and predicted that a reciprocal exhibition was likely to be expected.[12] Peter Jones of the Welsh Arts Council felt that: 'The Art Committee... will be particularly enthusiastic if it turns out to be an exhibition of 'Socialist-Realism'.'[13] After assessing the Group for political acceptability, the Ministry of Culture advisers decided that the Group was rather 'popesque' and it could not be seen to be supporting an exhibition containing solely this type of art.[14] Surprisingly undaunted, Griffiths also wrote to the Polish Cultural Institute in London. Contact was, eventually, made with the Polish Artists Association but, in the end, this came to nothing.[15]

exhibiting artists
Amboise:

Mervyn Baldwin
Geoffrey Davies
Arthur Giardelli
Tom Gilhespy
Adrian Heath
Robert Hunter
Glyn Jones
Mary Lloyd Jones
Michael Punt
Eric Rowan
Terry Setch
David Shepherd
Christopher Shurrock
Anthony Stevens
David Tinker
William Wilkins

100 Amboise exhibition poster

1 Fraser Jenkins, David, 'Arthur Giardelli, Glyn Jones, Terry Setch,' *Link* 12, 1978
2 Roper, Gerda, 'Exhibition with the expert touch', *The Western Mail*, 12 July 1978
3 Walker, Ian, '56 Group', *The Guardian*, 18 July 1978
4 'Art group lose that early zeal', *The Bristol Evening Post*, 14 July 1978
5 Annual Report, 1978-79, Di
6 Annual Report 1978-79, Di; Report on Amboise Exhibition to Meyric Hughes, British Council, from Griffiths, 24 April 1979, Rxi
7 *Olivier Debré*, Welsh Arts Council, 1977; Giardelli, Preface, *Groupe 56 Pays de Galles: Exposition de Peintures, Sculptures et Constructions*, Musée de la Poste, Amboise, 1979
8 Giardelli, A., & Shiel, D. (2001), p.109

9 Spencer, Charles, 'Introduction', *Grŵp 56 Cymru, 56 Group Wales*, Newport Museum and Art Gallery, 1979
10 Annual Report 1978-79, Di
11 Circular about 'Eastern Germany' from Griffiths, 5 August 1977, Riv
12 Forty, G. M., to Griffiths, 7 July 1977, Riv
13 Jones, Peter, to Forty, G. M., 12 December 1977, Riv
14 Jenkins, R. T., British Embassy, Berlin, to Forty, G.M., British Council, London, 28 December 1977 & 8 March 1978, Riv
15 Correspondence between Griffiths and Polish contacts, 1978-81, Kiii

Art in the Making, 1978 - 79

The Cross, Pontardawe
27 Ionawr - 10 Chwefror 1979
Dydd Llun - Dydd Gwener 10-5
Dydd Sadwrn 10-1

The Cross, Pontardawe
27 January - 10 February 1979
Monday - Friday 10-5
Saturday 10-1

exhibiting artists:

Mervyn Baldwin
Paul Beauchamp
Barrie Cook
Alistair Crawford (associate)
Arthur Giardelli
Robert Hunter
Glyn Jones
Mary Lloyd Jones
Heinz Koppel
Michael Punt
Terry Setch
David Shepherd
Christopher Shurrock
David Tinker
William Wilkins

101 Standard flyer for the
exhibition overprinted with
details for The Cross, a
community centre in Pontadawe.

102 A selection of
the exhibition panels.

Whilst not a typical Group exhibition, *Art in the Making: An Exhibition for the Village Halls of Wales* was an attempt, in 1978-79, to extend the remit of the Group by showing work where 'it can be seen by people who rarely have the opportunity to visit galleries showing the work of contemporary Welsh artists.'[1] It was hoped that it would be shown in community halls, church halls, schools, libraries and other places which lacked normal gallery facilities. It was also an attempt to explain something of the process of making contemporary art. Group members Cook and Shurrock worked with Welsh Arts Council exhibition staff Andrew Knight and Joy Goodfellow on its development.[2] Wilkins, the recently elected Group press officer, energetically liaised with the Council over publicity.

Consisting of thirty-two panels on free-standing linked screens, four foot wide and seven foot high, it featured work by fifteen Group members. Shurrock and designer Roger Fickling devised the panels to include artists' statements as well as photographs of each artist's working environment by Steve Benbow. It was intended that one of the exhibiting artists would be available to talk about their work at each venue. There was no hiring fee and the Welsh Arts Council provided insurance, transport and help with installation and dismantling. Venues were required to staff and publicise the exhibition although the Council supplied cards and posters.

Curiously, the exhibition opened at the conventional venue of Wrexham Arts Centre on 9th December 1978. Wilkins was concerned that 'from a press and PR point of view I wish the exhibition was opening in …Cross Hands Library or Halfway's pub.'[3] Glyn Jones expressed concerns about 'the predictability of the venues' when he returned his submission form to the Council. He advised Knight about library contacts and Prendergast suggested possible north Wales venues.[4]

Knight was disappointed at the standard of some of the artwork.[5] Cook felt that it reflected a lack of commitment to the project and this contributed to him resigning from the Group.[6] Nevertheless, Goodfellow reported that 'the exhibition proved extremely popular and travelled very well indeed.'[7] In the end it toured to four libraries, two art centres, a community centre, a further education centre and a cathedral. Owain Glyndŵr Centre, Machynlleth, was double booked and the Group had to withdraw.[8] Artist talks were given at several venues, although these were not well attended. Sadly, Paul Beauchamp's construction *Nimrod* was found damaged on the gallery floor in Aberystwyth.[9]

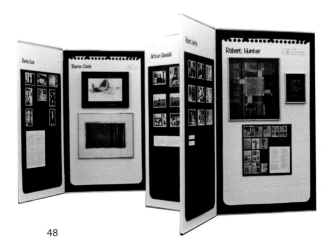

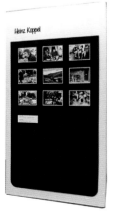

1 'Art in the Making', Welsh Arts Council
press release, November 1978, Rv
2 Conversation with Cook, 29 April 2012
3 Wilkins, to Griffiths, 22 October 1978, Rv
4 Jones, Glyn, to Knight, Andrew, 20
September 1978, Rv
5 Grifffiths to Knight, Andrew, 14
November 1978, Rv
6 Conversation with Cook, Ruan Minor,
Cornwall, 8 January 2011
7 Annual Report, 1978-79, Di
8 Ward, Valmai, to Griffiths, 31 July 1979, Rv
9 Ward, Valmai, to Griffiths, 27 Feb. 1980, Rv

Reassessment and Resignation, 1977 - 79

Outbursts of criticism continued. Griffiths wrote solicitously: 'It is said that we have had more than our share of the cake and other artists should have a turn. There is talk of elitism.'[1] Tinker advised: 'We must have determination to face up to various unpleasant situations. There has always been the envy of artists outside the Group towards the Group, and in many cases that has turned to spurning the Group.'[2]

There was concern, too, about the possibility of hostility in official circles. Tinker wrote: 'I saw Tony Stevens on Friday and we agreed that we are likely to have a rough passage from the WAC committees from now on. We have become 'the establishment' in the eyes of many people now, and so are suspected of being avid of power and position or perhaps they are jealous of our position (as they see it!) which we know from inside is a fragile structure.'[3] The Welsh Arts Council, nevertheless, continued its support.[4]

With the Group's purpose being questioned, however, it embarked upon a rigorous process of self-analysis. At a meeting in December 1978 at Chapter Arts Centre consideration was given to four papers by, jointly, Glyn Jones and Setch and, separately, Giardelli, Tinker and Wilkins. These discussed a wide-range of issues including criticism, professionalism, participation, presentation, quality control, age-range, sub-groups, venues and the constitution.[5] 'Proposals concerning the Group' were circulated to members with a series of questions eliciting 'yes' or 'no' answers. These addressed such matters as becoming a member, ceasing to be a member, the size of the Group, meetings, exhibitions, selection and hanging. The results were analysed and presented at a meeting in January 1979 at University College Cardiff.[6]

'The general principle that artists decide what they exhibit was upheld but the idea of occasional selection by nominated members or by distinguished outsiders was accepted,' the 1978-79 annual report recorded. It continued: 'There are to be changes in the process of becoming a member. A proposal for a five-year review of membership was rejected.'[7] In addition, associate membership, which could lead to resentment when holders were not invited to become full members, was ended.[8] It was also felt that no member should be asked to resign unless two-thirds of the members voted for it, that there should be more exhibitions of sub-groups and that those hanging work should have authority to omit work to avoid overcrowding.[9]

Curiously, events would seem to contradict Rowan's comment in 1979 that: 'As for internal dissent, this raises no problems because there is virtually nothing in the group's function to cause it.'[10] A spate of resignations occurred during the period of reassessment. Beauchamp resigned in October 1978 as 'the Group had lost its youthful approach. Membership gave him a sense of security which he found stultifying.'[11] Shortly before the January 1979 meeting, Baldwin wrote: 'Frankly I do not like the way the Group is shaping up. It seems clear that it is about to change its nature in at least one of several ways…'[12] He was concerned that: it might increase in size; about selection of work by members; a possible stipulation about the frequency of exhibiting; and more meetings and didactic exhibitions. Giardelli persuaded him to stay but he finally left in February 1980.[13] Cook resigned after the January 1979 meeting feeling that: 'At the last meeting an important opportunity was lost to restore the vibrancy of the group's image. I believe it has become a convenient vehicle for many members to exhibit work without the self-searching and philosophical demands which make a group's identity worthwhile.'[14]

More resignations followed the 1979 annual general meeting, including Setch (see page 26).[15] Koppel left, stating simply: 'I do not wish to continue my membership.'[16] Shepherd did not believe that long-term membership was healthy for the Group and resigned, reassured that new members would 'add new vigour.' He also believed that 'the size and nature of my work has always proved somewhat of a problem.'[17] Rowan resigned in 1980 because he had left Wales, writing of 'a 'graceful retirement', tendered with regret.'[18]

1 Griffiths to Wilkins, 16 Nov 1977, Gvd
2 Tinker, David, Paper for consideration by the Group, 26 October 1978, Bii
3 Tinker to Griffiths, 10 May 1977, Fvid
4 WAC guaranteed against a loss of £1,200, 1977-78. It granted £726 in 1978-79 & £1,500 in 1979 (AGM minutes, 1977-79), Cii
5 Meeting, 8 December 1978, Bli
6 Meeting, 26 January 1979, Bii
7 Annual Report, 1978-79, Di
8 Interview with Griffiths, 23 March 2009

9 Meeting, 26 January 1979; December 1979 Constitution, Ai
10 Rowan, Eric, in Stephens, Meic, ed. (1979), pp.69-70
11 AGM, 21 October 1978, Cii
12 Baldwin to Giardelli, 19 January 1979, Fvif
13 Baldwin to Griffiths, 3 February 1980, Gve
14 Cook to Griffiths, 28 January 1979, Gve
15 Griffiths to Setch, 1 December 1979, Gve
16 Koppel to Griffiths, 17 December1979, Gve
17 Shepherd to Giardelli, 30 December 1979, Fvif; Conversation with Shepherd, 5 September 2012
18 Rowan to Griffiths, 5 May 1980, Gve; AGM, 22 November 1980, Cii

Five New Members, 1980

In 1979 five young members, including only the second woman to join, were recruited.[1] They had all moved to Wales to work and most of them were to have a significant impact upon the Group.

Anthony Davies [born Andover 1947; member 1979-88] studied at Winchester, graduated from the Royal College of Art and attended the British School in Rome. He became a visiting lecturer at art colleges in Cardiff and Newport and had a studio at Chapter Arts Centre. A painter and printmaker with a strong social conscience, his work is figurative, expressionist and surreal. Lithographs and etchings in sequences are often about people, including himself, and their frailties. Edward Lucie-Smith indicated that: 'What they aim to convey is the fascination of modern urban life, the urgency and glamour of the inner city, as well as its squalor and violence.'[2] He moved to Belfast in 1985 and to New Zealand in 1994.

Ian Grainger [born Umtali, Rhodesia 1942; member 1979-89; died 2007] attended Sunderland and Birmingham colleges of art, was a fellow at Chicago Art Institute and studied engraving in the British School at Rome. He became a lecturer in printmaking at Cardiff in 1973 and the Gregynog Art Fellow at the University of Wales, 1980-81. Primarily a printmaker, his work was rich in surreal imagery derived from disparate sources and included reflections on time and the apparently insignificant but crucial details of observed objects.[3] 'Some works,' he explained, 'show the whole process of creation and are covered with notes on the ideas which generated each image and how it was developed.'[4]

Erica Daborn [born Winchester 1951; member 1979-87] studied in Winchester and at the Royal College of Art. She was a teaching fellow and later a lecturer at Cardiff, 1977-85. She had a studio at Chapter Arts Centre. Her figurative yet highly imaginative and humorous works, often in tempera, explore fantasy and the unconscious in an expressionist style. 'Her work', wrote Michael Williams, 'has always presented a psychological and surreal view of life and, at the same time, been critical or satirical, with its cutting edge aimed at a male-dominated society.'[5] In 1985 she held a residency at a computer software company in Brynmawr.[6] She moved to California shortly afterwards.

Harvey Hood [born Staffordshire 1946; member from 1979] attended Birmingham College of Art and the Royal College of Art. Since 1973 he was a senior lecturer and, latterly, head of sculpture, at Cardiff College of Art. An abstract sculptor, he has been much concerned with materials. When he joined the Group he was making large timber constructions.[7] Public sculpture includes the 1982 enclosed steel *Archform* at Newport Station. He became interested in iron-casting to make unusual objects which, because of his interest in the metaphysical, might be allowed to rust. The components in his 2004 cold cast iron sculpture *From Guitar to Typewriter* are understood as real and, yet, they indicate a relationship between each other. Since retiring from University of Wales Institute Cardiff in 2000, he has run sculpture workshops at Berllanderi near Raglan.

103 Anthony Davies *The Sadist (series of self portraits)* 1982/83, 44 x 55 cm, stone lithograph
104 Ian Grainger *Self Portrait in Beret* c.1975, 82 x 57 cm, etching
105 Erica Daborn *Double Act* 1980, 140 x 112 cm, egg tempera
106 Harvey Hood *Rhomboidal* 1978, 200 x 500 x 400 cm, oak & ash

Gary Woodley [born London 1953; member 1979-82] attended Berkshire, Camberwell and Chelsea schools of art. At the time of joining, he was a junior fellow in fine art at South Glamorgan Institute of Higher Education, Cardiff. A sculptor of delicate, immaculately constructed minimalist works, he also made systems-based drawings.[8] His *Homeomorphic Sequence* of plywood boxes using different woods created optical effects where lines intersected. He has returned to London.

The work of these new members was presented in spring 1980 at University College Cardiff. Raymond Eyquem, curator of art, regarded it as an important exhibition.[9] William Wilkins reflected that: 'It will be immediately apparent that the group has not elected them to membership on the basis of a common style or ideology... The basis of election has always been the simple respect for an artist's work, the sense of his or her professionalism and imagination.'[10]

1 Press release for *Five New Members*, April 1980, Sii
2 Lucie-Smith, Edward, in *Peter Grimes & Urban Frontiers: An Exhibition of Prints by Anthony Davies*, Oriel, Cardiff, 1982
3 *Ian Grainger*, Oriel, Cardiff, 1975
4 *Five New Members*, University College Cardiff Art Group, 1980, p.7
5 Williams, Michael, in *Erica Daborn: The Journey*, Oriel, Cardiff, 1985
6 *Art at Work: An Exhibition of Paintings by Erica Daborn at Control Data UK Ltd.*, Brynmawr, 1985, Welsh Development Agency / Welsh Arts Council
7 *Harvey Hood: New Sculpture*, Oriel, Cardiff, 1979
8 *Gary Woodley, Sculpture*, Oriel, Cardiff, 1979
9 Draft letter from Griffiths to new members, early 1980, Sii
10 Wilkins, William, Introduction to *Five New Members*, University College Cardiff Art Group, 1980

107 Gary Woodley
1st Homeomorphic Series (No 3)
1981, 107 x 25 x 4 cm
sycamore, pear and birch ply

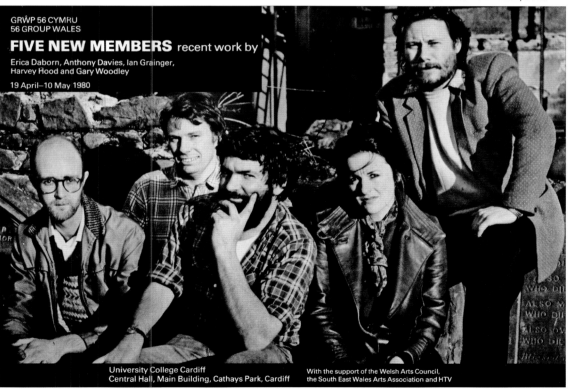

108 Poster showing, from left: Gary Woodley, Harvey Hood, Ian Grainger, Erica Daborn and Anthony Davies

GRŴP 56 CYMRU
56 GROUP WALES

FIVE NEW MEMBERS recent work by
Erica Daborn, Anthony Davies, Ian Grainger,
Harvey Hood and Gary Woodley

19 April–10 May 1980

University College Cardiff
Central Hall, Main Building, Cathays Park, Cardiff

With the support of the Welsh Arts Council,
the South East Wales Arts Association and HTV

Driving Force: Giardelli, Tinker and Griffiths

Numerous people have contributed to the organisation and profile of the Group. Malthouse was a key figure in establishing and running it in the early years and others have, at times, been important. The Group's high level of activity and effectiveness in Britain and on the Continent over several decades was, however, primarily due to three individuals whose skills and determination complemented each other: Arthur Giardelli, David Tinker and Mary Griffiths. For twenty-four years this inner core worked together, a well-oiled engine which drove the Group forward. They also provided stability, despite changes in membership.

Giardelli steered the Group along a visionary course. His first letter to Malthouse in August 1956, accepting the invitation to join, makes it clear that: 'If there is anything in which I can help, please let me know and I will do what I can.'[1] From early on he was concerned about the Group's effective organisation. He wrote to Malthouse in May 1957: 'I feel sure that all members of the Group would like those who are in Cardiff to regard themselves as an executive committee so that action can quickly be taken in these matters - perhaps all is already done!'[2] Giardelli became chair of the Group in 1961, remaining in the position for thirty-eight years. Whilst he seems to have been unchallenged, there was concern about succession and Tinker was installed as vice-chair in 1977. After standing down in 1998 Giardelli became president until he died in 2009.

Griffiths regularly wrote to Giardelli and recalls that: 'Arthur would always reply. He never ducked an answer, however difficult... I would do Arthur's bidding. I didn't see myself as a driving force. I didn't see Tinker as a driving force. Arthur, yes.' He never bossed her and she never challenged him. His influence abroad, she feels, had been essential in obtaining exhibitions. Griffiths believes that he was very unselfish in advancing the Group when 'he could have pushed for a one man show.'[3] Shiel, interviewing Giardelli, put her views directly to him: 'She speaks very highly of your abilities, not only as Chairman but in making introductions, careful letter-writing, public relations and possible speech at the opening, often in the language of the country. What she admired was the assurance with which you could meet with artists or art administrators, academics or government officials.'[4]

Tinker, one of the three founders and a committed Group member for the rest of his life, made an overall contribution that was as important, in a complementary way, to that of Giardelli and Griffiths. He was actively involved in the early organisation of the Group and was the treasurer, 1961-63 and 1965-96, and also vice-chair, 1977-96.[5] Like the others, Tinker was generous with his time. He wanted, as well as creating his own work, to contribute to improving the lot of the artist in general. 'Above all,' Wakelin emphasises, 'he was committed to the democracy of the group show as a way of making opportunities for artists to exhibit...'[6] He wrote carefully considered papers to inform discussions about the Group's future.

Griffiths was appreciative of Tinker's involvement and skills as treasurer, noting that 'he prepared the budget in good time.' He also 'did more than his fair share of hanging.'[7] When Tinker felt he should give up being

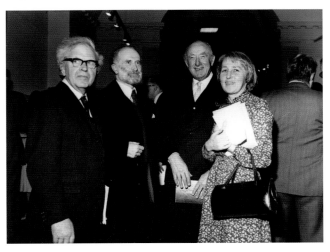

109 A doodle, *Little Boxes*, by Baldwin on the agenda for the 1973 annual general meeting. It spells the name 'Mary Griffiths' on building blocks. Elisabeth Elias stood down as secretary at this meeting and Griffiths would, shortly, take up the position again until 1991.

110 Giardelli, Tinker, Lord Elwyn-Jones and Griffiths at the opening of the 25th Anniversary Exhibition at the National Museum of Wales, 1981.

The Garden

treasurer in 1976, Griffiths wrote to him: '…a sensible Treasurer with one foot (at least) on the ground is preferable to a scatty artist even if he lives next door.'[8] Again, in 1982, Giardelli wrote: 'David's work as treasurer is far too important for us to let him go.'[9]

Griffiths, a trained barrister, served as secretary to the Group for a total of twenty-six years, 1963-71 and 1974-91. She later explained: 'I wanted something to do separate from family life.'[10] There is an interesting contemporary parallel with Ann Landers, the non-artist secretary and treasurer to the South Wales Group, and later Welsh Group, on a small retainer for thirty years, 1962-92.[11]

Griffiths did not enjoy being in the public eye but, behind the scenes, she was a remarkably determined, efficient and hard-working administrator. She took minutes and prepared catalogues, as well as handling extensive correspondence with the committee, members, exhibition venues, carriers, insurers and funders. 'I had,' she explains, 'a great big cupboard, a typewriter and photocopier.'[12] Shiel reminded Giardelli how: 'She saw herself as the fulcrum of the Group… All correspondence would apparently be sent to her and then, as she put it, she would 'frame questions' to put to you by letter.'[13] She was the key link with members. Despite this: 'If there was any difficulty they wouldn't have discussed it with me. I was staff, so to speak.'[14]

She recalls frustrations at obtaining catalogue details and photographs from members, persuading them to attend meetings, chasing up artworks and collecting subscriptions. Transport, too, 'was a bit of a headache but we managed.' Nevertheless, 'I was very fortunate to have something that was challenging and interesting.'[15]

Griffiths had worked voluntarily but later, when resources allowed, she received an honorarium.[16] There was much concern when she decided, for the first time, to give up the position to find more regular paid work. Tinker wrote: 'You have been completely indispensible to us throughout the time that you have been working for the Group.'[17] Giardelli entreated: 'I know we still exist largely due to your efforts.'[18]

Elisabeth Elias, another barrister, became secretary between Griffiths's two terms of office. Griffiths was, at that time, redesignated vice-chair, although it seems that Mary 'had felt rather jealous seeing her friend with the Group's papers under her arm.'[19]

Griffiths acknowledges her husband's support. Bruce Griffiths, a judge, served as chair of the Art Committee of the Welsh Arts Council, the Contemporary Art Society for Wales and Welsh Sculpture Trust.[20] He helped the Group in many ways, notably in developing good relations with Bologna and Czechoslovakia, and was made an honorary member in 1984. The Griffithses spent time abroad for his health. Betty Evans became assistant secretary in 1988, 'held the fort' and 'had a key to the house.'[21] Griffiths retired in 1991 to spend more time with her husband. Evans continued to help Julian Sheppard, the new secretary, until 1996.

111 Giardelli invariably headed his many letters to Griffiths with cartoon sketches of a golden plover, the name of his Pembrokeshire home. Griffiths typed all her letters, keeping carbon copies. Tinker often, and Giardelli always, wrote in fountain pen; the former meticulously, yet elegantly; the latter expressively.

A large correspondence, from a quarter of a century of working together, survives. 'Others more expert than me,' wrote Griffiths in 1979, 'think the Group will be important for anyone doing research into art in Wales of this period so I keep a good deal of material.'[22]

1 Giardelli to Malthouse, 30 August 1956, Fii
2 Giardelli to Malthouse, 2 May 1957, Fii
3 Interviews with Griffiths, 23 March & 2 April 2009
4 Giardelli, A. & Shiel, D. (2001), p.113
5 AGM, 10 October 1977, Cii
6 Wakelin, Peter, 'David Tinker and the Art Community in Wales' in Meyrick, Robert, ed. (2002), p.21 & p.23
7 Interviews with Griffiths, 23 March & 2 April 2009
8 Griffiths to Tinker, 6 May 1976, Fvic
9 Giardelli to Griffiths, 6 August 1982, Fvi-i
10 Interview with Griffiths, 23 March 2009
11 Wakelin, Peter (1999), p.49 & p.98
12 Interview with Griffiths, 2 April 2009
13 Giardelli, A. & Shiel, D. (2001), p.113
14 Interview with Griffiths, 23 March 2009
15 Interview with Griffiths, 2 April 2009
16 Tinker to Griffiths, 8 May 1983, Fvi-j; Annual audited accounts 1961-1997, Eii
17 Tinker to Griffiths, 5 July 1971, Fvic
18 Giardelli to Griffiths, 20 August 1971, Fivc
19 Giardelli, A. & Shiel, D. (2001), p.113
20 Stephens, Meic, 'Obituary: Judge Bruce Griffiths', The Independent, 30 January 1999
21 Interview with Griffiths, 2 April 2009 22 Griffiths to Setch, 1 December 1979, Gve

Twenty-fifth Anniversary, 1981

Exhibitions leading up to the twenty-fifth anniversary received mixed reviews. 'In nearly all respects,' indicated *The South Wales Argus* of an exhibition at Llantarnam Grange, 'this is a disappointing and uninspiring exhibition, lacking in drive or new direction.'[1] The *Five New Members* show at University College Cardiff was better received. *The Guardian* reported that: 'The exhibition as a whole certainly has bite... it is insistently distracting and a distinct improvement on its most recent predecessors.'[2] In early 1981, however, an exhibition of graphic work at Cardiff's Sherman Theatre was described by *The Western Mail*, rather unflatteringly, as: 'a pot-pourri, a graphic party, is just a bit of a gossip...'[3] Undaunted, the Group toured that summer to Perth, Livingston, Dundee and Aberdeen.

All members showed in the May 1981 *25th Anniversary Exhibition* at the National Museum of Wales.[4] Consisting of paintings, sculpture, prints and drawings, this was opened by Lord Elwyn-Jones, a former lord chancellor. It would be the last time the Group exhibited with the National Museum for fifteen years. The exhibition toured to the National Library and, with the addition of Derek Southall's work, to the refurbished Mostyn Art Gallery in early 1982.[5] The catalogue, edited by Wilkins, included an historical essay by David Fraser Jenkins.[6] Wilkins, Glyn Jones and Mary Lloyd Jones were interviewed on the radio. An unusual accompanying event, *The Artist in the Witness Box*, was held at the National Library. Giardelli, Tinker, Hunter and Mary Lloyd Jones fielded questions with Judge Bruce Griffiths in the chair.[7]

The catalogue essay by Fraser Jenkins draws attention to an increase of interest in contemporary art in Cardiff which was tending to make the Group seem less representative. He attributed much of the improved situation for artists in south Wales to the Group's activities. Its greatest achievement, he believed, was the arrangement of exhibitions, publicity and fund-raising. Variety was ensured by showing sub-groups and by the turn-over in membership. He believed that the Group recognised that there was a danger of ready patronage from Welsh institutions giving it a status which contradicted its original ethos. The Group had received little acknowledgement from London and had, as a consequence, turned its back on the capital. 'It is debateable,' he felt, 'whether this is a strength or a weakness, but it is, ironically, in retrospect where the Group becomes its most Welsh.'[8]

That year the artist Kyffin Williams lashed out at the Group. 'His prime antipathy,' *Avant-Garde* reported, 'is for the '56 Group of predominantly abstract painters or English carpetbaggers as he describes them, who came down to Wales because they could not make it in the metropolis. The 56 Group has taken over Welsh art, Williams complains, and he is out of favour in his homeland as a result... perhaps, he speculates, it is sheer resentment for the fact that he actually sells canvases and makes money.'[9] Wilkins, also interviewed for the article, observed that: 'Sometimes Kyffin Williams gives the impression that he is Welsh painting. But he's not, you know... We acknowledged that there were international trends and saw no reason why

112 Poster for 25th Anniversary Exhibition designed by Geoffrey Davies. He and Shurrock designed the catalogue, in similar style, which was funded by Texaco.

113 Arthur Giardelli *At the Sea's Edge*
1980, 91 x 58 cm, paper and brocade
This was exhibited in the 25th Anniversary Exhibition.

painting in Wales shouldn't move forward with them.' Despite the heartfelt bitterness, Williams may have touched a raw nerve with regard to sales as little was being sold at the time from Group exhibitions.[10]

At this time, too, changes occurred in Welsh Arts Council policy. Griffiths reported: 'There is to be a 3% cut and the Committee agrees that 'smaller artists' groups' will be affected... They hope to help as much as they can by lending their transport and by continuing to act as an advisory and service agency. Apart from Oriel they are not initiating any touring exhibitions... they hoped to replace purchasing for their collection by starting a scheme for payment by instalments...'[11] Huw David Jones reiterates this and explains that the Council 'decided to redirect funds towards developing a network of galleries across Wales that could coordinate their own exhibition programme.'[12] The Group continued to receive a grant from both the Council and HTV Wales in 1981-82.[13]

Heath and Woodley resigned as they had left Wales.[14]

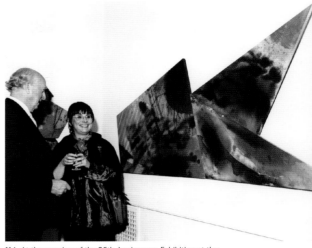

114 At the opening of the 25th Anniversary Exhibition at the National Museum of Wales, Lord Elwyn-Jones and Mary Lloyd Jones beside her cotton-dyed *Clouds over the Landscape*, 1981.

1 Breen, Pat, 'Exhibition a disappointment', *The South Wales Argus*, 13 March 1980
2 Stears, Derek, 'New Members', *The Guardian*, 29 April 1980
3 *The Western Mail*, 16 February 1981
4 *Grŵp 56 Cymru yn 1981 / 56 Group Wales in 1981*, National Museum of Wales, 1981
5 Annual Report, 1981-82, Di; Exhibition Price List, Mostyn Art Gallery, 1982, Sivc
6 AGM, 17 October 1981, Cii. Texaco sponsored the catalogue with £1,000
7 Annual Report, 1981-82, Di
8 Fraser Jenkins, A. D. (1981), p.6

9 'Painting: Kyffin Williams', *Avant Garde*, Spring / Summer 1981
10 AGM, 17 October 1981, Cii
11 Griffiths to Tinker and Giardelli, 16 October 1981, Fviiia
12 Jones, Huw David (2012), p.16
13 Financial Report, October 1981, Fviiia. WAC grant for 1981-82 was £1,000 and the HTV Wales grant was £300
14 Annual Report, 1981-82, Di

115 The 25th Anniversary Exhibition in the newly refurbished Oriel Mostyn, Llandudno, in 1982, including three abstracts by Heath *(Chittoe, No.2; Monkton No.2; Westwood)* and Dayborn's large painting, *The Woman's Role*, not shown in Aberystwyth, which was also discussed on HTV's *Where the Tide Turned* in 1983.

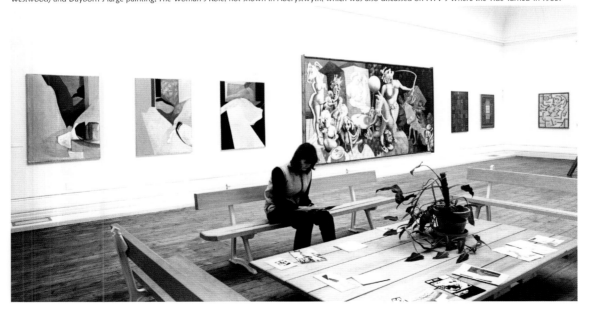

116 Derek Southall *Black Mountains*
1981, 183 x 245 cm, acrylic on canvas

117 Peter Ellis surrounded by his installation
Pokin' the Pud at Andrew Knight Gallery,
Cardiff, 1985.

118 Peter Prendergast in his studio, Deiniolen, north Wales, 1996

New Members, 1981 - 82

Derek Southall [born Coventry 1930; member 1981-83; died 2011] was a painter who studied at Coventry, Camberwell and Goldsmiths' College.[1] He worked in Berlin on a scholarship and was influenced by Martin Bloch and Karl Schmidt-Rottluff. After teaching and residencies, he moved to Bath and became the 1980-83 senior fellow in fine art at South Glamorgan Institute of Higher Education, Cardiff. From earlier abstract work he began, in 1977, to paint expressionist landscapes 'that throw a punch not only because of their tempestuous energy but because the big, dark, heavy images are like solid muscle.'[2] Acrylics of the Black Mountains grew from an early memory.[3] He later moved to Somerset.

Peter Ellis [born Prestbury, Cheshire, 1950; member 1982-91] is a kinetic sculptor, installation artist and printmaker who studied at polytechnics in Manchester and Wolverhampton and at Chelsea College of Art.[4] Appointed junior fellow in fine art at Cardiff in 1974, he later worked at Chapter and Llanover Hall arts centres and was a senior lecturer at South Glamorgan Institute of Higher Education, Cardiff, 1983-90. He held artist residencies in Stuttgart, Swansea and the Ukraine.[5] Exhibitions include Chapter Arts Centre in 1980 and Wigan Education Art Centre in 1984.[6] His work, from found materials, explored 'the humour of banality and the commonplace.'[7] 'Mechanical movement intrigues me,' he wrote; 'It is regular, sensual, hypnotic, ridiculous, ambiguous and inevitable.'[8] In 1990 he began to make bronzes of unusual subjects such as socks.[9] He was chair of the Association of Artists and Designers in Wales, 1981-82. In 1992 he was appointed a senior lecturer at Leeds Metropolitan University and is now involved with film, photography and embroidery.[10]

Peter Prendergast [born Abertridwr, Caerphilly 1946; member 1982-2007; died 2007] was a painter. Encouraged by Gomer Lewis to attend Cardiff College of Art, he later went to the Slade School of Fine Art, where he was taught by Frank Auerbach, then to the University of Reading.[11] Part-time, from 1970, he lectured at Liverpool, taught at a school in Bethesda, and, from 1980, at Coleg Menai, Bangor. Living near Bethesda from 1970 and, later, at Deiniolen near Llanberis, much of his expressionist work responded to the rugged landscape with areas of colour characteristically delineated in black. Exhibitions included a 1981 Welsh Arts Council tour as well as at Oriel Mostyn in 1982-83 and Oriel Ynys Môn in 2006.[12] He showed figure drawings in the 1980s and work from Ireland in 1988.[13] Prendergast was also a member of the Association of Artists and Designers in Wales, the Royal Cambrian Academy, Royal West of England Academy and Ysbryd / Spirit - Wales.

1 *Derek Southall: Paintings*, Nicola Jacobs Gallery, London, 1982
2 Thompson, David, in *Derek Southall: Landscape of Feeling: The Welsh Paintings 1980-83*, Oriel, Welsh Arts Council, 1983
3 *Grŵp 56 Cymru, 56 Group Wales: Peter Ellis, Peter Prendergast, Derek Southall*, University College Cardiff, 1982
4 As 3 above
5 Walker, Ian, in *Peter Ellis: Artist in Residence*, Glynn Vivian Art Gallery & Museum, 1982
6 *Shucks: An Exhibition of Kinetic Constructions, Drawings and Prints by Peter Ellis*, Drumcroon, Wigan, 1984
7 *56 Group Wales*, Pembroke Dock Library, 1988

8 *56 Group Wales: 30th Anniversary Exhibition*, Worcester, 1987.
9 *56 Group Wales: Glasgow / Derby*, 1990; *56 Group Wales*, Glynn Vivian Art Gallery, 1990
10 Email from Ellis, 20 April 2012.
11 Taylor, John Russell, et al (2006) *The Painter's Quarry: The Art of Peter Prendergast*, Seren; Obituaries, 2007, by Curtis, Tony, *The Independent*, 17 January; *The Telegraph*, 20 January; Stephens, Meic, *The Guardian*, 22 January; *The Times*, 28 February; Prendergast, Peter, in Curtis, Tony (1997) *Welsh Painters Talking*, pp.104-16
12 Peter Prendergast in *The Dark Hills, The Heavy Clouds*, Welsh Arts Council, 1981; *The Road to Bethesda: Paintings and Drawings*, 1960-82, 1982, Oriel Mostyn
13 *30th Anniversary Exhibition*, Worcester, 1987; *56 in 88*, Oriel Mostyn, 1988

Where the Tide Turned, 1982 - 83

In spring 1982 the Ellis, Prendergast and Southall show was described by Derek Stears in the *The Western Mail* as 'well-balanced and stimulating.'[1] That summer the Group took part in *Artists Inc.*, an exhibition of work 'from the four corners of Britain' at St Paul's Gallery in Leeds. They joined representatives from the Dundee Group, Exeter's artist-run gallery Spacex and Northern Ireland's Art and Research Exchange. There was a symposium about communal studios and artists' groups.[2] Consolidating links with Scottish counterparts, it showed again with the Glasgow Group, this time at Edinburgh's new City Art Centre with John Griffiths as a guest. 'The wide range of attitudes represented in this exhibition,' Wilkins wrote, 'is evidence of the members' concern that younger artists of ability get elected, regardless of their stylistic character.'[3] Giardelli attended the crowded launch. *The Scotsman*, perhaps with a little bias, felt that it was 'an international match in which it must be said that the Welsh look outnumbered and out-gunned.'[4] That October the Group showed at Cardiff's John Owen Gallery, described damningly by Stears as 'a visually feeble exhibition.'[5]

In early 1983, with Group support, four members - Anthony Davies, Geoffrey Davies, Erica Daborn and Ian Grainger - showed at University College Swansea and at Howard Gardens Gallery, South Glamorgan Institute of Higher Education, Cardiff. Derrick Turner, the vice-principal, spoke to 'a considerable and lively crowd.'[6] Noel Upfold also noted the good effect of recruiting younger members.[7]

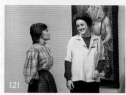

Wilkins's negotiations with HTV Wales led to an hour long televison programme in 1983. Entitled *Where the Tide Turned: A Portrait of the 56 Group Wales*, it was presented by Elinor Jones and John Edmunds.[8] Giardelli talked about the Group, introduced members and firmly rebuked the suggestion that it was sometimes referred to as 'Dad's Army'. Four other members, who had been selected by ballot, were interviewed. Reactions to their artwork were recorded at St David's Hall from those attending a concert and a wrestling match.[9] 'I've had a lot of good words from people,' wrote Tinker, 'who have gone out of their way to say how it gives them an insight into what's happening in the art world in Wales.'[10]

The Welsh Arts Council continued to support the Group as did HTV Wales, the British Council and Texaco.[11] Despite a general grant cut, the Council managed to allocate an additional sum to the Group in 1982.[12] It did not take support for granted and Giardelli believed that 'our plans are part of what persuades the Welsh Arts Council to give us money.'[13] Council representatives, journalists and members were invited that July to a social event at Wilkins's Carmarthenshire home.[14]

Although the Welsh Group, another association of artists, exhibited at the National Museum of Wales in 1983. It was, Wakelin records, experiencing difficulties. The Welsh Arts Council was no longer willing to collaborate with it for the open exhibitions. Recent members' exhibitions, too, had been disappointing. Tinker was elected chair of this group, a position he held until 1998. Galleries had become less inclined to show mixed exhibitions, preferring individual artists.[15]

Stills from *Where the Tide Turned*, HTV Wales, 1983.

119 The title showing the studio setting for the programme.

Artists with presenters, Elinor Jones and John Edmunds:

120 Arthur Giardelli
121 Erica Daborn, right
122 Glyn Jones, left
123 David Tinker, left
124 William Wilkins, left

1 Stears, Derek, 'A well-balanced initiation rite', *The Western Mail*, 24 April 1982
2 Annual Report, 1981-82, Di
3 Wilkins, William, in *Glasgow Group / 56 Group Wales*, City Art Centre, Edinburgh, 1982
4 Gago, Edward, *The Scotsman*, 28 June 1982
5 Stears, Derek, 'Little to vitalise art', *The Western Mail*, 11 October 1982
6 Annual Report, 1982-83, Di

7 Upfold, Noel, *Drawn Together: New Work by Four Artists with the 56 Group Wales*, Howard Gardens Gallery, 1983
8 HTV Programme Review, HTV, 1983
9 Annual Report, 1982-83, Di
10 Tinker to Griffiths, 8 May 1983, Fvi-j
11 AGM, 1982, Cii; Annual Report, 1982-83, Di. WAC granted £2,500.
12 Griffiths to Giardelli, Tinker & Wilkins, 23 February 1982, Fvi-i
13 Giardelli to Griffiths, 16 November 1982, Fvi-i
14 Draft invitation to Wilkins's home on 18 July 1982, Fvi-i
15 Wakelin, Peter (1999), p.51 & p. 98

Galleria d'Arte Moderna, Bologna, 1983

In Autumn 1983 the Group held an extensive exhibition at the Galleria d'Arte Moderna in the Italian university city of Bologna.

In 1981 Griffiths wrote to Henry Meyric Hughes, now regional director of the British Council in Milan, explaining how much the Group would like to exhibit in Italy.[1] 'Commercial galleries are very unlikely to take the risk,' he explained, 'and your best chance is clearly with one of the municipalities, many of whom, incidentally, have considerable funds at their disposal for cultural exchanges, if only you are in a position to reciprocate!'[2]

Meyric Hughes mentioned an exhibition of graphics by artists from Bologna organised by Galleria d'Arte Moderna. He asked the director, Franco Solmi, to send Griffiths details. 'Bologna, for their part,' he reported, 'would be glad to hear more about the kind of exhibition that you would like to tour to Italy…'[3] Solmi proposed exchanging exhibitions.[4] This arrangement was consolidated by Giardelli's 1982 visit to meet the director.[5]

The British Council's representative in Cardiff, Hugh Salmon, was involved with such practical matters as publicity.[6] The Welsh Arts Council advised about transport, insurance and the catalogue.[7] Texaco and HTV Wales provided sponsorship.[8]

Seventeen members exhibited eighty paintings, graphics and sculptures. The catalogue, in Italian and English with some Welsh, included contributions from Solmi, Giardelli, David Fraser Jenkins and James Holloway, assistant keeper at the National Museum of Wales. The Giardellis, the Griffithses, Punt and Tinker attended the opening.[9]

Around five thousand people visited the exhibition over a month and Giardelli was interviewed on Italian television.[10] An article headed 'Welsh Art Out to Conquer Our Museums' appeared in *L'Unita*, concluding that 'the exhibition is important because it is the first of its kind in Italy and because it gives testimony of the common

125 Banner promoting the Group's exhibition in the Piazza Maggiore, Bologna.

exhibiting artists:

Erica Daborn
Anthony Davies
Geoffrey Davies
Peter Ellis
Arthur Giardelli
Tom Gilhespy
Ian Grainger
Harvey Hood
Robert Hunter
Glyn Jones
Mary Lloyd Jones
Michael Punt
Christopher Shurrock
Derek Southall
Anthony Stevens
David Tinker
William Wilkins

126 At the launch in Bologna showing: Stevens's fired clay figure *Eartham*, Hood's wood sculpture *Circumscribe* and Southall's painting *Red Hill, Wessex*, left. Tinker and Bruce Griffiths (with spectacles) are standing at the centre. Marilena Pasquali, assistant director of the gallery, stands centre right, facing.

undertaking, between Italy and Wales, to strengthen the possibilities of cultural exchange.'[11]

In a letter to Peter Jones, art director at the Welsh Arts Council, Giardelli reflected that Solmi and assistant director Marilena Pasquali, 'both said it was a very good exhibition and spoke penetratingly and clearly of the individual artists. Their views were those of experienced professionals helping me to see the Group from quite another angle. This is why we must travel... What the Group will do as a result of this experience, I cannot say: but it gives food for thought and renewal.'[12]

Griffiths referred to difficulties she had experienced in a report to the British Council. The gallery had been a little slow answering letters and Meyric Hughes 'came to the rescue several times.' Quite a few works sustained damage in transit. There had been delays in artists deciding which work to submit. It had also been frustrating not being able to sell work, which seems to have been due to Italian custom regulations. 'In the circumstances', she pointed out, 'it must be recognised that the contribution of the artists was generous.'[13]

The return exhibition of Bolognese etchings from the Galleria d'Arte Moderna included work by Giorgio Morandi and visited four venues in Wales.[14]

127 Galleria d'Arte Moderna, Bologna

1 Griffiths to Meyric Hughes, Henry, 12 June 1981, Sxiia
2 Meyric Hughes, Henry, to Griffiths, 20 July 1981, Sxiia
3 Meyric Hughes, Henry, to Griffiths, 27 November, 1981, Sxiia
4 Meyric Hughes, Henry, to Griffiths, 29 January 1982, Sxiia
5 Solmi, Franco, to Griffiths, 9 April 1982, Sxiia
6 Salmon, Hugh, to Griffiths, 17 June - 6 December 1983, Sxiia
7 Correspondence with Welsh Arts Council, 4 February 1982
to 30 October 1983, Sxiib
8 Translation of a notice issued in Italian from the British Council by
Sandra Soster in advance of the opening on 17 September 1983, Sxiia
9 Griffiths to Solmi, Franco, 15 August, 1983, Sxiia
10 Pasquali, Marilena to Griffiths, 22 October 1983, Sxiia
11 '56 Group Wales Exhibition at Bologna', Griffiths to Wilson, Muriel,
British Council, 16 November 1983, Sxiia; Translation of 'L'arte gallese alla
conquista dei nostri musei', L'Unita, 21 September 1983, Sxiid
12 Giardelli to Jones, Peter, 25 September 1983 (typed version), Sxiif
13 Griffiths to Wilson, Muriel, British Council, 16 November 1983, & Wilson,
Muriel to Griffiths, 26 January 1983, Sxiia
14 Solmi, Franco, La Scuola Bolognese Dell'Acquaforte, Galleria d'Arte Moderna Bologna, 1984. The exhibition was toured by the Welsh Arts Council,
1984-85, starting at the National Museum of Wales, Cardiff, and visiting
Brecknock Museum in Brecon, Carmarthen Musem and Llanelli Library, Sxiif

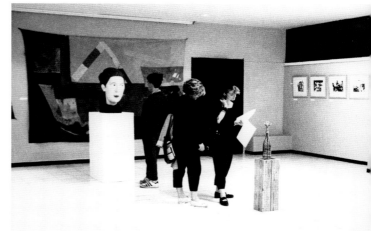

128 Mary Lloyd Jones Banner 1982, 213 x 366 cm, dyes on cotton

129 Visitors to the Bologna exhibition viewing Tinker's polychrome terracotta head Virginia Southcott and Ellis's kinetic sculpture La Belle de Jour. Mary Lloyd Jones's Banner is hanging on the wall.

Secret Ballot and Recruitment, 1984

The thorny matter of maintaining quality surfaced with a proposal that, every three years, there should be a secret ballot to decide who would remain in the Group. Accepted with one abstention, anyone not attracting 51% of votes in a secret ballot was to be asked to resign.[1] Draft papers were discussed in January 1984 when Hunter announced 'that he had always been against secret ballots and, though he accepted the decision of the Group as democratic, he would be resigning.'[2] Prendergast felt 'I don't think I will want to go through the ordeal of re-election after three years.'[3] Ballot papers were returned for the 1984 annual general meeting. 'It looks like an interesting meeting,' Stevens reflected, 'with shades of the 'Will Roberts' long knives days…'[4] Sixteen were entitled to vote, and three did not, but no-one was voted out.[5] At the same meeting, life and honorary memberships were amalgamated and Hunter, proposed by Prendergast, as well as Bruce Griffiths, were elected.[6] Stevens would shortly join them.

Alain Ayers [born Dartford, Kent, 1952; member 1984-86] is a stone sculptor who worked in Ontario before studying at Hereford, Exeter and Birmingham. He became junior fellow in fine art at South Glamorgan Institute of Higher Education, Cardiff, 1982-83.[7] After a European teaching fellowship he was appointed part-time lecturer at West Glamorgan Institute of Higher Education, Swansea, 1985-87. He showed with Hood and Nicol and exhibited calcite boulders at University College Cardiff and bronzes in Czechoslovakia.[8] He resigned because the Group 'cannot offer the kind of exhibitions that fully interest me.'[9] Commissioned to make a limestone sculpture *Taliesin* in Llandrindod Wells, he was included in *Stoneworks* at Powis Castle in 1988.[10] He also belonged to the Association of Artists and Designers in Wales. Now living in Norway, he works with digital film media.

Philip Nicol [born Caerphilly 1953; member 1984-91] is a painter who attended Cardiff College of Art and became a lecturer at South Glamorgan Institute of Higher Education, Cardiff, in 1982 and at Limerick College of Art, 1983-84.[11] He participated in many Group shows. Included in the 1984 touring *British Art Show*, he also held exhibitions in Cardiff, at Andrew Knight Gallery, Oriel and Chapter Arts Centre, and in Swansea at the Glynn Vivian Art Gallery. He chaired the Association of Artists and Designers in Wales in 1988. His paintings depict a cinematic inner-city twilight landscape with a sense of isolation of both objects and figures. Carol-Anne Davies believes that 'whilst these spaces are 'real' locations, they are more important for their metaphysical qualities..'[12] They are paintings about the psychological effects of urban life.[13] Since leaving the Group, he has been development officer for the Butetown Artists' studio and gallery complex. He won the University of Glamorgan Purchase Prize in 1998 and the Gold Medal for Fine Art at the National Eisteddfod of Wales in 2001. More recently he has been a lecturer in fine art in Cardiff and is exhibition director at Bay Art.

130 Alain Ayers *The Nest* 1984
60 x 45 x 45 cm, Bathstone, painted

131 Philip Nicol *One Two*
1985, 260 x 230 cm, acrylic on canvas

1 AGM, 29 October 1983, Cii
2 Minutes of meeting, 7 January 1984, Biii
3 Prendergast to Griffiths, 9 January 1984, Gvh;
4 Stevens to Griffiths, 22 October 1984,Gvh
5 Membership Ballot, 24 October 1984, Cii
6 AGM, 27 October 1984, Cii
7 Alain Ayers, CV, 2012
8 *Ayers, Hood & Nicol*, Vale of Glamorgan Festival Exhibition, 1984; *56 Group Wales: Eight New Members*, University College Cardiff, 1986; *Výstava Skupiny 56 Wales*, 1986, p.8
9 Ayres to Griffiths, 7 October 1986, Gv-i
10 *Stoneworks*, Oriel 31 / The Welsh Sculpture Trust, 1988
11 *Paintings: Philip Nicol*, UWIC, 2005
12 Davies, Carol-Anne in *Prospect: Philip Nicol*, Cardiff Bay Arts Trust, 2000, p.2
13 Clarkson, Jonathan in *Paintings: Philip Nicol*, Newport Museum & Art Gallery/Oriel Mwldan, Cardigan, pub.UWIC, 2005, p.6

A Birthday Celebration and other Exhibitions, 1984 - 86

Nicol and Ayres joined in time for *A Birthday Celebration*, marking the tenth anniversary of Oriel, Cardiff, in spring 1984. Earlier in the year the Group had shown in Haverfordwest Library. For the Oriel show, the Welsh Arts Council's art officer at the gallery, Isabel Hitchman, visited members to discuss their work. The exhibition was opened by Idwal Symonds, chair of HTV's Welsh board, in an atmosphere of celebration.[1]

During its first decade Oriel received three hundred thousand visitors, held a hundred and thirty-nine exhibitions and showed around eight hundred artists and craftspeople. Publicly-subsidised galleries such as Chapter, Wrexham and Aberystwyth arts centres and Mostyn had developed. More artists from Welsh art colleges were staying in Wales and graduates from elsewhere were taking up research fellowships and studios.[2]

The Group felt that there should be more visual art at Welsh festivals. In August 1984 Ayres, Hood and Nicol exhibited at the Vale of Glamorgan Festival, St Donat's Castle.[3] In the catalogue Wilkins reflected that: 'Membership fluctuates around 20 which enables it to fill large galleries easily but also allows the creation of small exhibitions without too great a fragmentation of the Group's identity.'[4]

The Welsh Arts Council register of artists was consulted for possible future members.[5] Mary Lloyd Jones made a plea in early 1985 'to see a better balance between male and female members of the Group.'[6] Maggie James was elected soon afterwards, only the third woman member, along with John Mitchell, Michael Williams, Paul Davies and Emrys Williams, the latter two boosting membership from the north of Wales.[7]

In autumn 1985, with HTV Wales support, the Group held its third joint exhibition with the Glasgow Group. *Life & Landscape from Scotland & Wales* was shown in Newport.[8] 'The Welsh work on display,' opined *The South Wales Argus*, counterbalancing 1982 remarks in *The Scotsman*, 'is predominantly more contemporary, both in its attitude, preoccupations and stylistically.'[9] Ivor Davies reflected that: 'Neither is the sort of group to have a manifesto because the approach of each member is distinct and individual...'[10]

Following Kieran Lyons's recruitment in 1986, an exhibition of *Eight New Members* was shown at University College Cardiff. Wilkins indicated: 'We usually make it the occasion on which to give our newly elected members the chance to exhibit.'[11] That summer the Group showed, again with HTV support, at Fishguard Music Festival.[12]

The Welsh Arts Council requested a spending plan for 1984-90.[13] This coincided with Ellis becoming the Group's only sponsorship officer in 1985.[14] Michael Williams took over from Wilkins as press officer in 1986.[15]

1 Annual Report 1983-84, Di
2 Hitchman, Isabel, *A Birthday Celebration*, Oriel, 1984
3 Annual Report 1983-84, Di
4 Wilkins, William, in *56 Group Wales: Alain Ayers, Harvey Hood, Philip Nicol*, Vale of Glamorgan Festival, 1984
5 Griffths to Giardelli, 7 September 1984, Fvik
6 Jones, Mary Lloyd, to Griffiths, 7 January 1985, Gvh
7 Meeting, 12 January 1985, Biii
8 Annual Reports, 1984-87, Di
9 Thurston, Gerry, 'Wales has the edge', *South Wales Argus*, 12 September 1985
10 Davies, Ivor, 'Introduction', *Life and Landscape from Scotland and Wales*, Newport Museum and Art Gallery, 1985
11 Wilkins, William, 'Introduction', *Eight New Members*: Grŵp 56 Cymru/56 Group Wales, University College Cardiff, 1986
12 Kemp, Mary, '56 Group presents a Panorama of art', *The County Echo*, 22 July 1986
13 Griffiths to Jones, Glyn, 7 February 1984, Gvh; WAC grant for 1985-86 was £2,000.
14 AGM, 26 October 1985, Cii
15 AGM, 25 October 1986, Cii

exhibiting artists
Oriel:
Alain Ayers
Erica Daborn
Anthony Davies
Geoffrey Davies
Peter Ellis
Arthur Giardelli
Tom Gilhespy
Ian Grainger
Harvey Hood
Robert Hunter
Glyn Jones
Mary Lloyd Jones
Philip Nicol
Peter Prendergast
Michael Punt
Christopher Shurrock
Anthony Stevens
David Tinker
William Wilkins

132 Invitation to the opening of Oriel's 10th Birthday Exhibition.

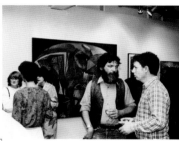

133 Hood, right, talking to Grainger at Oriel's tenth birthday opening party. On the wall behind is Geoffrey Davies's oil and sand on canvas *Wrecked Caravan*, 1984.

134 Report on Oriel's tenth anniversary in *The Cardiff Journal*, 3rd May 1984

THIS driftwood creation of The Last Supper is among works at a 10th-birthday exhibition at the Oriel Gallery in Charles Street, Cardiff. Art Officer Isabel Hitchman, is pictured with the work, which is by Penarth artist Erica Daborn.

Supper at the gallery

135 Maggie James *Kirsten's Ladder*
1986, 56 x 56 cm, gouache on paper

136 Paul Davies working on *Mud Map of Wales*, National Eisteddfod of Wales, Fishguard, 1986.

137 *Mud Map of Wales*, as above

Members North and South, 1985

Geoffrey Davies resigned in 1985 as his work was changing direction. Mary Lloyd Jones left the following year due to exhibiting and employment commitments, as well as concern about mixed exhibitions. She felt, however, that 'to be accepted by the Group was an important step in my development.'[1]

Maggie James [born Cardiff 1956; member 1985-91] is a painter who attended Newcastle Polytechnic and the Royal College of Art. In 1985 she taught part-time in the Fine Art School at Cardiff and later became a tutor at Cardiff Prison. She worked, from 1988, at Llanover Hall Arts Centre and Cardiff's Open College of the Arts. Exhibiting often, she revealed a fascination with, successively: closed urban landscapes; atmospheres of the night; and 'everything that exists in front of my eyes,' that, 'has an urgency, a necessity that I want to try and fix on paper.'[2] In 1990 she was interested 'in the potential of one domestic space in terms of its drama, physical and metaphysical.'[3] She has exhibited at 39 Steps Gallery in London, Andrew Knight Gallery in Cardiff and Oriel y Bont at the University of Glamorgan. She became education facilitator at Bay Art in 2004.

Paul Davies [born Mumbles, Swansea, 1947; member 1985-93; died 1993] was a painter, sculptor, land and performance artist who went to St Martin's School of Art (during which he attended the 1966 *Destruction in Art Symposium*), studied sociology at Essex and design at Liverpool.[4] He lectured at Cheshire School of Art in 1974 and Coleg Gwynedd, Bangor, 1980-93. With his brother Peter he established Beca, a political movement in Welsh art.[5] From 1984 it organised exhibitions about the state of Wales and Welsh identity. The name derives from the nineteenth-century Rebecca rising against tollgates and injustice.[6] Prendergast nominated him to the Group 'because I thought he would be a conscience for us, a personality that would woo us out of complacency, someone to remind us of the indigenous culture of Wales, someone striving to make images that were Welsh...'[7] Artist-in-residence with Merthyr Tydfil Groundwork Trust, he received commissions from the Welsh Water Authority and Ebbw Vale Garden Festival. Following his early death, tributes were shown at Gwynedd Museum and Wrexham Arts Centre.[8] He also belonged to the Welsh Group, the Association of Artists and Designers in Wales and Gweled.

John Mitchell [born Walton-on-Thames, Surrey, 1942; member 1985-88] is a painter and sculptor who studied at Kingston College of Art.[9] After lecturing, he became a Gregory Fellow at Leeds and then MA director at Birmingham Polytechnic. He was a senior fellow in fine art at Cardiff, 1983-86, and part-time lecturer, 1986-87. He held exhibitions at Camden Arts Centre, the Serpentine Gallery, Leeds University and Galerie Swart in Amsterdam, and, whilst in Cardiff, at Birmingham's Ikon Gallery. He exhibited five times with the Group including Czechoslovakia. He is concerned with 'the use and application of arithmetic systems, in particular the Fibonacci sequence.'[10] In the early 1980s he began to make three-dimensional systems-based truncated cone forms.[11] He became a principal lecturer at Wimbledon, 1987-2003, later moving to Newlyn.

1 AGM, 26 October 1985, Cii; Jones to Griffiths, 20 October 1986, Gv-i
2 *Life and Landscape: Scotland & Wales*, Newport Museum & Art Gallery, 1985; *Eight New Members*, University College Cardiff, 1986; *30th Anniversary Exhibition*, Worcester, 1987
3 *56 Group Wales*, Chepstow, 1990
4 *A Mare in a Grey Sheet / Caseg Mewn Cynfas Lwyd: Paul Davies, 1947-1993*, Wrexham Arts Centre, 1998; Hourahane, Shelagh, 'A Continuing Presence: a Profile of Paul Davies (1947-93)', *Planet* 130, August/September 1998, pp.36-45
5 Hourahane, Shelagh, 'Maps, Myths and the Politics of Art' in Bala, Iwan (1999), p.69
6 Bala, Iwan (1999), p.20
7 Prendergast, Peter (1993) 'Tribute to Paul Davies', *56 Group Wales: Works on Paper*, 1993
8 *Paul Davies: Dylanwad Parhaus / A Continuing Presence*, Oriel Bangor, 1994
9 *John Mitchell: Cones, Pyramids, Piers & 'Projections' - Objects Without Subjects*, Ikon Gallery, 1987
10 *Life & Landscape in Scotland & Wales*, Newport Museum & Art Gallery, 1985
11 Briers, David, in *Barrie Cook, John Mitchell*, Howard Gardens Gallery, 2006

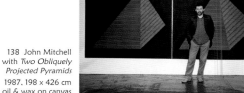

138 John Mitchell with *Two Obliquely Projected Pyramids* 1987, 198 x 426 cm oil & wax on canvas

Kieran Lyons [born Guildford 1946; member 1985-2000] is a painter, installation and lens-based artist. He studied sculpture at Bath and Yale University School of Art and Architecture and took a doctorate at University of Wales Newport with Punt.[1] On a University of Auckland fellowship he made installations with a fictional company called E-Z-GRO. On returning to London in 1977, he joined a video/performance collective at 2B Butler's Wharf. Appointed a senior lecturer at Gwent College of Higher Education, Newport, in 1981, he became full-time in 1989 and programme leader in fine art in 2002. When he first joined the Group he showed wall-hanging works, the starting point for which was a child's toy cannon, an image transformed by drawing and chance photographic processes.[2] His research and artwork, in part, reflects a visual fascination with military themes.[3] A drawing of a seventeenth-century gun, for example, is depicted as though it had been manufactured recently. He has drawn historical inspiration, too, from living in Chepstow. By 1996 working with digital multimedia was changing his approach to art practice and his interactive installations and digitally projected works have, subsequently, been widely exhibited.[4]

139 Kieran Lyons
The death and final entombing of poor Harry Marten, Chepstow 1680
1987, 45 x 25 cm, ink on rag paper

Emrys Williams [born Liverpool 1958; 1985-91 & from 2004] is a painter brought up on the north Wales coast who studied at the Slade School of Fine Art and became, in 1990, a lecturer at Coleg Menai, Bangor. In 2006 he wrote: '…seaside spaces have formed the basis of investigations into ideas to do with memory, imagination and the way one might reconstruct our experience through remembered fragments… There is a deliberate tension in the work between depicted

140 Emrys Williams *Windy Day II* 1988, 24 x 70 cm, oil on canvas

imagery and abstract concerns of scale, material and the nature of the painting as a physical object.'[5] He also draws inspiration from modern literature.[6] In his earlier more expressively-handled work he used thicker oil on canvas. This gave way to bright, yet thinner, acrylic on panel or paper.[7] A member of the Royal Cambrian Academy and a former artist-in-residence with Welsh National Opera, he won the University of Glamorgan Purchase Prize in 2006, the Gold Medal for Fine Art at the 2007 National Eisteddfod and was 2007 Welsh Artist of the Year.

Michael Williams [born 1936 Patna, India; member 1985-96] read history at Oxford and studied art history and painting in Paris. After lecturing in art history at St Martin's School of Art and becoming head of department, he moved to Goldsmiths' College to teach painting until 1981.[8] He then lectured part-time in England and Ireland. Having moved to Presteigne, belonging to the Group brought him into contact with other artists in Wales.[9] His earlier work had pop art inclinations but he abandoned this for intensive attention to detail.[10] Landscape and still-lifes began with drawings and were developed in his studio. 'I like watercolour,' he wrote, 'for its precision, liquidity and transparency.'[11] He also paints in oil.[12] In 1986 he received a Welsh Arts Council grant and Greek Government scholarship to paint in Greece and has also travelled in Eastern Europe and Turkey. In the early 1980s he edited *Link*, the newsletter of the Association of Artists and Designers in Wales. In 1993 he was the buyer for the Contemporary Art Society for Wales. He has exhibited with Austin Desmond in London and, in 1996, moved to Stroud.

141 Michael Williams *City Moves* 1995, 71 x 127 cm, watercolour

1 Kieran Lyons, CV, 2012
2 *Eight New Members*, University College Cardiff, 1986
3 See, for example: Lyons, Kieran, 'Military Avoidance: Marcel Duchamp and the 'Jura-Paris Road,' *Tate Papers* 5, 2006
4 *56 in 96*, Turner House, Penarth,1996
5 Williams, Emrys, in Jones, Glyn, ed. (2006)
6 Moorhouse, Paul, in *A Kind of Fiction: The Art of Emrys Williams*, Oriel, Welsh Arts Council, 1992
7 *Emrys Wilams: Sunny Spells*, Oriel Mostyn / The Berwick Gymnasium, Norhumberland, 1995, p.16
8 *New Paintings by Michael Williams*, Silk Top Hat Gallery, Ludlow, 2006; *Michael Williams: Watercolours and Drawings*, Silk Top Hat Gallery, Ludlow, 2010
9 Conversation with Michael Williams, 19 May 2012
10 *56 Group Wales*, Royal West of England Academy, 1993
11 *Eight New Members*, University College Cardiff, 1986.
12 *Michael Williams: Recent Landscapes in Oil*, Austin Desmond Fine Art, 1991

142 Catalogue for the Czechoslovak tour, 1986-87

exhibiting artists:

Alain Ayers
Erica Daborn
Anthony Davies
Paul Davies
Peter Ellis
Arthur Giardelli
Tom Gilhespy
Ian Grainger
Harvey Hood
Maggie James
Glyn Jones
Mary Lloyd Jones
John Mitchell
Philip Nicol
Peter Prendergast
Michael Punt
Christopher Shurrock
David Tinker
William Wilkins
Emrys Williams
Michael Williams

143 Part of the Group's exhibition at Mirbachov Palace, Bratislava, showing sculpture by Punt and paintings by Gilhespy, Emrys Williams and Prendergast.

Czechoslovak Tour, 1986 - 87

One of the Group's most remarkable achievements was to tour an exhibition of forty-nine sculptures, paintings, relief constructions and graphic works around Czechoslovakia between September 1986 and January 1987.[1] Earlier attempts to exhibit in the German Democratic Republic and Poland had highlighted the diplomatic challenges of showing in Eastern Europe. With the Velvet Revolution three years away and Warsaw Pact troops in control, this country proved to be more fertile ground for cultural exchange, but not without considerable preparation.

Fruitful connections began to be made five years earlier. Zdeněk Vaníček, the first secretary at the Czechoslovak Embassy in London, was invited to Cardiff in 1981 by Bruce Griffiths of the Contemporary Art Society for Wales during negotiations to show a major exhibition of Czechoslovak art at the National Museum of Wales. Vaníček returned, getting to know the Griffithses better as well as the Giardellis, Betty and David Evans and others. He arranged for them to visit Prague in 1982 to meet officials and artists and to put forward an exhibition proposal.[2]

A delegation from the Contemporary Art Society for Wales also played a diplomatic role in negotiations by visiting Czechoslovakia in 1985.[3] They were entertained at the British Embassy.[4] Giardelli, Mary and Bruce Griffiths and Bill Cleaver, secretary to the Society, had a meeting with Josef Švagera, deputy minister of culture in Prague.[5] An exhibition by the Group was welcomed and, undoubtedly, a strong bargaining point had been that two Czechoslovak exhibitions had recently been shown at the National Museum of Wales.[6] The delegates were also welcomed by the Czechoslovak Society for International Relations and both Bruce Griffiths and Giardelli were awarded its silver medals.[7] The representatives then had a meeting at the Ministry of Culture of the Slovak Socialist Republic in Bratislava.[8] Bruce Griffiths broke the ice by indicating that: 'If you don't call us English we won't call you Czech.'

The British Council provided funding towards costs.[9] The exhibition also received financial assistance from the British Embassy in Prague.[10] The Welsh Arts Council carried the exhibition and made practical arrangements.[11]

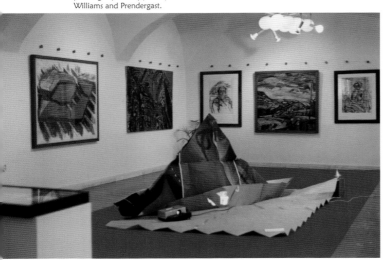

1 Annual Report, 1985-86, Di
2 Email from Vaníček, Zdeněk, 7 April 2012; David Evans indicates that the visit to Prague was linked to him attending a medical conference (conversation, 28 July 2012)
3 '56 Group Wales Exhibition in Czechoslovakia 1986', report by Griffiths, Tvid; Giardelli describes negotiations and the tour in Giardelli, A.,& Shiel, D. (2001), pp.110-11
4 Green, J. F., to Griffiths, 6 September 1985 and Griffiths to Green, 20 September 1985, Tvia
5 Notes of meeting with Dr. Švagera, deputy minister of culture in Prague, 9 September 1985, Tvia
6 Czechoslovak Sculpture 1867-1937, 1983, and Painting, Drawing and Sculpture by Ota Janeček, 1984; Griffiths to Green, British Embassy, Prague, 18 March 1985, Tvia; 'Welsh Group to Exhibit in Czechoslovakia', Group press release, 1986, Tvid
7 Programme for delegation of Contemporary Art Society for Wales to Czechoslovakia, 1985, Tvia
8 Notes of meeting at Ministry of Culture, Slovak Socialist Republic, 12 September 1985, Tvid
9 Correspondence with British Council, Cardiff, 1984-86; also letters to Griffiths from O'Sullivan, Michael, British Council, London, 15 July 1986, & from Hughes, Henry Meyric, British Council, London, 26 August 1986, Tvid
10 Green to Griffiths, 27 March 1985; Griffiths to Green, 21 Jan. 1986, Tvia
11 Correspondence in Tvic; '56 Group Wales Exhibition in Czechoslovakia 1986', report by Griffiths, Tvid

Silvia Ilečková of the Slovak National Gallery visited Wales in May 1986 to discuss arrangements, select work and explore the possibility of a reciprocal exhibition of twentieth-century Slovak painting.[12] Isabel Hitchman, now senior art officer with the Welsh Arts Council, made arrangements for her to visit the Group's artists and accompanied her.[13]

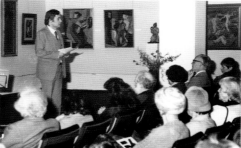

The tour opened in three rooms of the eighteenth-century Mirbachov Palace, Bratislava, in September 1986 with a catalogue prepared and printed in the city.[14] Six delegates from Wales - including Giardelli, the Griffithses and Gilhespy - were looked after well, introduced to artists and taken on trips.

The exhibition toured to Dům Umění, Brno, in November, then Galerie Umění, Karlovy Vary, in December and to Eastern Slovakia Gallery, Košice, in January 1987.[15] It was well received and around a hundred people attended the launch in Brno. Representatives, including Giardelli and Tinker, attended the December opening in Karlovy Vary.[16] Stephen Barrett, the ambassador for Britain, and distinguished artists came over from Prague.[17] Delegates visited artists Ota Janeček and Jan Bauch, the latter who would later hold exhibitions in Llandudno and Oxford.

During the tour the Group was presented with the silver medal of the Czechoslovak Society for International Relations 'for promoting friendship and co-operation with the Czechoslovak Socialist Republic'.[18] The deputy minister for culture formally thanked the Group and invited it to exhibit in Prague and elsewhere in Bohemia in 1990-92.[19]

The icing on the cake was the purchase by the Slovak National Gallery of twelve works from the exhibition.[20] These were a construction by Giardelli, three prints by Anthony Davies, a charcoal drawing by Prendergast, a watercolour by Glyn Jones, an acrylic by Nicol, three bronze sculptures by Ayres and two mixed media works by Shurrock.[21] Vaníček in 1986 was made an honorary member of the Group.[22]

Galerie Umění, Karlovy Vary:
144 General view of Group's exhibition.
145 Zdeněk Vaníček giving the opening speech in another part of the gallery.
146 Stephen Barrett, left, talks to Tinker beside his 1985 laminated wood sculpture *Maritime Gothic*.

12 Green to Griffiths, 18 February 1986; Meyric Hughes, Henry, Visiting Arts, to Griffiths, 21 February 1986, Tvia
13 Hitchman, Isabel, to Griffiths, 28 April 1986, Tvic; Annual Report, 1985-86, Di
14 Email from Vaníček, Zdeněk, 31 July 2012. The catalogue, of which 1,200 copies were printed, included contributions from Giardelli and Vaníček.
15 Griffiths to Green, 25 January 1986, Tvia; Transcript of address by Zdeněk Vaníček at private view in Karlovy Vary, 4 December 1986, Tvib; '56 Group Wales Exhibition in Czechoslovakia', report by Griffiths, Tvid
16 Griffiths to Potts, J. R., British Embassy, Prague, 28 November 1986, Tvia
17 'Report of the delegation to the opening of the 56 Group Wales exhibition at Karlovy Vary,' 3-8 December 1986, Tvid; Annual Report, 1985-86, Di
18 Giardelli to the Czechoslovak ambassador, London, 27 September 1986, Tvib; Medal and scroll, Tvie
19 Vaníček, Zdeněk, to Griffiths, 15 January 1987, Tvib
20 Giardelli to Vaníček, Zdeněk, 18 February 1987, Tvib; Giardelli describes how: 'I mentioned that I had a collection of Czech art and suggested that they ought to buy Welsh art. They agreed to do so and from the first exhibition they bought work by Peter Prendergast, myself and others...' in Giardelli, A., & Shiel, D. (2001), p.111
21 Draft purchase confirmation from Slovak National Gallery, 22 December 1986, Tvid; 'Big coup by our artists as they break into the Czech market', *The Western Mail* 27 March 1987, Di
22 Annual Report, 1986-87, Di

147 Christopher Shurrock *Valley*
1982-84, 29 x 36 x 4 cm, acrylic on wood panel.
One of twelve works purchased from the Group's exhibition by the Slovak National Gallery, Bratislava.

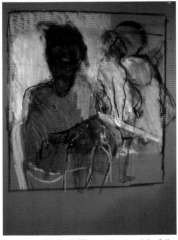

148 Tom Piper, c. 1989

149 Tom Piper *The Annunciation (after Fra Angelico version 3)* 1989 31 x 46 cm, computer generated image cibachrome photograph.

150 Sue Williams *Anne and the Sailor* 1992, 46 x 32 cm, pastel

New Members, 1987 - 89

Tom Piper [born North Dakota, USA, 1942; member from 1987] is a printmaker now specialising in three-dimensional computer-based modelling. Piper studied at North State College, South Dakota, and Eastern Michigan University, Ypsilanti.[1] He taught at Daemen College, Buffalo, and was head of printmaking at the Ruskin School, Oxford, 1973-77. Later he worked at Editions Alecto, as Tom Piper Lithography and at Jerusalem Print Workshop.[2] Appointed head of printmaking at Cardiff in 1984, he became director of the Centre for Research in Fine Art, 1994-2002. Piper has shown a wide range of traditional prints and computer-generated images. Illusion and the drama of association are themes.[3] The house as a metaphor, its repetition and variation has been a source of imagery.[4] 'The extreme view points,' he writes, 'are compositional devices I use and, along with the 'moving' furniture and deep shadows, add an atmosphere of mystery and magic.'[5] He co-founded the printmaking group Virtually-6. He held exhibitions at Oriel y Bont, Pontypridd, and Howard Gardens Gallery, Cardiff, in 2006.

Sue Williams [born Redruth, Cornwall, 1956; member 1988-2009] studied at Cardiff with Setch, completing an MA course in 1987. She has taught at art colleges in Exeter, Swansea and Cardiff. Early work concerned familiar objects but, since 1990, the figure has been a major preoccupation.[6] She draws quickly and spontaneously. Iwan Bala writes 'that the work is engaged with notions of self and highlights a number of pertinent gender issues that continue to resonate in contemporary culture, particularly in relation to fantasy, femininity and vulnerability.'[7] Women's stereotypes of both femininity and feminism are questioned.[8] Osi Rhys Osmond describes how: 'Actual words appear, mocking, taunting and heightening the emotional drama…'[9] Exhibitions include University College Cardiff and touring shows by the Mission and Glynn Vivian galleries in Swansea. She established a drawing programme *Bodyworks* in 1997 and, in 2000, received a Rootstein Hopkins Award and the Gold Medal at the National Eisteddfod of Wales. In 2006 she was short-listed for *Artes Mundi*. In 2009 she obtained Arts Council of Wales support to explore contemporary ideals of femininity in different cultures.[10] A member of the Arts Council of Wales Visual Arts Board, 1996-99, she co-founded Ysbryd / Spirit - Wales and is a member of Butetown Artists and the Women's Art Association.

Josephine Coy [born Eydon, Northamptonshire, 1939; member 1989-97] is a painter and photographer who studied at Swansea College of Art. In 1989 a visit to India on a Welsh Arts Council grant had a significant influence upon her work. Early work shown with the Group was figurative, reflecting a fascination with personal growth and transformation, Jungian psychology, mythology and Eastern philosophy.[11] By 1993 she was 'engaged in non-representational painting which evolves out of both intuition and conscious decision making… Through allowing words freedom from context, and by using writing as a form in itself, the meaning becomes ambiguous.'[12] She held one-person exhibitions in Cardiff in 1985, Coventry in 1987 and Bath in 1996. Now living in Bristol, her work, using digital photography, is concerned with the nature of existence.

151 Josephine Coy *Aperire 4* 1994 70 x 100 cm, mixed media on paper

1 Jones, Glyn, ed. (2006); *Tom Piper*, Howard Gardens Gallery, 2006
2 Sidey, Tessa (2003) *Editions Alecto: Original Graphics, Multiple Originals 1960-81*, Lund Humphries, p.263
3 *56 Group Wales*, Pembroke Dock Library, 1988
4 *The Art of the Possible*, Univ. College Cardiff, 1996
5 Hughes, Robert Alwyn, ed. (2011), p.26
6 *56 Group Wales*, Glynn Vivian Art Gallery, 1990
7 Bala, Iwan, 'Sue Williams: Her Choreography' in
Jackson, Tessa, ed. (2006) *Artes Mundi: Gwobr Gelf Weledol Ryngwladol Cymru / Wales International Art Prize*
8 'All Hers! Communications with Sue Williams' in Bala, Iwan (2003), p.97
9 Osmond, Osi Rhys, 'Visual Voices and Contemporary Echoes' in Kinsey, Christine & Lloyd-Morgan, Ceridwen (2005), p.159
10 Price, Karen, 'Artist upset at response to grant for buttock mouldings', *The Western Mail*, 11 July 2009
11 *Grŵp 56 Wales / 56 Group Wales*, Glynn Vivian Art Gallery, 1989
12 *56 Group Wales*, Royal West of England Academy, 1993

Funding Crisis after Thirty Years, 1987 - 89

In the late 1980s a Group member was often appointed to co-ordinate and select work for an exhibition. Gilhespy co-ordinated the *Thirtieth Anniversary Exhibition* at Worcester Museum and Art Gallery in 1987, which celebrated the first Group show in 1957.[1] Afterwards, he complained that 'mainly I was given a limited choice from recent work.'[2] The elegant catalogue was designed by Lyons and Bryony Dalefield.

In 1987-88 the Group co-operated with Richard Cox of South East Wales Arts Assocation in touring small works to a leisure centre, library, drama centre and school as part of its *Moving Pictures* scheme. Not dissimilar to *Art in the Making*, its aim was 'to make good contemporary art available in buildings which are heavily frequented by the public.'[3] These could be challenging venues.[4] 'I am always amazed,' wrote Cox,' at how little trouble we have in *Moving Pictures* bearing in mind the slightly risky nature of our venues.'[5]

exhibiting artists
Cardiff to Camden:

Paul Davies
Peter Ellis
Arthur Giardelli
Harvey Hood
Maggie James
Glyn Jones
Kieran Lyons
Philip Nicol
Tom Piper
Michael Punt
Christopher Shurrock
David Tinker
William Wilkins
Michael Williams
Sue Williams

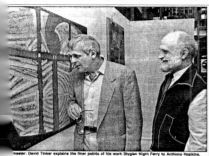

master: David Tinker explains the finer points of his work Stygian Night Ferry to Anthony Hopkins.

upil has moved on a stage

152 Tinker looks on whilst Anthony Hopkins inspects one his paintings at Swiss Cottage Library. *Ham and High*, August 1989.

Tinker co-ordinated *56 in 88* at Mostyn Art Gallery, Llandudno, and Paul Davies designed for it the Group's first fully bilingual catalogue.[6] He reflected that with 'a growth towards 'all Wales' representation... and the fact that the group 'flies the Welsh Art Flag' abroad, as it were, raises issues of national awareness and integrity...'[7]

Cardiff to Camden in 1989 travelled from Cardiff Old Library to Swiss Cottage Library, London, the Group's second showing in the city. Michael Williams visited the venue and wrote the catalogue essay. Tinker supervised hanging. Actor Anthony Hopkins launched the show in London, revealing that: 'David was my tutor for theatre design and stage movement in Cardiff back in 1955.' Despite this, publicity was generally poor.[8]

Wilkins made initial approaches to the British American Arts Association to develop visual art exchanges between Philadelphia and Wales which have, historically, been linked. Unfortunately, an exhibition never occurred due to funding difficulties and resistance to gallery control of artist selection.[9]

A Welsh Arts Council policy shift in 1987, from funding exhibitions and artists towards funding venues, created a serious financial difficulty. Giardelli felt that this was 'letting the administrators dominate the showing and selling of artists' works.'[10] The Council's wish to see a long-term plan led to a reassessment of the Group's priorities. Matters discussed included fund-raisers, agents, touring abroad and a book.[11] Despite representations, the grant towards running costs was discontinued, the last received being in 1985.[12] Transport charges, albeit small, were introduced in 1988.[13] Regular funding from HTV Wales continued until 1990.[14] Implications included abandoning negotiations to exhibit in Lisbon, raising the subscription to £20 in 1988 and to £50 in 1989, urging members to seek sponsorship and Griffiths waiving her honorarium. Giardelli reflected philosophically that 'the value of a work of art lies within itself and not in the amount of money that can be got from it.'[15]

Daborn, in Los Angeles, resigned in 1987 and wrote that the Group 'gave me encouragement and support, the opportunity to exhibit work widely, publicity and innumerable contacts...'[16] All members survived a ballot that year.[17] Anthony Davies in Belfast had to leave as he had lived away for over two years.[18] Mitchell, in London, resigned for the same reason. Grainger's membership ended in 1989 as he had not exhibited since Czechoslovakia.[19]

1 Annual Report, 1986-87, Di; 30th Anniversary Exhibition, Worcester, 1987
2 Gilhespy,Tom, 'Report by Tom Gilhespy concerning the exhibition at Worcester', 15 June 1987, Tvii
3 'The Development of a Visual Programme', SEWAA, 1986
4 Piper, who hung the exhibition at Abergavenny Drama Centre, felt that it 'was the worst place to show he had met in his life'. A print was stolen from the school (Griffiths to Giardelli, 30 Nov. 1987, Fvin)
5 Cox, Richard, to Griffiths, 1 March 1988, Tviii
6 Annual Report, 1987-88, Di
7 Davies, Paul, in *56 yn 88 / 56 in 88*, Oriel Mostyn / Mostyn Art Gallery, 1988
8 Interview with Griffiths, 23 March 2009
9 Foreign Links: US, 1986-90, Kii; Interview with Griffiths, 2 April 2009

10 Giardelli to Griffiths, 1 February 1987, Fvin
11 AGM, 17 October 1987, & papers by Tinker, Davies, P., & Williams, M., August 1987, & 'Notes of discussion', 9 September 1987, Cii
12 AGM, 8 October 1988, Cii; WAC grant £4,000, 1985 (accounts, ending 31 December 1985, Eii)
13 Hitchman, Isabel, 'Charges for WAC transport', 26 February 1988, Tix
14 Griffiths to Lyons, 21 May 1990, Uii; HTV Wales provided £400 in 1990.
15 AGMs, 8 October 1988 & 14 October 1989, Cii
16 Daborn to Giardelli, 15 July 1987, Gv-i
17 AGM, 17 October 1987, Cii
18 Correspondence between Davies, A., & Griffiths, 1987-88, Gvi & Gvj
19 Mitchell, John, to chair & members, 27 April 1988, Gvj; AGM, 14 Oct. 1989, Cii

153 Lyons hanging *Le Tourisme*, made from copies of *Le Figaro*, for the 1990 Chepstow Festival Exhibition at the town's Museum. Curator Anne Rainsbury was 'happy to consider a less orthodox approach to showing work.'[17]

Exhibiting and Reassessment, 1990 - 91

A pattern of exhibitions either guest-selected, as with David Briers at the Glynn Vivian Art Gallery, or co-ordinated by designated Group members, as with Hood in Glasgow and Lyons in Chepstow, continued. Giardelli felt that there was a 'new and welcome' degree of involvement in the Group's activities.[1] Briers made the point that the Group now included members who were born in the year of the Group's formation, a sharp reminder of the Group's longevity.[2]

The spring 1990 show coincided with Glasgow's designation as European City of Culture at the Glasgow Group's Gallery. It travelled on to St Michael's Gallery at Derby Cathedral and included Philadelphian landscape painter Kenneth Salins as a guest.[3] In a fresh move to attract funding, Stirling Fibre of Bonnybridge, Stirlingshire, provided sponsorship although the Group were unable to secure support from the Association for Business Sponsorship of the Arts.[4] The following year the Group toured the Czech Republic, exhibited in Haverfordwest and participated in an art fair at Cardiff Old Library.[5]

The raised subscription created difficulties. Giardelli tried to persuade members struggling to pay to stay in the Group but Tinker complained that 'it makes my situation as a treasurer difficult if not impossible.' In 1991 the subscription was reduced to £30.[6]

GRŴP 56 CYMRU / 56 GROUP WALES

154 Poster for the 1989-90 exhibition at Swansea's Glynn Vivian Art Gallery. It features Davies's glass mosaic *Baltic Republic* made during a residency in Leningrad. Another link with the city was the inclusion of sculpture by Dmitri Kaminker, who was on a residency organised by Gilhespy.[18]

'The artist values above all the judgement of other artists,' wrote Giardelli in a discussion paper prepared for an all-day gathering at Hood's home near Raglan in May 1991 to consider the Group's existence and policy. 'For this reason,' he continued, 'I am proud to belong to this group.' He ended: 'Our group was founded in protest and has been maintained, and has prospered, in difficulties. Where we go from now on depends on the vision and initiative of every member.'[7] Tinker felt that the Group should not grow too large in order to maximise exhibiting space for each member and to ensure that there was more contact between members.[8] Paul Davies believed that 'the group should strive to be mindful of representation from all parts of the country and from minority groups and women artists.' Documentation and publication, he felt, were also important.[9] Topics discussed included selling, diversity, exhibiting, sub-groups, recruitment and guest artists.[10]

Various members left the Group. Ellis resigned in 1991 on leaving Wales, and signed off: 'Thanks for the fun.'[11] Emrys Williams resigned because of difficulty attending meetings from north Wales.[12] Nicol and James resigned in 1991, the former indicating, in part, that his 'artistic beliefs were at variance with other members.'[13] James recognised that the Group had been a 'strong organisation to have been involved with.'[14]

The resignation, as secretary, of Griffiths in May 1991, due to time spent abroad, was a signifcant event. She would, later that year, be made an honorary member.[15] Julian Sheppard, retiring from Cardiff Institute of Higher Education, replaced her and Betty Evans remained assistant secretary.[16]

1 AGM, 13 October 1990, Cii
2 Annual Report, 1989-90, Di; Briers, David, *Grŵp 56 Cymru / 56 Group Wales*, Glynn Vivian Art Gallery, 1989. James & Sue Williams were born in 1956
3 AGM, 14 October 1989, Cii
4 Correspondence, Glasgow / Derby exhibitions, 1990, Uia
5 AGM, 5 October 1991, Cii
6 Tinker to Giardelli, 17 March 1991, Fvip; AGM, 5 October 1991, Cii
7 Giardelli, 'Paper' for meeting on 11 May 1991, Biii
8 Tinker, 'Statement and Discussion Paper' for meeting on 11 May 1991, Biii
9 Davies, Paul, 'Considerations' for meeting on 11 May 1991, Biii

10 Meeting at Berllanderi, Raglan, 11 May 1991, Biii
11 Ellis, 'Letter to the Group', September 1991, Gvk
12 Williams, Emrys, to Sheppard, 22 November 1991, Fviia
13 Nicol to Griffiths, 28 April 1991, Gvk
14 James to Griffiths, 29 April 1991, Gvk
15 Annual Report, 1990-91, Di; AGM, 5 October 1991, Cii
16 Griffiths to Group, 8 June 1991, Gvk
17 Lyons, Kieran, '56 Group Exhibition: Chepstow Museum', July 1990, Gvj
18 *Grŵp 56 Cymru / 56 Group Wales*, Glynn Vivian Art Gallery, Swansea, 1989-90

The Czech Republic Tour, 1991

On its 1986 tour the Group had been invited back to Czechoslovakia. Following the 1989 Velvet Revolution and the fall of Communism, the country was experiencing rapid change. It separated into the independent states of the Czech Republic and Slovakia on 1st January 1993.[1]

Supported by the British Council, Jiří Karbaš, from the Ministry of Culture in Prague, came to Wales in May 1990 to visit members and select work for the exhibition.[2] He was accompanied by Tinker and, as translator, Tracy Spottiswoode.[3] At a meeting in Cardiff he met members as well as Isabel Hitchman and Valmai Ward from the Welsh Arts Council.[4] Karbaš selected seventy paintings, constructions, sculptures and graphic works.

The tour, which only visited the Czech Republic, was launched by the head of art at the Ministry of Culture on 16th April at Úluv Gallery near Wenceslas Square, Prague.[5] It followed a show of contemporary Dutch art. Giardelli, Tinker, Karbaš, Zdeněk Vaníček, a representative of the British Embassy and artists Ota Janeček and Josef Liesler were present.[6] 'Since our exhibition in 1986,' reflected Giardelli, 'we have enjoyed in Wales further visits from Czechoslovakia. We have welcomed artists, art historians and exhibitions by Bauch and Wielgus, amongst others, and also exhibitions presenting the crafts of Czechoslovakia.'[7] A thousand copies of the catalogue were printed in Prague.[8] Giardelli was interviewed on Czech radio. Vaníček, now an art consultant, took the Group's delegation to art galleries and to the studios of Bauch and the surrealist Liesler.[9]

The exhibition subsequently toured to: Hluboká nad Vltavou near České Budějovice, South Bohemia, in June; Plzeň as well as Rakovník, West Bohemia, in July and August; and Frýdek-Místek in North Moravia in September. The latter was arranged and opened by Vaníček, who was interviewed on local radio. Venues are listed on page 94.[10]

It had been planned to visit both Bratislava and Košice in Slovakia, both of which had been visited in 1986, but these parts of the tour were cancelled.[11] It seems likely that this may be explained by strong separatist tendencies in Slovakia from 1989, particularly since elections in 1990.[12]

On arriving back in Wales, delegates were able to attend the launch on 19th April of *Spirit of Time, Spirit of Place: An Exhibition of Czech Contemporary Painting and Sculpture* at the Davies Memorial Gallery, Newtown. If Michael Nixon, the director, had not arranged this, the Group's tour might not have occurred.[13] Welsh Arts Council carriers were, neatly, able to swap the exhibitions.[14]

exhibiting artists:

Josephine Coy
Paul Davies
Peter Ellis
Arthur Giardelli
Harvey Hood
Maggie James
Glyn Jones
Kieran Lyons
Philip Nicol
Tom Piper
Peter Prendergast
Michael Punt
Christopher Shurrock
David Tinker
William Wilkins
Emrys Williams
Michael Williams
Sue Williams

155 Poster for the Group's exhibition in Prague, 1991, featuring Tinker's acrylic on canvas, *Stygian Night-Ferry*, 1988-89, 100 x 150 cm.

1 Email from Vaníček, Zdeněk, 31 July 2012
2 Annual Report, 1990-91, Di; Revised itinerary of Jiří Karbaš, 10-15 May 1990, 3 May 1990, Uvb
3 Griffiths to members, 5 May 1990, Uvb
4 Meeting, Cardiff, 11 May 1990 to discuss exhibition in Czechoslovakia in 1991, Uvb
5 Annual Report, 1990-91, Di
6 Email from Vaníček, Zdeněk, 31 July 2012; Annual Report, 1990-91, Di
7 Giardelli, Arthur, 'Introduction' to 56 Group Wales, Úluv Gallery, Prague, 1991
8 Email from Vaníček, Zdeněk, 31 July 2012
9 Annual Report, 1990-91, Di; Vaníček, Zdeněk, to Griffiths, 13 November 1990, Uva
10 Kučerová, Jana, Ministry of Culture, Prague, to Ward, Valmai, Welsh Arts Council, 16 May 1991, Uva; Annual Report, 1990-91, Di; Email from Vaníček, Zdeněk, 31 July 2012
11 Griffiths to Hitchman, Welsh Arts Council, 10 May 1991, Uva; Griffiths to Giardelli, 11 Aug. 1990, Uva
12 Email from Vaníček, Zdeněk, 31 July 2012
13 Griffiths to Nixon, Michael, 24 October 1990, Uvb
14 Ward, Valmai, to Griffiths, 14 September 1989, Uva; Annual Report, 1990-91, Di

156 Zdeněk Vaníček and Giardelli at the Lennon Wall, Prague, 1991. The graffiti had been a source of irritation to the communist régime.

157 Bryony Dalefield *The Cherubim* 1991, 183 x 142 cm, glazed cotton and embroidery thread

158 David Gould *Minutiae* 1993, 30 x 26 cm, acrylic on paper

New Members, 1990 - 91

Bryony Dalefield [born New Zealand 1951; member 1990-2000; chair 1999-2000] learned to sew from her mother and studied at Elam School of Fine Arts, University of Auckland, majoring in photography. She arrived in London where she started to make quilts. In 1986 she moved to Chepstow where she exhibited at the local museum. 'These are composite figures,' she explained, 'made by a process of accumulation, as a coral reef is formed - each individual coral medusa briefly floating free in the ocean currents before it settles and becomes a petrified part of the mother reef… So far these endeavours result in creatures that rear up and stare back at me with the question - 'Who do you think you are?'[1] She draws upon sexuality, genealogy, natural features, myths and histories. *Provided With Eyes*, a 1995 exhibition at Swansea, toured to New Zealand. She later showed in Northern Ireland and Penarth.[2]

David Gould [born London 1947; member 1991-2001] is a painter who studied in Gloucestershire and at the Royal College of Art. A scholar at the British School in Rome, he became a junior fellow in fine art at Cardiff College of Art, then head of foundation at Byam Shaw, London. He returned to Cardiff in 1982 as lecturer in foundation studies and, 1992-2008, director of its foundation course. The process of working with hand-cast paper to create a relief surface fascinates him. 'The imagery can suggest both weight and lightness, and the space is enigmatic and discontinuous, penetrating in and out, ending and restarting, and broken by neutral areas. The colour is limited, largely tonal in character, and used to generate visual rhythms, by linking or separating one element from another.'[3] He also paints watercolour landscapes which 'develop through close, prolonged and searching observation and a gradual, cumulative depiction of the chosen subject.'[4] He is a member of Butetown Artists.

Helen Sear [born Banbury 1955; member 1991-92] is a lens-based artist who attended the University of Reading and the Slade. She became a junior fellow in fine art, and later lectured in lens media, at Cardiff.[5] Widely exhibited, she moved in 1992 to London, having also received a scholarship from the British School in Rome. She resigned never having exhibited with the Group.[6] She is currently a reader at the University of Wales, Newport.

Richard Powell [born London 1958; member 1991-93] exhibited his beaten tinplate steel *Uncertain, Chocolate Compass* at Rhondda Heritage Park in 1992, his only showing with the Group. A sculptor and printmaker, he studied at Chelsea and Cardiff, taught part-time, worked with Welsh National Opera, held a residency at the Glynn Vivian Art Gallery and, in 1992, received a commission at Margam Sculpture Park.[7] He still lives and works in Cardiff exploring the meaning of architectural space and using photography extensively.

159 Carol Hiles, 1991 160 Carol Hiles *Blue Garden* 1999, 102 x 122 cm, oil on canvas.

Carol Hiles [born Reading 1959; member from 1991; chair 1998-99] is a painter and community artist who studied at Cardiff with Glyn Jones and Setch. She was an artist-in-residence with National Health Service trusts in Gwent, 1991-2002, and at the Royal Glamorgan Hospital, 2002-03, and became a senior lecturer at the University of Glamorgan in 2003. 'I am interested in the construction of parks as spaces,' she writes; 'the arrangement of natural and man-made forms which combine a sense of liberty with confinement. I enjoy the encounter of formality with vivid nature.' Small-scale drawings, once back in the studio, 'are arranged and reformed using abstracted space and colour to create another environment and experience.'[8] She succeeded Giardelli as chair for a year, is a member of Butetown Artists and of the Welsh Association of Community Artists.

1 *56 Group Wales*, Royal West of England Academy, 1993
2 Bunting, Peter, in Dalefield, Bryony (1995) *Provided With Eyes*, Glynn Vivian Art Gallery, p.29
3 Gould, David, in *Raymond Eyquem: The Art of the Possible*, University College Cardiff, 1996
4 *56 Group Wales*, Royal West of England Academy, 1993
5 Buckman, David (2006 ed.), p.1424
6 Annual Report, 1992-93, Di
7 Buckman, David (2006 ed.), p.1287-88; www.g39.org, 2012
8 Hiles, Carol, in Jones, Glyn, ed. (2006); Hughes, Robert Alwyn, ed. (2011)

A More Moderate Realism, 1992 - 93

Concerns about funding and Welsh Arts Council policy continued. 'The Visual Art panels seem to give great stress to Community Arts and to the maintenance of galleries as centres of excellence, both of them admirable ideas and most welcome,' Tinker reflected, 'but there seems to be less interest in, and support for, the more radical and personal artists.'[1] Hitchman advised using the Programme Support Scheme administered by regional arts associations for exhibitions touring Wales, ideally with applications through a gallery.[2] Giardelli recalled painfully that: 'For many years we received an annual grant which I believe there is plenty of evidence that we used to good purpose.'[3] Another difficulty arose when, in 1993, the Council doubled its transport fees.[4]

Two exhibitions occurred concurrently in spring 1992. That at Oriel, Theatr Clwyd, Mold, was selected by Lois Williams 'to provide an insight into each artist's individual concerns as well as giving a general overview of the Group's activities.'[5] The other, *From Wales to Rhondda*, was shown at Rhondda Heritage Park, Trehafod, and Newport Museum & Art Gallery. Dalefield withdrew 'due to unsuitable exhibiting conditions for her textiles.'[6] Publicity costs were assisted by a one-off grant from HTV Wales.[7]

There was a well-attended launch that summer at Bristol's Royal West of England Academy. Michael Williams noted that 'the policy of limiting the Group to 'about twenty' in number is maintained...'[8] Substantial funding was received from the Foundation for Sport and the Arts.[9] Some members found it 'thin and disparate,' Lyons attributing this to the lack of a selector.[10] Paul Bevan and Eileen Little were guests.[11]

The Group returned to Rhondda Heritage Park in late 1993 with *Delweddau ar Bapur - Works on Paper*, which moved to Newport Museum and Art Gallery with the Programme Support Scheme. Professor Vyacheslav Shestakov of Moscow University selected works.[12] He wrote that 'the early avant-garde experiments with ready-made objects and radical inspiration have given way to a more moderate realism and photorealism, although some members... prefer to work in a more abstract way... they are also deeply interested in Welsh history, traditions and landscape.'[13] 'I would like to suggest,' Isabel Hitchman ventured in her opening speech at Newport, 'that the Group continue to seek constantly to extend its female membership, in the interests of art in Wales and its own development.'[14]

By 1992 over half the members had joined in the previous seven years.[15] There were more departures. 'Last year was a good year,' Prendergast wrote; 'this year I have a bit of a cash flow problem... In the meantime I am offering my resignation to the group.'[16] Giardelli, as on previous occasions, persuaded him to stay. Gilhespy left in 1992, with much regret, 'due to pressures of work and circumstances.'[17] Punt departed in 1993, not having exhibited for two years and working in Amsterdam. He was made an honorary member.[18] Sear and Powell soon left. Sadly, Paul Davies died in November 1993, having contributed extensively to both exhibitions and debate.[19]

1 Tinker to Giardelli, 7 January 1992, Fviib
2 Hitchman, Isabel, to Giardelli, 28 April 1992, Fviib
3 Giardelli to Hitchman, Isabel, 11 May 1992, Fviiig
4 Sheppard to Giardelli, 23 April 1993, Fviiig
5 Williams, Lois, 'Exhibition Commentary', *56 Group Wales / Grŵp 56 Cymru*, Oriel Gallery, Theatr Clwyd, Mold,' 1992
6 Townsend, Gary, to Sheppard, 27 February 1992, Fviib
7 Sheppard to Symonds, I., 29 May 1992, Fviib; Annual Report, 1991-92, Di. This was for £500.
8 Williams, Michael, 'Introduction', *Grŵp 56 Cymru / 56 Group Wales*, Royal West of England Academy, 1993
9 Annual Report, 1992-93, Di; £2,500 was received from FSA.
10 Meeting, 9 October 1993, Biii
11 Annual Report, 1991-92, Di
12 Annual Report, 1992-93, Di
13 Shestakov, Vyacheslav, in *56 Group Wales: Works on Paper*, Rhondda and Newport, 1993
14 Hitchman, Isabel, Speech at launch of *Works on Paper*, Newport Museum & Art Gallery, 1994, Uix
15 Sheppard to Anderson, Mary, 11 May 1992, Fviib
16 Prendergast to Sheppard, 21 January 1992, Gvi
17 Gilhespy to Giardelli, 11 October 1992, Fviib
18 Punt to Giardelli, 1 Oct. 1993, Fviic; AGM, 9 October 1993, Cii
19 Annual Reports, 1992-94, Di

exhibiting artists
Bristol:

Paul Bevan (guest)
Josephine Coy
Bryony Dalefield
Paul Davies
Arthur Giardelli
David Gould
Carol Hiles
Glyn Jones
Eileen Little (guest)
Kieran Lyons
Christopher Shurrock
David Tinker
William Wilkins
Michael Williams
Sue Williams

ROYAL WEST OF ENGLAND ACADEMY
QUEEN'S ROAD CLIFTON BRISTOL

WORKS BY THE 56 GROUP
WALES

13 JUNE - 10 JULY 1993
MONDAY to SATURDAY 10am - 5.30pm
SUNDAY 2pm - 5pm

161 Poster for 1993 Royal West of England Academy exhibition featuring *Wales Seen from the English Side*, an electronically enhanced photograph by Little & Lyons.

162 Arthur Giardelli *Close on the Wave Soothes the Wave Behind* c. 1993, 124 x 93 cm, mixed media
This was shown at Bristol in 1993. Reworked, it was exhibited in 1995 as *A Looming Storm*.

Return to the Continent, 1994

In autumn 1994 the Group, including all those newly elected, were invited to exhibit in *Libr'art*, the seventh Salon International de l'Art at Libramont, Belgium. Wilkins had suggested showing in Brussels due to the forthcoming fiftieth anniversary of its liberation by the Welsh Guards in 1944.[1] Sheppard contacted the British Council in Brussels which passed information to the British Embassy as it was 'co-ordinating all possible activities related to the Liberation.'[2] They contacted exhibition organisers in Libramont.[3]

The art fair style event was held in the Halle aux Foires, Sheppard indicating that 'they have given us the most prestigious space at the entrance of the exhibition.'[4] This included twenty-five metres of screens. An oil painting by Glyn Jones received a commendation. The event, including artists from twenty-four countries, attracted ten thousand visitors in ten days. The Foundation for Sport and the Arts provided funding.[5]

The recently renamed 'Arts Council of Wales', receiving funding directly from the Welsh Office, organised transport to Belgium and Sheppard brought it back.[6] This facility, administered by Valmai Ward, would be disbanded in 1995. Giardelli was concerned about both the financial impact and loss of 'the skill, reliability and devotion in handling valuable works of art...'[7]

163 Artstation (Anne Hayes & Glenn Davidson)
Shell and Pine 1993, 220cm high, paper and air fan,
at *Libr'art*, Libramont, Belgium, 1994.

164 Peter Bunting *Nature*
1989/90, 137 x 168 cm, oil on canvas

Artstation [Glen Davidson, born Birmingham 1957, & Anne Hayes, born Leeds 1957; members 1994-2001] is the working name for a partnership of two multi-disciplinary artists.[8] Davidson, who studied in Stourbridge, and Hayes, at Jacob Kramer College in Leeds, both attended South Glamorgan Institute of Higher Education, Cardiff. They worked as Live Support System in the early 1980s and, later, as Artstation. In 1988-90 they held a fellowship in cybernetics and social systems at the University of Amsterdam. 'Artstation use the computer as a medium,' a 1996 catalogue explained, 'specialising in Virtual 3D - from which they create transdisciplinary works, multi-media and computed architectural installations.' Projects include paper sculptures commissioned by the British Council to represent Wales at the 1993 Stuttgart Expo Garden Festival and *Paradise Fruit* for the 1997 *Paradise Gardens* exhibition at the National Museum of Wales. Artstation were members of Cardiff's Old Library Artists.[9]

Peter Bunting [born Switzerland 1947; member 1994-96] is a widely-travelled painter who, in 1962, encountered the work of Yves Tanguy, inspiring his interest in surrealism. The study of philosophy at Cambridge was followed by painting at Byam Shaw School of Art, London. In the mid-1970s he lived on the Yorkshire coast. Later, he taught part-time at Newport.[10] 'His early work,' explain England & Co, with whom he has exhibited since 1997, 'was landscape-based, dealing with the themes of growth and natural forces, and his painting continues to be an 'ordering process' and an exploration of the relationship between surfaces and space.'[11] In 1995 he showed works that 'deal with dreams, delusions, the organs of sense and those of support.'[12]

1 Wilkins to Sheppard, 26 October 1991, & Sheppard to Wilkins, 31 October 1991, Gvi
2 Correspondence between Sheppard & British Council, Brussels, 2-9 March 1993, Ux
3 Martin, Annette, Salon International de l'Art, Libramont, to Sheppard, 9 Dec.1993, Ux
4 Notice to members showing at Libramont, 26 April 1994, Ux.
5 Meeting, 18 February 1995, Biii; FSA granted £1,420

6 Lord, Peter (1998), p.266; Notice to members about Libramont, 7 March1994, Ux
7 Annual Report, 1993-94, Di; Giardelli to Hitchman, 15 September 1994, Fviiig
8 www.artstation.org.uk, 2012
9 'Artstation' in *56 Group Wales: 56 in 96*, Turner House, Penarth, 1996; Artstation website, as 8 above
10 Buckman, David (2006), p.219
11 www.englandgallery.com, 2012
12 Bunting in *56 Group Wales*, The Old Library, Cardiff, 1995

Shani Rhys James [born Melbourne, Australia, 1953; member 1994-2001] is a painter who studied in Loughborough and St Martin's School of Art. Her principal subject is a remorselessly truthful scrutiny of herself, often in the context of her upbringing in the theatre. 'Shani Rhys James,' writes Andrew Patrizio, 'follows a distinguished tradition of twentieth-century figuration which has refused to leave behind life-like representation, yet nevertheless feels impelled to foreground the materials it deals in...'[1] Objects may be included which reference seventeenth-century Dutch or Flemish still-lifes.[2] She won the Gold Medal at the National Eisteddfod of Wales in 1992, the Hunting/Observer Art Prize in 1994 and the Jerwood Painting Prize in 2003. Her exhibitions were, at this time, toured by Wrexham Arts Centre, Oriel Mostyn and Aberystwyth Arts Centre.[3] She received an MBE in 2006 and was made an honorary fellow of the University of Wales Institute Cardiff the following year. She lives in Llangadfan, mid Wales, shows with Martin Tinney Gallery, Cardiff, and is a member of the Royal Cambrian Academy.

165 Shani Rhys James *Red Beret*
1991, 122 x 91 cm, oil and gesso

166 Stephen West *Buried Head* 1992
61 x 61 cm, egg tempera on gesso on board

Stephen West [born Reading 1952; member 1994-2001] is a sculptor, painter and printmaker who initially studied engineering, but changed to art at Berkshire College of Art and Design, St Martin's School of Art and the Royal College of Art. He taught in London, coming to Wales in 1984 and working in arts administration. In 1999 he became head of residencies and co-director of Cywaith Cymru / Artworks Wales and director of creative development for Safle, 2007-08.[4] Interested in the cross-over between drawing and sculpture, his work has a vigorous expressive style, captured in charcoal drawings and direct carving. 'My drawings are done quickly and are about the mood and thought and emotion of that time... The inside and outside of a head is important as form but also it is a key to a poetic idea.'[5] He exhibited widely in Wales in the 1990s and recently showed at MOMA Wales, Machynlleth. He is a member of the Royal Cambrian Academy.

Sue Hunt [born London 1959; member from 1994] is a painter and printmaker who studied in High Wycombe, at Canterbury College of Art and South Glamorgan Institute of Higher Education, Cardiff. She has worked in community arts, as an artist-in-residence and as a part-time senior lecturer at both Norwich and Cardiff.[6] She paints, draws and etches still-lifes and is concerned with formal elements of abstraction.[7] 'My work has continued to focus on the making of the paintings themselves,' she writes; 'the layers of colour, translucent, opaque, playing off each other and off the objectivity of the forms that are introduced.'[8] She has exhibited in Wales and London as well as Jaipur in Rajasthan, India. In the late 1990s she showed with Mary Lloyd Jones and Tessa Waite in Newport, Swansea and Brecon.[9] Recent work includes silverpoints with botanical imagery.[10] She belonged to the Association of Artists and Designers in Wales, served on the Visual Arts Advisory Board for the Arts Council of Wales, 1994-98 and is currently a member of Virtually-6 printmakers.

167 Sue Hunt *Still-life with White Jug on Blue and Russet*
c.1995, 89 x 70 cm, acrylic on canvas

1 Patrizio, Andrew, 'Reflections on New Work' in *Facing the Self: Shani Rhys James*, Oriel Mostyn, 1997, p.15; see also interview in Curtis, Tony (1997)
2 Lucie-Smith, Edward, et al (2004) *Shani Rhys James: The Black Cot*, Gomer, pp.23-24
3 Williams, Jeni, 'The Cradle of Flesh: Jeni Williams on Shani Rhys James's latest exhibition', *Planet* 165, June/July 2004, pp.15-22
4 West, Stephen ' Making sense of it - artists and rural communities' in Bala, Iwan, ed. (2005) *Groundbreaking: The Artist and the Changing Landscape*, Seren / Cywaith Cymru, Artworks Wales
5 West, Stephen, in *56 Group Wales: 56 in 96*, Turner House, Penarth, 1996
6 *Sue Hunt: Recent Work*, CBAT, 2003; *Sue Hunt: Works on Paper*, Jawahar Kala Kendra, Jaipur / UWIC 2004
7 Jones, Glyn, ed. (2006); Hughes, Robert Alwyn, ed. (2011)
8 Hunt, Sue, in *56 Group Wales: 56 in 96*, Turner House, Penarth, 1996
9 *Shared Language / Iaith Rhyngom*, Newport Museum & Art Gallery / Glynn Vivian Art Gallery, Swansea, 1997
10 Hiscock, Karin, 'Sue Hunt: Paintings and Silverpoints', 20 October 2011, www.suehunt.co.uk

168 Martyn Jones with *Julep*
1999-2000, 200 x 200 cm, oil on canvas

169 Cherry Pickles *Indian Self Portrait*
1997, 91 x 91 cm, oil on linen

New Members, 1995

Martyn Jones [born Aberdare 1955; member from 1995; publicity officer 1996-2000; treasurer from 2008] is a painter and printmaker who studied in Cardiff and at Chelsea School of Art. He became a junior fellow at Bath Academy of Art and, from 1986, lecturer in fine art and head of department at Merthyr Tydfil College. 'In essence my paintings are descriptive - shape and colour taken from the world at large. My work represents an ongoing dialogue in touch with my own feelings and sensations. A completed work may be transformed into something quite different from that which was originally envisaged.'[1] Preliminary sketches are later translated into paintings which explore place and time.[2] Exhibited in Wales, London and New York, he won the University of Glamorgan Purchase Prize in 2000.[3] He lives in Cardiff and has been a member of Ysbryd / Spirit - Wales.

Cherry Pickles [born Bridgend 1950; member 1995-2001] studied mathematics at the University of Ulster and art at Chelsea and the Slade School of Fine Art. She became a part-time lecturer at Falmouth, Canterbury and Cardiff and part-time senior lecturer at the latter until recently. Her painting, rich in colour and humour, focuses on self-portraiture and landscape. She has shown the world, as frequently seen, from a car mirror.[4] Reflections indicate a concern with looking and perception. In 1996, she wrote that she was 'interested in painting dirt and distortion on mirrors because it makes you aware of the mirror and puts you in a very familiar situation.'[5] 'The artist may act out roles to deepen the psychological engagement of her imagery,' Lambirth observes, 'but her artistic investigation remains an enquiry into the nature of human behaviour, in all its quirky manifestations'[6] She often travels away from her Pembrokeshire home, indicated by paintings of Greek mythology in a contemporary context and of the Dominican Republic and Haiti.

Brendan Stuart Burns [born Nakuru, Kenya, 1963; member 1995-2011; vice-chair 1998-2001] is a painter who studied at Cardiff, where he was influenced by Setch, and the Slade.[7] He is currently a lecturer at the University of Glamorgan. His early work reflects turmoil, political protest and religious concerns.[8] Engagement with the Pembrokeshire coast, however, has been his principle subject. Burns records, through drawing, notes and photography his wide-ranging sensory responses to this environment; to the colour and texture of rocks, sand and water in changing tidal, light and weather conditions. Later, he works from this material. 'The result of all the observation,' Wakelin reflects, 'is a dialogue between the reality located here and the painting in the studio… His objective is to create an equivalent to the sensuality of being alive in the world…'[9] In this respect, the work of Prendergast has been important to him.[10] Alston feels that these paintings 'stake out reflective territories beyond the specifics of place.'[11] Burns has held many exhibitions and has twice won the Gold Medal in Fine Art at the National Eisteddfod of Wales and other prizes. A recent residency at Oriel y Parc, St Davids, provided time for painting that is both sculptural and spiritual.[12] He was a co-founder of Ysbryd / Spirit - Wales.

1 Jones, Martyn, in *56 Group Wales*, The Old Library, Cardiff, 1995
2 Jones, Martyn, in Hughes, Robert Alwyn, ed. (2011), p.24
3 *Martyn Jones: Overland*, 2006
4 Lambirth, Andrew in *Cherry Pickles: A Gathering of Difficulties. Portraits*, 2005, p.13
5 Pickles, Cherry, in *56 Group Wales: 56 in 96*, Turner House, Penarth, 1996
6 Lambirth, Andrew in *Critic's Choice*, The Art Shop, Abergavenny, 2006, p.20
7 For Setch influence, see interview in Curtis, Tony (2000), pp.103-04
8 Alston, David (2007) *Into Painting: Brendan Stuart Burns*, Seren, pp.13-14
9 Wakelin, Peter, 'Sea Changes: The Art of Brendan Stuart Burns' in *Not the Stillness: Paintings by Brendan Stuart Burns*, Newport Museum and Art Gallery, 2002; see also 'Not the Stillness: The Work of Brendan Burns' in Bala, Iwan (2003), pp.72-78
10 *Influere: Brendan Stuart Burns*, Oriel y Parc, 2009
11 Alston, David, in *Tidal: Brendan Stuart Burns*, Oriel Davies, Newtown, 2005
12 Burns, Brendan Stuart, ed. (2012) *Glimpse: Brendan Stuart Burns*, Retreats Group Ltd

170 Brendan Stuart Burns *Silver Crash* 1997, 21 x 34 cm, oil on board

The Russian Connection and New Members, 1995

Images from Wales, an exhibition selected by Vyacheslav Shestakov, led to an invitation in 1994 from the Russian Ministry of Culture for the Group to exhibit in 1995 at the House of Artists off Gorky Park in Moscow.[1] An invitation had also been received to exhibit in Tbilisi, Georgia.[2] An exchange exhibition of Russian art was to have been shown at Cardiff Old Library. Aberystwyth Arts Centre, too, expressed interest in showing selected Moscow artists.[3]

The Group's exhibition had reached an advanced stage when it had to be cancelled after the British Council, which had previously supported Group exhibitions, felt unable to fund the transport costs.[4] 'This was a wonderful opportunity for Welsh visual art to be seen on a wider stage,' reflected Giardelli; 'It was a great honour to have been invited at all.'[5] The exhibition was shown as planned, however, at Cardiff Old Library in spring 1995.[6]

Efforts were made to resurrect the project, focusing upon the transfer to Moscow of the 1996 exhibition at Turner House, Penarth. Eventually, however, it became clear that, due to difficulties in Russia, the Ministry of Culture had become an unreliable financial partner.[7] This, despite a generous offer of support from the Estorick Foundation, for which Michael Estorick was made an honorary member.[8]

The 1994-95 financial year was regarded as one of the worst the Group had sustained, largely due to preparing the aborted exhibition. The secretary, assistant secretary and treasurer all gave notice in 1995 that they wished to stand down.[9]

Dennis Gardiner [born Staffordshire 1957; member from 1995; treasurer 1998-2006] is a painter and construction artist who studied at Newcastle-under-Lyme, Staffordshire University, the London College of Printing and Royal College of Art. Having lectured at various universities he has taught, since 1986, diploma courses in art and design at Pontypool College of Technology, later Gwent Tertiary College, and is currently head of the foundation diploma. 'My paintings,' he wrote in 1996, 'deal with my conscious and unconscious response to my cultural environment.' His abstract work references commonly experienced features in, for example, architecture or fabrics. 'These visual anomalies,' he writes, 'are reinterpreted and encapsulated in my recycled constructed wood canvases painted with acrylic, creating a physical and intellectual statement of colour, form and marks about today's urban landscape.'[10]

Peter Lewis [born Manchester 1939; member 1995-2001] is a painter and sculptor brought up in west Wales. He studied at Carmarthen and St Martin's schools of art, served in Army Intelligence and became a postgraduate at the Royal College of Art.[11] After fellowships he taught in the 1970s at St Martin's and the Central schools of art. He paints, often in series, the Carmarthenshire countryside. Compositions, he writes, 'are constructed as in a spider's web - anchored to the edges and paying particular attention to the corner areas of the support, which helps to give the necessary tensions and pressure on the lines and forms hung within... I find it important to strike the right balance between an abstract concept and an identifiable figuration.'[12]

171 Dennis Gardiner *The Eternal* 1999, 56 x 64 x 6 cm, acrylic on wood

172 Peter Lewis *Untitled* 1994, 26 x 36 cm, ink on paper

1 Bazhanov, Leonid, Russian Ministry of Culture, to Giardelli, 17 June 1994,Uxi; Giardelli, A., & Shiel, D. (2001), p.111; Annual Report, 1993-94, Di
2 Sheppard to Cox, Richard, Arts Council of Wales, 17 January 1995; Dvalisvili, Maka, Georgian Artists' Association, to Sheppard, 17 January 1995, Uxi
3 West to Sheppard, 1 September 1994 & 3 February 1995, Uxi
4 Spence, Sara, British Council, to Sheppard, 4 Nov. 1994 & 15 Feb. 1995, Uxi. In 1995 estimated costs were £14,750 for road transport, packing, insurance and air fares for four artists (Sheppard to Cox, Richard, Arts Council of Wales, 17 January 1995, Uxi)
5 'Snub for first art tour to Moscow', *The Western Mail*, 18 April 1995, p.7; Giardelli stated later that the decision had been made partly because 'the quality was mixed' (Giardelli, A., & Shiel, D. (2001), p.111)

6 *56 Group Wales: Images from Wales*, The Old Library, Cardiff, 1995
7 Shestakov to Sheppard, Oct. 25 1996; Sheppard to Boot, Katie, British Council, London, 28 Oct. 1996; Rogers, Brett, British Council, to Sheppard, 4 Nov. 1996, Uxi
8 Hitchman, Isabel, to Sheppard and Giardelli, 17 January 1996, Uxi; Meeting, 17 February 1996, Biii
9 AGM, 14 October 1995, Cii; The loss on the year was around £800
10 Gardiner, Dennis, in *Raymond Eyquem: The Art of the Possible*, University College Cardiff, 1996; also Jones, Glyn, ed. (1996) & Hughes, Robert Alwyn, ed. (2011)
11 'Peter Lewis', www.agentmorton.com, May 2012
12 Lewis, Peter, in *56 Group Wales: 56 in 96*, Turner House, Penarth, 1996

173 *The Art of the Possible* catalogue cover designed by Artstation.

The Art of the Possible, 1996 - 99

Raymond Eyquem: The Art of the Possible, was a tribute in 1996 to a long-term supporter of the Group on his retirement from the School of European Studies at University of Wales Cardiff.[1] As the University's curator of art, he had arranged many exhibitions. After participation in the 1969 *Breton-Welsh Artists*, Janet Siviter explained, the Group 'went on to become a regular contributor to artistic life in the University.'[2] This exhibition, which Eyquem selected, toured to Pembroke Dock and Bangor with Arts Council support.[3]

174 Detail of *56 in 96* catalogue and poster, 1996

56 in 96, at Turner House in Penarth, marked the fortieth anniversary of the Group's foundation. David Alston, recently appointed keeper of art at the National Museum & Gallery, Cardiff, selected it and wrote: 'Malthouse's rallying manifesto of forty years ago was we are told instantly disputed by all the artists who nonetheless signed up... The guts of this statement was seen I suspect at the time to be an espousal of the international modern to the detriment of the indigenous parochial - however given the amoebic evolution of the group it has become an elastic embracing of many tendencies.'[4] A 1997 *40th Anniversary Exhibition* at Worcester celebrated the Group's first exhibition in 1957 at the City Art Gallery. This toured, appropriately, to Tenby and Cardiff.[5]

Despite these exhibitions, there was concern about the Group's future. Tinker was replaced in 1996, after three decades as treasurer, by Sue Williams and, after two decades as vice-chair, by Glyn Jones.[6] Bob Weir succeeded Sheppard as secretary. Martyn Jones became press officer as Michael Williams left the Group, having moved from Wales. Bunting left for the same reason and, in the following year, so did Coy.[7] The subscription was also raised.[8] In 1997 Tinker suggested the establishment of a policy and action committee but 'between ourselves,' he later advised Weir, this 'became too involved with 'principles' rather than practicalities. To keep the Group going, if there is a universal desire to keep it going, we need an administrative structure first, then we can argue over principles.'[9] The Arts Council, mindful of the Group's heritage, funded in 1998 the organisation of its archive.[10]

Giardelli's resignation as chair in 1998, after thirty-seven years, was a notable event and he was, uniquely, appointed president.[11] 'It's essential,' he explained, 'that the responsibility, which I must say is considerable, is passed on, primarily to the new chairman and secretary.'[12] Hiles, who had shadowed him during the previous year, took over as chair. Burns became vice-chair and Gardiner treasurer.[13]

An exhibition of *New Work* was launched in 1999, visiting Carmarthen, Wrexham and Maesteg. William Brown, as exhibition officer, hung this at Plasnewydd Primary School, Maesteg.[14] 'There was an inventory but no list of titles,' he explained, 'so I 'extemporised' a little here and there.'[15] The same year, with Arts Council support, Walt Worrilow selected an exhibition at Howard Gardens Gallery, Cardiff, which travelled to Theatr Clwyd, Mold.[16]

For family reasons Hiles resigned as chair in 1999, having overseen the Howard Gardens launch.[17] She was succeeded by Dalefield.[18] Wilkins, who had made important contributions to the Group, resigned.[19] The Welsh Group, meanwhile, was celebrating its fiftieth anniversary and organising themed exhibitions to make it more attractive to venues.[20]

1 Annual Report, 1995-96, Di
2 Siviter, Janet, in *Raymond Eyquem: The Art of the Possible*, Grŵp 56 Wales/56 Group Wales, 1996
3 Meeting, 17 February 1996, Biii: £2,800 Programme Support Scheme.
4 Alston, David, 'A Group Tour', *56 in 96: An Exhibition of 56 Group Wales*, Turner House, 1996
5 AGM, 11 October 1997, Cii
6 AGM, 26 October 1996, Cii
7 Annual Report, 1995-96, Di; Correspondence, Coy & Weir, April 1997, Gvi
8 The subscription was raised to £55, payable in two instalments
9 Meeting, 11 January 1997; Tinker to Weir, autumn 1997; Tinker, 'Memorandum, Policy & Action Committee', autumn 1997, Biii
10 Meetings, 30 May & 10 October 1998, Biii; Wakelin, Peter, '56 Group Wales Archive Project:

Progress Report to AGM', 10 October 1998, Cii
11 AGM, 10 October 1998, Cii
12 Giardelli, A. & Shiel, D. (2001), p.113
13 Annual Report 1997-98, Di; AGM, 10 October 1998, Cii
14 AGM, 10 Oct. 1998, Cii; Weir, Bob, 'New Work' Exhibition, 1999, Uxvi
15 Brown, to Weir, Bob, 27 September 1999, Uxvi
16 Notice to Members, 19 May 1999, Biii
17 Conversation with Hiles, 28 July 2012
18 AGM, 16 October 1999, Biii
19 Meeting, 16 October 1999, Biii
20 Wakelin, Peter (1999), p.52; Thomas, Ceri (2008), p.76

New Members, 1997

Peter Spriggs [born Cardiff 1963; member from 1997; vice-chair 2004-06; chair 2006-08; past-chair 2008-10] is a painter who studied in Cardiff with, amongst others, Glyn Jones and Setch, and at the Royal College of Art. After working in adult education he became a lecturer in 1990 at Coleg Sir Gâr, Carmarthen.[1] He received Arts Council career development support to study Catalonian art in Barcelona. In recent work he combines two motifs; Gaudi's mosaics and a piece of Welsh iron slag suggesting a head, both by-products of industrialism. He also visited Canada with a Creative Wales Award. 'I find painting still lifes a critical activity,' he explains; 'Each brush stroke… is an aesthetic decision and one to do with intuition.'[2] He has painted single and clustered burning candles, first observed in St Sophia's Cathedral, Bayswater, as 'articulating an equilibrium between observation and belief.'[3] Spriggs was chair at a vital time in the Group's re-establishment. He lives in Llanelli and was a founder of Ysbryd / Spirit - Wales.

175 Harding and Spriggs with Spriggs' *Strawberry* and *Melon*.
South Wales Evening Post, Thursday April 15, 1999

Robert Harding [born Southport, Lancashire, 1954; member from 1997] is a sculptor who studied in Coventry, at Exeter College of Art and the University of Lancaster.[4] Appointed in 1982 as a part-time lecturer at Dyfed College of Art, now Coleg Sir Gâr, he has lectured elsewhere.[5] He took a course in welding and fabrication and favours using steel, often scrap, as it enables him to retain control.[6] It is manipulated into unexpected, often juxtaposed, contrasting forms which are hung, fixed to walls or free-standing.[7] In a postmodernist vein, these may have ironic or playful titles reflecting reused objects and suggesting psychological states.[8] They range in size from a small hanging bivalve-like pod, *Nutcases*, made from engineering nuts, to a large painted sprung steel bow, *Slice of Life*, shown at Ebbw Vale.[9] He also uses glass, bronze, plastic, rope or coins.[10] The recipient of both the Richard and Rosemary Wakelin Purchase Award and the Welsh Artist of the Year Sculpture Prize, he lives in Llantrisant and also belongs to the Welsh Group.

176 Peter Spriggs
Candle, after Las Meninas
2004, 60 x 40 cm, acrylic on canvas

William Brown [born Toronto 1953; member 1997-2001; exhibition officer 1998-2000; died 2008] was a painter and printmaker brought up in a Canadian Scottish family.[11] Little is known about his early life, although he moved to Britain in 1977, teaching in Somerset. His style is naïve, yet witty and sophisticated, using vivid colours, and loose, expressive brushwork. Imagery is drawn from travels, mythology, poetry, folklore and folk-art. Membership coincided with works on the theme of Loup-Garou, a werewolf, and linocuts inspired by the Welsh custom of the Mari Lwyd.[12] At this time Cardiff Old Library artists, including Brown, were asked to leave their studios to make way for what would be a short-lived Centre for Visual Arts. He lived in Bridgend and probably did not find the Group a natural home.[13] He also joined the Welsh Group.

177 Robert Harding
Tree Ring: £7 of 2p coins
1997, 30 x 30 x 30 cm, coins

178 William Brown *Loup-Garou*
1998, 90 x 154 cm, acrylic on canvas

1 Spriggs in Jones, Glyn, ed. (2006)
2 Spriggs in *Painting: Ysbryd / Spirit - Wales,* 1998
3 Spriggs in Hughes, Robert Alwyn, ed. (2011)
4 Interview in Curtis, Tony (2000), pp.117-42
5 Briers, David, *Seven Sculptors Working in Wales,* Glynn Vivian Art Gallery, 1986
6 Krikorian, Tamara, in *On & off the Level: Neil John Evans & Robert Harding,* Glynn Vivian Art Gallery, 1994, p.6
7 Harding in Hughes, Robert Alwyn, ed. (2011)
8 Harding in *Revelations: Processes of Making Art,* The Welsh Group, 2000
9 *Size Matters: An Exhibition of Sculptures by Robert Harding,* Oriel y Bont, University of Glamorgan / Oriel Henry Thomas Gallery, CCTA, Carmarthen, 2002
10 Harding in Jones, Glyn, ed. (2006)
11 Moore, David, 'William Brown', obituary, *The Guardian,* 30 July 2008; Gascoigne, Laura, 'William Brown', obituary, *The Independent,* 26 July 2008; *What's Behind the Blanket?,* Glynn Vivian Art Gallery, 1996
12 *Beyond Loup-Garou,* Newport Museum & Art Gallery, 1998; Brown, William & Greenslade, David (1998) *March,* Bridgend; Greenslade, David, 'Performing in the Llan: David Greenslade on the art of William Brown', *Planet* 169, 2005, pp.59-62
13 Advised by Carys Brown, May 2012

What is the 56 Group Wales Doing? 2000 - 05

179 Glyn Jones, 2005

exhibiting artists
Gate Gallery:

Brendan Stuart Burns
Denis Gardiner
Arthur Giardelli
Robert Harding
Clive Hicks-Jenkins
Harvey Hood
Sue Hunt
Dilys Jackson
Glyn Jones
Martyn Jones
Christine Kinsey
Tom Piper
Peter Seabourne
John Selway
Christopher Shurrock
Peter Spriggs
Emrys Williams

180 (right)
Glyn Jones *Rangoli 1*
2005, 72 x 71 cm
oil and acrylic on paper

Tony Curtis selected this
work for the exhibition
Amongst Friends.

With the Group facing serious difficulties by 2000, no exhibitions occurred between 2001 and 2004. It is hard to identify the full causes of this breakdown although, with the removal from the committee of Tinker and Giardelli, lack of continuity seems to have been a factor. Sadly, Tinker died in 2000. Giardelli, in his late eighties, was caring for his wife Bim. Dalefield stood down as chair for personal reasons in 2000 and Weir was replaced as secretary by Peter Seabourne in 2001.[1] Of other members, Lyons had resigned the previous year as he needed research time and several did not continue membership through the uncertain years which followed.[2]

A series of meetings, initially between Glyn Jones, Seabourne, Spriggs, Gardiner and Harding, took place in this period at Chapter Arts Centre.[3] There was concern about uncollected subscriptions.[4] Seabourne arranged a meeting in 2001 indicating that the Group had reached 'something of a citical stage in its development.'[5] Giardelli responded: 'I admire and am grateful for your devotion to the Group and hope you will succeed in reviving it.'[6]

Throughout 2002 there was discussion about whether the Group should disband. A motion to approach the Welsh Group about a merger was rejected.[7] Not surprisingly, Giardelli reported: 'I often have people asking me: what is the 56 Group Wales doing?'[8] Glyn Jones suggested relaunching the Group with an exhibition to celebrate its fiftieth anniversary and Peter Wakelin, Group archivist, was invited to discuss it.[9] In 2004 Hood joined the discussions. Exhibitions were planned and participation invited. Jones described it as 'like starting the Group again.'[10] A turning point may have been a well attended general meeting at the Gate Arts Centre, Cardiff in late 2004. Glyn Jones was confirmed as chair and Spriggs as vice-chair.[11]

Amongst Friends: An exhibition of work chosen by friends of the artists, was launched in 2005 at the Gate Gallery.[12] Two works by seventeen artists were selected and accompanied by an explanatory statement by each friend. That autumn nineteen members showed in *56GW* at Penarth's Washington Gallery. The artists are not 'so relentlessly serious,' wrote Rosemary Markham, 'that they cannot, as a group, have a quiet period.'[13] This exhibition transferred to Oriel Henry Thomas Gallery, Carmarthen, where Glyn Jones and Wilkins gave talks.[14]

Peter Seabourne [born Abergavenny 1944; secretary 2001-11; member from 2004] is a painter who studied at Newport, Manchester, Cardiff and Aberystwyth. He taught in Llantarnam School, St Julian's School, Newport, and, 1981-87, Coleg Gwent and he lives in Usk. He first became involved with the Group as its secretary in 2001 at the suggestion of Gardiner.[15] At the time he was invited to become an exhibiting member he was painting ambiguous images of landscape.[16] By 2011 he was 'more interested in taking the figure out of its original context and placing it in another, more disturbing arena.' Surreal paintings of identical dolls explore ideas of tension between figures and in relation to empty space.[17] He often references seventeenth-century Dutch painting.

181 Peter Seabourne
The Two Mollies II 2006
50 x 39 cm, oil on canvas

1 AGM, 28 Oocber 2000, Cii; Dalefield to Weir, autumn 2000, Gvi; Meeting, 7 April 2001, Biii
2 Lyons to Weir, 27 September 2000, Gvi; Artstation, Brown, Gould, Lewis, Pickles, Rhys James & West left, 2001-04 (membership lists, May 2001 & Nov. 2004)
3 Meetings, 2001-05, Biii
4 Meeting, 7 April 2001, Biii
5 Seabourne to members, 19 October 2001, Biii
6 Giardelli to Seabourne, 25 October 2002, Fviif
7 Meeting, 26 January 2002, Biii

8 Giardelli to Seabourne, 17 January 2003, Fviif
9 Meetings, 16 October 2002 & 14 May 2003, Biii
10 Meeting, 16 June 2004, Biii; Conversation with Jones, Glyn, 30 April 2012
11 EGM, 4 December 2004, Cii; Conversation with Seabourne, 7 August 2012
12 Text for *Amongst Friends*, 2005, Uxviii
13 Markham, Rosemary, '56 reasons to enjoy Welsh art', *The Western Mail*, 23 Sept. 2005
14 AGM, 3 December 2005, Cii
15 Conversations with Seabourne, 28 February 2012, and Spriggs, 6 April 2012
16 Meeting, 16 June 2004, Biii; Seabourne, Peter, in Jones, Glyn, ed. (2006)
17 Seabourne in Hughes, Robert Alwyn, ed. (2011)

Clive Hicks-Jenkins [born Newport 1951; member from 2004] originally worked as a dancer, choreographer and stage designer but, in the 1980s, became a painter and print-maker.[1] His work, which now has a clear narrative focus, evolved from a concern with still-life and landscape. It is neo-romantic with a strong sense of theatre. In 2001 he exhibited drawings inspired by the tradition of the Mari Lwyd and emulating the Stations of the Cross.[2] His later *The Temptations of Solitude* was initiated after seeing fragments of a Tuscan altarpiece illustrating the lives of the desert fathers.[3] He has explored miraculous happenings and collaborated on books, such as Peter Shaffer's *Equus*, for the Old Stile Press. Anthony Hepworth and Martin Tinney have shown his work and the National Library of Wales staged a major retrospective exhibition.[4] Now living near Aberystwyth, he is a member of the Welsh Group, the Royal Cambrian Academy and an honorary fellow of the School of Art, Aberystwyth University.

182 Clive Hicks-Jenkins
Study for an Annunciation
2003, 78 x 43 cm, acrylic on board
Simon Callow selected this work for the exhibition *Amongst Friends*.

183 Christine Kinsey *Atonement 1*
2009, 40 x 30 cm, oil on canvas

Christine Kinsey [born Pontypool 1942; member 2004-09] is a painter and writer who studied at Newport College of Art and University College Cardiff. She taught in secondary schools and was, from 1968, co-founder and director of Chapter Arts Centre.[5] After living in the Netherland Antilles, she lectured part-time in Carmarthen, 1982-2001. From 2007 she was an honorary research fellow at Swansea Metropolitan University. Words, including those of Jung, are a starting point for visual work.[6] 'The themes of liberation and enclosure,' she explains, 'are vehicles that articulate the narrative line in my paintings…'[7] These are set against knowing about being female, growing up in an industrial Welsh valley, living in west Wales and her sense of being Welsh. 'In her exploration of the historical and spiritual dimensions of women's lives,' explains Ceridwen Lloyd-Morgan, 'she openly confronts Scripture as mediated by male authority over two millennia…'[8] She was a co-founder of the Association of Artists and Designers in Wales.

Dilys Jackson [born Badulla, Sri Lanka, 1938; member from 2004; vice-chair 2008-10; chair from 2010] is a sculptor and environmental artist who attended the Slade School of Fine Art and Swansea College of Art.[9] Studying special education and psychology informed working in Cardiff special schools. She has organised exhibitions for women's arts festivals, managed environmental arts projects, held residencies in Wales and abroad and received commissions.[10] Earlier involvement in political protest was reflected in an installation using packing case shapes to suggest a production line of victims. Now, she explains, her work 'derives from the kinaesthetic relationship that I experience between natural forms and those of the human body.'[11] Cylinder or pod forms in bronze, stone or ceramic may be contrasted with bronze elements cast from bark. Recently she has used cast iron.[12] She has chaired Cywaith Cymru / Artworks Wales, the Women's Arts Association and Sculpture Cymru and belongs to the Welsh Group and the Royal British Society of Sculptors.

1 Wakelin, Peter, ed. (2011) *Clive Hicks-Jenkins*, Lund Humphries
2 *The Mare's Tale: Paintings, Drawings and Relief Prints by Clive Hicks-Jenkins*, Newport Museum and Art Gallery, 2001
3 Wakelin, Peter, ed. (2004) *The Temptations of Solitude: Paintings by Clive Hicks-Jenkins*, Grey Mare Press; Lloyd-Morgan, Ceridwen, in O'Kane, Martin, & Morgan-Guy, John (2010), pp.313-14
4 Price-Owen, Anne, 'Clive Hicks-Jenkins', *Planet* 203, 2011, pp.48-61
5 *Chris Kinsey: Cymreictod: Welsh Women/Menywod Cymru*, Chapter Arts Centre, 1989; *Christine Kinsey: Another Life: Paintings and Drawings/Bywyd Arall: Peintiadau a Darluniau*, Henry Thomas Gallery, Carmarthen, 1994; Kinsey, 'A Space of Silent Belonging', *Planet* 193, 2009, pp.33-41
6 Osmond, Osi Rhys, 'Visual Voices and Contemporary Echoes' in Kinsey, Christine and Lloyd-Morgan, Ceridwen (2005), pp.161-63
7 Kinsey in Jones, Glyn, ed. (2006)
8 Lloyd-Morgan, Ceridwen, as 3 above, p.314
9 Hourahane, Shelagh, 'Making Opposites Meet' in Jackson, Dilys (2003) *Dilys Jackson: Sculptor*, Cardiff; Jackson in Hughes, Robert Alwyn, ed. (2011), pp.20-21
10 For her work with Groundwork Ogwr see: Cope, Phil, et al, eds. (1996) *Chasing the Dragon*, Valleys' Initiative for Adult Education, pp.58-60
11 Jackson in Jones, Glyn, ed. (2006) 12 Jackson, Dilys, in *Iron Maidens / Morynion Haearn*, 2009

184 Dilys Jackson
Spikes 2007
each 120 x 20 x 20 cm, cast iron

Tom Piper

Carol Hiles

185 Two sample pages from the Group's 2006 promotional folder

Fiftieth Anniversary and Beyond, 2006 - 07

Glyn Jones, as Spriggs points out, 'has regenerated the Group and pointed it in its current direction.'[1] To facilitate his planned focus upon the fiftieth anniversary, funding was obtained from the Arts Council for Wales.[2] He co-ordinated an A4 bilingual promotional folder about the members. Designed and produced by Pixel, additional funding was obtained from the Estorick Foundation, the Contemporary Art Society for Wales and Coleg Sir Gâr. In 2006 Spriggs replaced Glyn Jones as chair. Robert Alwyn Hughes, who joined in 2005, became vice-chair and Hood treasurer.[3]

As part of the anniversary it was decided to create an annual fellowship for a recent graduate from a Welsh art school to exhibit alongside members.[4] They were nominated by art schools and then assessed by the Group. 'We are finding,' explained Spriggs, 'that this is a good means of attracting new blood into the Group.'[5] Beth Marsden, Coleg Sir Gâr, was appointed for 2006, and Alison Harris, University of Glamorgan, for 2007.

Plans for an exhibition at National Museum Cardiff in the summer of 2006 had to be cancelled due to extensive re-roofing work.[6] The Museum's interest, however, was signalled by two lunchtime events; a talk by Michael Tooby from the Museum and an interview with Group founder Michael Edmonds.[7] The Museum also displayed one work from each decade of the Group. The anniversary was celebrated, too, by the nearby Kooywood Gallery showing work by twenty current members.

The main celebratory exhibition, towards the end of 2006, was *50 Years of the 56 Group Wales* at the National Library of Wales. Arranged at relatively short notice,

186 John Selway
The Conformist 2002
122 x 183 cm, oil on canvas
This was shown at the National
Library of Wales in 2006.

187 50th anniversary exhibition
at the National Library of Wales showing,
left, two paintings by Emrys Williams, *Reading*
and *To the Lighthouse No 17*, and, beyond
the cases, *Spikes*, a sculpture by Jackson.
Facing on the right are paintings, left,
Time, Light and Shadow by Spriggs and
The Man who Lived in a Tree by Hicks-Jenkins.

Burns and Spriggs liaised with the Library. 'It is appropriate and wonderful,' wrote a delighted Giardelli, 'that they are giving us (and we them!) the exhibition.'[8] The title was, perhaps, a little optimistic as a high proportion of the eighty-three works were by current members. Nevertheless, it included Malthouse, Tinker, Edmonds, Wright, Setch, Wilkins, Crawford and Mary Lloyd Jones. Historic works were borrowed from the National Museum and Aberystywth School of Art. *Where the Tide Turned*, the 1983 HTV Wales programme about the Group, was also shown. It now seemed charmingly dated.

Several reviews of the exhibition appeared.[9] Shiel in *Cambria* lamented 'the cramming together of extremely disparate work in various media,' and, 'the omission of examples of work by important painters and sculptors.' Overall, however, he felt that 'the exhibition demonstrates the astonishing evolvement of the language of art internationally since the last World War and with what accomplishment that diverse language is being handled in Wales.'

2007 exhibitions in Wales, generally co-ordinated by designated members, reinforced the Group's revival. One in the summer at Cynon Valley Museum & Gallery was transferred to Llantarnam Grange Art Centre. *New Work* was shown at St David's Hall that autumn and, to close the year, there was also a show at The Gallery restaurant in Barry. 'The exhibition,' Spriggs explained to members, 'is part of the Group's policy to show in diverse venues.'[10] Robert Alwyn Hughes, with his digital skills, had been commissioned in 2006 to produce a website for the Group, which was launched in 2007.[11] The Group's archive catalogue was also completed.[12] Sadly, Prendergast, a member since 1982, died.[13]

188 Invitation to the opening of the 2007 Llantarnam Grange exhibition featuring Kinsey's *A Moment in the Dance*.

Robert Alwyn Hughes [born Dowlais 1935; member from 2005; vice-chair 2006-08; chair 2008-10, past-chair from 2010] is a painter who studied at Newport, Leicester and the Royal colleges of art. He exhibited abstract work and was, in 1962, appointed lecturer at Cheltenham College of Art.[14] He became head of photographic studies. Retirement in 1991 enabled him to concentrate on painting and managing a web design business. His work draws eclectically upon personal memories, the Welsh landscape, archaeology, history, cultural traditions, poetry, music, war, the bible and mythology. Characteristically, it consists of large, cinematic visual narratives with a contemporary twist.[15] 'The language of abstraction, of photo-realism, of pop art, of renaissance frescoes,' writes Bala, ' - all these jostle for our attention...'[16] His *Black Box Series* includes free-standing blades of colour on black photographed in a landscape, in part exploring how art defines space.[17] Newport Museum and Art Gallery held a major exhibition in 2006. Later that year he exhibited for the first time with the Group in Aberstwyth. Although living in Cheltenham, he also belongs to the Watercolour Society of Wales and the Welsh Group. His chairing of the latter coincided, uniquely, for a short period with that of 56 Group Wales.

189 Robert Alwyn Hughes *Untitled.... or maybe !... Someday I'll fly away....* Three panels, each 213 x 122 cm, 2004-05, mixed media on canvas

1 Spriggs interview with Shiel, Derek, '56 Group Wales: Exhibiting at Home and Abroad', unpublished, 2007, Vxi
2 Newland, David, to Seabourne, 16 May 2005, Fviif. £4,437 received from ACW for the fiftieth anniversary exhibitions.
3 AGM, 9 December 2006, Cii
4 AGM, 3 December 2005, Cii
5 Spriggs interview with Shiel, Derek, as 1 above
6 Spriggs to Tooby, Michael, 2 September 2007, email, Uxxia
7 AGM, 9 December 2006, Cii
8 Giardelli to Spriggs, undated message with work details, autumn 2006, Uxxib
9 Shiel, Derek, '56 Group Wales 2006', *Cambria*, December/January 2006-07, pp.52-53; Moore, David, '56 Group at 50', *Planet* 180, December/January 2006-07, pp.122-24; Lloyd-Morgan, Ceridwen, 'Cynhaeaf Hanner Canrif: Dathlu Pen-Plwydd *Grŵp* 56 Cymru', *Taliesin*, Gwanwyr 2007, Cyfol 130, pp.86-96
10 Spriggs to members, 19 September 2007, Uxxvi
11 19 June, 2006 & 14 September 2006, emails, Vviii; AGM, 9 December 2006, Cii; www.56groupwales-art.co.uk
12 Moore, David, 'Archiving & History Project, Report for AGM', Dec. 2007, Cii; Moore, David, & Wakelin, Peter, *Catalogue of Records of 56 Group Wales, 1956-2007*, 2007
13 Meeting, 14 March 2007, Biii
14 He exhibited in *Four Welsh Painters, One Sculptor*, Howard Roberts Gallery, Cardiff, 1961
15 O'Leary, Hannah, in Jones, Glyn, ed. (2006); Lloyd-Morgan, Ceridwen, in O'Kane, Martin, & Morgan-Guy, John (2010), p.313
16 Bala, Iwan, in *Robert Alwyn Hughes: The Indistinct Breath of the Image, Recent work, 1990-2006*, Newport Museum and Art Gallery, 2006
17 Hughes, Robert Alwyn, *Black Box Series*, 2006

New Members, 2007

190 Richard Renshaw with *The River Gods are Angry* 2005, 10 x 152 x 25 cm, slate

Richard Renshaw [born Beverley, Yorkshire, 1950; member from 2007] is a sculptor who studied geology at the University of Manchester.[1] He worked briefly as a geophysicist but realised that climbing mountains around the world, funded by part-time construction jobs, was a greater priority than a secure career. He developed an interest in woodcarving and contemporary art and the 1988 Royal Academy Henry Moore exhibition influenced him to become a sculptor. Now working in stone, iron, bronze and wood, he is fascinated by the interaction of sculpture with landscape. Much of his work is abstract although it is influenced by the natural environment. Commissions include work for the Groundwork Trust and a cast bronze plaque of natural objects on the Beacons Way Art Trail. He has held many exhibitions in Wales and London, including the 2007 *Confluence* at Craft in the Bay, Cardiff, with Sue Hiley Harris.[2] He lives in Cwmdu in the Black Mountains.

Antonia Spowers [born Knaresborough, Yorkshire 1934; member from 2007] is a sculptor who studied in Paris, Florence and London. In 1998 she moved to Talgarth in Wales. Interested in the physical properties of materials, both natural and man-made, and in their potential to express ideas, she makes assemblages on different scales.[3] Her earlier work, concerned with environmental and sustainability issues, used paper, glass and wire to convey states of energy. More recently she has used molten glass and bronze to express the life and death of civilisations and concepts of dislocation and chaos.[4] A large cast-iron and hardwood sculpture *Not Quite Cloned* was included in the 2010 Sculpture Cymru exhibition at Kidwelly Castle.[5] She has held residencies, including one in Lithuania, received commissions, exhibited in Wales and London and belongs to the Welsh Group, the Royal British Society of Sculptors and the International Association of Paper Artists.

191 Antonia Spowers *The Golden Gates* 2008
145 x 206 x 4 cm, painted aluminium and gold glass mosaic

192 Ken Elias
Indelible Landscape (ii) 2006
79 x 57 cm, acrylic & collage on paper

Ken Elias [born Glynneath 1944; member from 2007] is a painter and printmaker who, initially, worked as a laboratory technician. Taught by former Group members - Roberts in evening classes, Hudson and Tyzack at Cardiff, Selway and Zobole at Newport - he, in turn, taught in south Wales schools for twenty years. He then lectured at Swansea College of Further Education, 1990-96.[6] Earlier work was concerned with consumerism and pop art. Later work features memories of a 1950s Glynneath childhood, particularly visits to the local cinema, a process described as 'reclaiming the landscape of childhood with an adult vision.'[7] Parallels are drawn between personal and cinematic narratives. Wakelin recognises that 'Elias has tried to replicate in paint the way in which, as a writer, Denton Welch created fictions out of autobiography.'[8] Geometric form, echoing hard-edged abstraction, is part of his imagery. He returned to Glynneath in 1994. Exhibited extensively in Wales, he belongs to the Welsh Group and Royal Cambrian Academy.

1 'Richard Renshaw' in Moore, David (2007) *8 Stones, 8 Artists: Exploring the Beacons Way Art Trail*, Little Fish Press, pp.12-13
2 Moore, David, in *Confluence: Sculpture by Sue Hiley Harris & Richard Renshaw*, Craft in the Bay, Cardiff, 2007
3 Spowers in Hughes, Robert Alwyn, ed. (2011), pp.40-41
4 *The Circle Squared*, Newport Museum & Art Gallery, 2009. This focuses on glass.
5 Spowers, Antonia in *Ironstone: An international exhibition of contemporary cast-iron sculpture*, Kidwelly Castle, Sculpture Cymru, 2010, pp.46-47
6 Thomas, Ceri, 'Et in Arcadia Ego: Ceri Thomas explores the painted world of Ken Elias', *Planet* 141, June/July 2000, pp.36-42; Thomas, Ceri, ed. (2009) *Ken Elias: Thin Partitions*, Seren
7 Elias, Ken, *Finding a Way*, Newport Museum and Art Gallery, 2005, p.24
8 Wakelin, Peter, 'Solid Geometry: The Art of Ken Elias' in *Ken Elias: Finding a Way*, 2005, p.15

All of These Things, 2008 - 10

2008 was an active year. *Exhibiting at Home* opened in February at Howard Gardens Gallery, University of Wales Institute Cardiff, where many members and new graduate fellow Christian John Olsen, had trained or taught.[1] That spring a showing at The Art Shop, Abergavenny, was accompanied by a talk from David Moore about the Group's past. Giardelli, in his final appearance at a Group show in the summer, made a spontaneous and entertaining contribution to the launch of *Mixing West* at Tenby Museum & Art Gallery.[2]

All of These Things, the Christmas 2008 show at Oriel Myrddin Gallery, Carmarthen, was linked to a second talk on the Group's history. Inspired by the arrangement of Giardelli's art collection, gallery director Meg Anthony advised: 'I would like to go for a dramatic installation of works… Like an RA style double/triple hang, dense and curious.'[3] Meanwhile, in Aberystwyth, an exhibition and publication surveying the Welsh Group on its sixtieth anniversary had been launched at the National Library.[4]

2009 exhibitions were *Mix 56* at Cardiff's Wyndam Arcade Gallery and *Opening Show* at Swansea's Mumbles Road Gallery. The exhibition in 2010 at Queens Hall Gallery in Narberth, sadly, followed Giardelli's death at the end of 2009.[5] Kevin Sinnott exhibited for the first time.

In 2008 Hughes became chair, Jackson vice-chair, Spriggs past-chair and Martyn Jones treasurer, Seabourne remaining secretary.[6] Concern about the accuracy of the Group's entry in an encyclopaedia of Wales highlighted the need for a researched account of its history.[7] Sue Williams and Kinsey resigned in 2009 due to incompatible work commitments, reducing to four the number of women members.[8]

Kevin Sinnott [born Sarn, Bridgend, 1947; member from 2009] is an expressionistic figurative painter who studied at Cardiff, Gloucestershire and the Royal College of Art. Living in London, he won a prize at John Moores Liverpool, became a visiting lecturer and established a successful career. He drew upon older motifs in Turkish bath paintings inspired by Ingres' *Le Bain Turc*.[9] In 1995 he returned to Wales, settling in Maesteg.[10] 'I started to feel that relationship between figure and landscape as an enhancement of my work and that was a direct result of my returning to Wales.'[11] Recently, place has become less important. 'The main aspect of my narrative,' Sinnott explains, 'has been the physical relationship of a man and a woman, a boy and a girl.'[12]

193 Publicity leaflet designed by Hughes, 2008, featuring images of members. It promoted the Group's website.

exhibiting artists
Carmarthen:

Brendan Stuart Burns
Ken Elias
Dennis Gardiner
Arthur Giardelli
Robert Harding
Clive Hicks-Jenkins
Carol Hiles
Harvey Hood
Robert Alwyn Hughes
Sue Hunt
Dilys Jackson
Glyn Jones
Martyn Jones
Christine Kinsey
Christian John Olsen (fellow)
Tom Piper
Richard Renshaw
Peter Seabourne
John Selway
Christopher Shurrock
Antonia Spowers
Peter Spriggs
Emrys Williams

194 The unusual arrangement of works in *All of These Things* at Oriel Myrddin Gallery, Carmarthen, 2008

195 Kevin Sinnott in front of *Hard to Get* 2011, 244 × 305 cm, oil on linen

1 Press Release for *Exhibiting at Home: 56 Group Wales*, Howard Gardens Gallery, Cardiff, 2008
2 AGM, 6 December 2008, Cii
3 Conversation with Meg Anthony, Nov. 2009; Anthony, Meg, 'Exhibition proposal: All of These Things', 2008
4 Thomas, Ceri (2008). The exhibition toured to Conwy and Newport.
5 There was a tribute to Giardelli by Osmond, Osi Rhys, in *Oriel Q Newsletter*, 29 December 2009
6 AGM, 6 December 2008, Cii
7 Meeting as 6 above; Davies, J., Jenkins, N., Baines, M. & Lynch, P. I., eds. (2008) *The Welsh Academy Encyclopaedia of Wales*, UWP, Cardiff. This refers to the Group by its pre-1967 name only and inaccurately lists Giardelli as one of four founders. To refer to the original members 'as a pressure group to divert art policy and production in Wales from what they perceived as a national to an international agenda' misrepresents what was, essentially, an exhibiting group primarily concerned to create opportunities to show its members' work, much of which was influenced by international movements in art.
8 AGM, 5 December 2009, Cii; Conversation with Kinsey, August 2012. She resigned on 16 January 2009.
9 *Kevin Sinnott: Turkish Bath Paintings*, Flowers East, 1992
10 Sinnott, Kevin (2008) *Behind the Canvas*, Seren
11 Sinnott in Curtis, Tony (1997), p.133
12 Sinnott in Hughes, Robert Alwyn, ed. (2011)

196 The cover and Hood's pages from the Group's 2011 book.

Marking 56 Years, 2011 - 12

At the 2010 annual general meeting Jackson became chair and Rebecca Spooner secretary. Heledd Mair Griffiths would succeed Spooner in 2011.[1] That year a book, compiled and designed by Hughes to promote the current members, was launched and the Group exhibited at Oriel Canfas Gallery, Cardiff.[2]

'56 Years of 56 Group Wales' are explored in 2012 with this account of its history. Kooywood Gallery showed work by the three founders and National Museum Cardiff featured selected abstract artists from the Group's early decades.[3] *Marking 56 Years* at Cardiff's Bay Art in the summer included current, and three new, members and graduate fellows, Kay Keogh and Victoria Malcolm.[4] Current members also exhibited at Machynlleth in the autumn. The University of Glamorgan is due to exhibit a private collection of works by the founder members with a related publication.[5]

Pete Williams [born London 1965; member from 2012] is a printmaker and sculptor, living in Penarth, who studied at Cheltenham and Brighton. He has lectured in Newport, Carmarthen and Swansea and directed print workshops in Portsmouth and Cardiff, establishing the independent Print Market Project in Cardiff in 2011. He favours a non-toxic approach, making bold woodcuts and constructions from found materials. At a recent residency at Aberystwyth Arts Centre his pace at running in the countryside was reflected in the way he cut large blocks.[6]

Alison Lochhead [born Cardiff 1953; member from 2012] is a sculptor and ceramicist, now living in Ceredigion, who studied at Loughborough and Wolverhampton. Later, she learnt weaving in Poland and lectured part-time in Bath. After working in Oman she returned to Wales, using paper pulp to make large wall pieces. Now combining clay and cast iron, these 'fuse or are fused apart; resisting each other, reflecting the actions within the landscape.'[7] She makes sinister vessels and casts of her body.[8] Lochhead is a member of Sculpture Cymru.

Justine Johnson [born Orange, United States, 1960; member from 2012] studied drama and costume design in San Francisco, shibori in Japan, sculpture in Carmarthen and fine art at Middlesex University.[9] She has designed sportswear, lectured in costume design and worked with disadvantaged people. 'I am searching consistently for emotional truths,' she writes, 'through the making of structures and forms.'[10] These emphasise the unique characteristics of bronze, cast iron, leather, wool and cast concrete. Exhibited widely, she is a member of Sculpture Cymru.

197 Pete Williams *Devil's Bridge Rocky Woods.* 8.05m 11358s 1h.21t 2012. 244 x 244 cm, woodcut block

198 Alison Lochhead *Dug Up Contortion* 2011 36 x 62 x 30 cm, cast iron & ceramic

199 Justine Johnson *Unity* (detail) 2012. 295 x 96 x 96 cm, bronze

1 2010 AGM, postponed to 23 January, 2011; AGM, 10 December, 2011, Cii
2 Hughes, Robert Alwyn, ed. (2011)
3 *56 Group Wales: The Founders*, Kooywood Gallery; *Going Modern: The Struggle for Abstract Art in Wales*, National Museum Cardiff
4 Kay Keogh, University of Glamorgan, & Victoria Malcolm, Coleg Sir Gâr
5 Maskell, Barrie, & Thomas, Ceri (forthcoming) *Twelve/56: 12 artists in 1956 Wales and beyond*, University of Glamorgan
6 www.printmarketproject.com, 2012
7 Lochhead, Alison, in *Iron Maidens*, Llantarnam Grange Arts Centre, 2009
8 Wakelin, Peter, 'Alison Lochhead: Death Boats', *Planet* 194, Spring 2009, pp.154-56
9 www.justinejohnson, 2012
10 Johnson, Justine, in *Iron Maidens*, 2009

56 Group Wales, 56 Years

A group of artists in existence for over fifty years will, inevitably, have experienced considerable change. Despite this, 56 Group Wales has, throughout, been an exhibiting association of independent artists. Members have lived or worked in Wales, the nation's name being added, in Raymond Eyquem's words, 'to define its geographical base and spirit.'[1] It has limited its membership to maximise exhibiting space for each artist.[2] For many years it stood for non-selection by outsiders although this policy was relaxed on the Continent and, on other occasions, from the late 1970s. The majority of members have been painters, as in the London Group, but sculptors have also been prominent and exponents of other media - such as printmakers and installation artists - have been represented. Members have spent varying amounts of time in the Group and there have been periods of intense reassessment of its values.[3] Significant artists, too, have kept their distance from it.[4]

Whilst it does not stand for a particular ideology or style, in the early decades the Group allied itself to modernism and internationalism. Abstract tendencies have been prevalent but it has always been more wide-ranging. 'They were united far more,' explained Bryn Richards in 1971, 'by what they rejected in the art situation in which they found themselves than by what they accepted.'[5] There has been a marked swing towards more figurative forms of expression in recent decades. Postmodernist tendencies, too, such as social concerns, have combined with renewed interest in the culture and history of Wales. This is also apparent in the Welsh Group.[6] Indeed the two groups, which have always had members in common, have become closer in nature.[7]

Externally, the art scene in Wales has changed dramatically from the 1950s-style open art exhibitions which the Group regarded as conservative and which it was, in part, founded to counteract. Arts councils, under various names, have developed and supported the activities of artists and the Group has benefited considerably. Arts centres, public and independent galleries, whilst experiencing economic fluctuations, have proliferated. The Group has, in its wider concern for the professional artist, campaigned for, and exhibited in, many of them.

Strong links with art colleges, although not as extensive as they were, have been a feature of the Group and it has been an important way in which art lecturers have been able to show their work more widely. Many who became members moved to Wales to work in its art schools.[8] Some have made important contributions to the practice and appreciation of the visual arts in Wales, responding to its history, culture and environment in original ways. Teaching links with Cardiff and, to a lesser extent, Newport colleges of art have been particularly strong, most noticeably following the 1960s art education changes. Many fine art fellows at Cardiff joined in the 1970s and early 1980s. More recently, dramatically more members have been full-time artists.[9]

It is remarkable that 56 Group Wales, along with the Welsh Group, has survived whilst other artist associations, such as the Association of Artists and Designers in Wales, have come and gone.[10] Rowan indicated in 1969 that 'the main problem now facing the Group is to avoid a repetition of the kind of stultification which caused its own genesis.'[11] Its long survival, however, may be attributed to: clear, visionary and strategic direction; insistence upon quality; lively internal debate; tenacious and efficient administration; careful financial management; a capacity for renewal; and diligent networking. Regular Welsh Arts Council revenue support was vital to the Group until it ended in the late 1980s, although it continued for specific projects. More recently, with the loss of continuity at the end of the 1990s, the Group faltered. It has, however, survived due in part to the realisation that past achievements have been worth building upon.

One of the Group's greatest achievements has been its exhibiting ambition, both inside and outside Wales and, in particular from the late 1960s

200 At the launch of *Marking 56 Years* at Bay Art in 2012: Hughes, centre left, talks to Setch beside Jackson's steel sculpture *High Valley*. Front right, Spowers talks to David Moore. Hood's cast iron sculpture *Domus / Subprime* may be seen between them. Two-dimensional works by Selway, Gardiner and Shurrock are on the walls.

to early 1990s, on the Continent. Unrealised projects reveal the true extent of this. No other artist group from Wales, and possibly few from anywhere in Britain, have achieved, in this period, the same level of international exposure.[12] Many of these exhibitions were in high profile venues and attracted diplomatic support. High points included Nantes in 1974, Bologna in 1983, a tour of Czechoslovakia in 1986 and of the Czech Republic in 1991. For a sustained period the Group played a substantial role in developing cultural exchanges between Wales and other countries. This was due largely, in addition to general factors, to Giardelli's European outlook and language skills, attention to diplomacy, good relationships with key people and help from Welsh galleries in showing exchange exhibitions. The Group also learnt from failure and, occasionally, had to compromise slightly its principles.

The extent to which the Group represented Wales is indicated in that, of two hundred and twenty-five exhibition showings over fifty-six years, well over one third were outside it.[13] The intensity of earlier exhibiting is reflected in that more than double the number of showings occurred in the first half of its existence than in its second.[14] Of exhibiting in the 1960s, the number of showings outside Wales first equalled and, then, more than doubled those inside Wales and most of these were in England. In the 1970s there was a marked re-focusing back home, although still with many showings outside. In the early 1980s the overall number of showings halved, with most in Wales. Through the 1990s, the numbers evened up again before a marked withdrawal into Wales and, since 1997, all showings have been in Wales. Despite the city's art credentials, the Group has only exhibited in London twice.

Exhibiting success, however, had a downside. Bryn Richards remarked in 1971 that the Group had 'seen itself change from a number of revolutionary outsiders to a group of respected establishment figures.'[15] The hard-won high profile, particularly by the mid-1970s, inevitably attracted criticism from those who felt that the Group had become unduly dominant and was attracting too large a slice of public funding. Concern about the diffusion of modernism and international movements in art have also associated it with cultural colonialism.[16] This, despite the Group's involvement, particularly from the 1980s, of artists with artistic and cultural concerns which were more specific to Wales.

The Group's future success is likely to reflect its ability to embrace social, economic, cultural and political opportunities. Its current graduate fellowship scheme indicates a desire to encourage a younger generation of artists.[17] Recent recruitment of more women members, too, should help redress an inequality which is not apparent in other groups, notably the Welsh Group.[18]

The founder members were identified by *The Times* in 1957 as providing Wales with 'a taste of the avant-garde.'[19] Work by 56 Group Wales members today reveals a diversity of art practice. It embraces the new and experimental as well as mature work of great imagination, skill and distinction.

1 Eyquem, Raymond, '56 Group Wales: Images', introduction to *Lettera*, Quaderno 1, June 1975
2 From 12 members in 1956, it doubled in 1967, stabilising between 20 & 24, with a slight rise to 26 in 1997. The Welsh Group, larger in the past, has 36 members in 2012.
3 The average length of membership for past members has been 11 years, ranging from Giardelli's 53 to Sear's 1.
4 Shurrock to Seabourne, 14 October 2002, Fviif
5 Richards, Bryn, 'Some Members of the 56 Group', *The Anglo-Welsh Review*, Vol. 20, No. 45, 1971, autumn, p.180
6 Wakelin, Peter (1999), p.83; Bala, Iwan (1999), pp.14-15
7 Piercy, Jill, 'The Atrocities Over There,' *Planet* 126, December 1997/January 1998, p.94; Thomas, Ceri (2008). Between 1998 and 2008, 9 of the 48 Welsh Group members discussed were, at the same time, in 56 Group Wales.
8 Of 88 full members, 20 were born in Wales, 54 in England, 1 in Scotland and 13 abroad.
9 Main occupation whilst in the Group: 1956-84 - Cardiff, lecturers17 & fellows 7; Newport, lecturers 12; other Welsh lecturers & fellows 5; England, lecturers & fellows 2; part-time lecturers/artists, 3; other professions, 3. 1985-2012 - Cardiff, lecturers 3 & fellow 1; Newport, lecturer 1; other Welsh lecturers 8; England, lecturers 1; part-time lecturers/artists 4; other professions 3; full-time artists 18 (including 5 retired lecturers/teachers).
10 AADW, 1974-88 (www.archiveswales.org.uk)
11 Rowan, Eric, in *56 Group Wales*, Scottish tour, 1969
12 The Welsh Group did not, until relatively recently, have such ambitious exhibiting aspirations. Even a visit to Bristol in 1968 was unusual as was an exhibition to Glasgow in 1997 which, subsequently, toured to the European Parliament in Strasbourg (Wakelin, Peter, 1999, pp.50-52). It did, however, tour in the Republic of Ireland, 1999, to Libramont, Belgium, 2001, and to Chicago, 2003 (Thomas, Ceri, *Mapping the Welsh Group at 60*, The Welsh Group, 2008, pp.76-77). The London Group visited Scotland in 1945, Sydney, Australia, in 1946 and Amsterdam in 2006 (Redfern, David, 2008).
13 37 % were outside Wales (22% in England, 7% on the Continent, 4% in Scotland and 4% in the Republic & Northern Ireland)
14 71% 1956-84; 29% 1985-12
15 Richards, Bryn, as 5, above
16 Lord, Peter (1998), p.266; Bala, Iwan (1999) p.13
17 The average age of the Group was: 36 in 1956; 39 in 1967; 45 in 1977; 44 in 1987; 49 in 1997; 59 in 2007; 63 in 2012. David Alston made a plea, in opening *Marking 56 Years* in 2012, that there should be more members under 56. The figures for the London Group do not range to such an extent but have risen steadily in the post-war period.
18 19% of all members were women (1956-84, 2 women; 1985-2012, 15 women). London Group: 23 % of all members were women by 2006 (Redfern, David, 2008). Welsh Group: 25% of all members, 1955-99, were women (Wakelin, Peter, 1999, p.94); 40% of all members, 1998-2008, were women (Thomas, Ceri, 2008) & 50% in 2012 (figure from Heledd Mair Griffiths). 29% of 56 Group Wales women were in a partnership with a Group man; in the London Group, by 2006, it was 22% (Redfern, David, 2008).
19 'Wales Gets a Taste of the Avant-Garde', *The Times*, 11 July 1957

Bibliography

There are many references to books, catalogues, articles, press coverage and archives (references 'A' to 'V') in the footnotes. Only publications regularly referred to are listed here.

Art History

Garlake, Margaret (1998) *New Art, New World: British Art in Postwar Society*, Yale

Jones, Huw David (2012) 'An Art of Our Own: State Patronage of the Visual Arts in Wales, 1945-1967', *Contemporary British History*, Taylor & Francis

Lord, Peter (1998) *The Visual Culture of Wales: Industrial Society*, University of Wales Press

Lord, Peter (2000) *The Visual Culture of Wales: Imaging the Nation*, University of Wales Press

Lloyd-Morgan, Ceridwen, 'Decline or Transformation? Modern Welsh Artists and the Welsh Biblical Heritage', in O'Kane, Martin, & Morgan-Guy, John (2010) *Biblical Art in Wales*, Sheffield Phoenix Press

Rowan, Eric, in Stephens, Meic, ed. (1979) *The Arts in Wales, 1950-75*, Welsh Arts Council

Rowan, Eric (1985) *Art in Wales: An Illustrated History, 1850-1980*, Welsh Arts Council / University of Wales Press

Wakelin, Peter (2004) *An Art-Accustomed Eye: John Gibbs & Art Appreciation in Wales, 1945-1996*, National Museums & Galleries of Wales

Artists

Bala, Iwan, ed. (1999) *Certain Welsh Artists: Custodial Aesthetics in Contemporary Welsh Art*, Seren

Bala, Iwan (2003) *Here + Now: Essays on Contemporary Art in Wales*, Seren

Brown, Peter (2009) 'Newport College of Art, 1958-1975' in *No More World's to Conquer: The Story of Newport's University*, University of Wales, Newport

Buckman, David (2006 ed.) *Artists in Britain since 1945*, Art Dictionaries Ltd.

Curtis, Tony, ed. (1997) *Welsh Painters Talking*, Seren

Curtis, Tony, ed. (2000) *Welsh Artists Talking*, Seren

Giardelli, A. & Shiel, D. (2001) *Arthur Giardelli: Paintings, Constructions, Relief Sculptures. Conversations with Derek Shiel*, Seren

Hudson, Mark (2011) *Transition: The Inner Image Revisited - Expanding Form, Materials, Image: Leicester, Cardiff 1960-68*, Art Space Gallery

Kinsey, Christine & Lloyd-Morgan, Ceridwen, eds. (2005) *Imaging the Imagination*, Gomer

Meyrick, Robert, ed. (2002) *Enter the Conjuror's Cabinet: David Tinker, Painter, Sculptor, Stage Designer, Teacher - a Retrospective*, University of Wales, Aberystwyth

Tinker, David (c.1997) 'Looking Back', unpublished autobiographical writings

Osbourne, Peter & Samuel, Gordon, eds. (2007) *Towards a Rational Aesthetic: Constructive Art in Post-War Britain*, Osbourne Samuel

Stephens, Meic, ed. (1971) *Artists in Wales*; (1973) *Artists in Wales 2*; (1977) *Artists in Wales 3*, Gwasg Gomer

56 Group Wales

Art in Wales (1969) *The Twentieth Century: Today - 56 Group Wales*, Welsh Arts Council

Fraser Jenkins, A.D. (1981) 'The 56 Group Wales on its twenty-fifth anniversary', *56 Group Wales in 1981*

Giardelli, Arthur, ed. (1976) *Grŵp 56 Cymru, 56 Group Wales: The Artist & How to Employ Him*

Hughes, Robert Alwyn, ed. (2011) *56 Group Wales / Grŵp 56 Cymru*

Jones, Glyn, ed. (2006) *56 Group Wales / Grŵp 56 Cymru*

Richards, Bryn (1971) 'Some Members of the 56 Group', *The Anglo-Welsh Review*, Vol. 20, No. 45

Other Artist Groups

Fowler, Alan, ed. (2008) *A Rational Aesthetic: The Systems Group and Associated Artists*, Southampton City Art Gallery

Lynton, Norbert, et al (1998) *Painting: Ysbryd / Spirit - Wales*

Redfern, David (2008) *The London Group: Origins & Post War History*, London Group

Robbins, David, ed. (1990) *The Independent Group: Postwar Britain and the Aesthetics of Plenty*, MIT Press

Thomas, Ceri (2008) *Mapping the Welsh Group at 60*, The Welsh Group

Wakelin, Peter (1999) *Creating an Art Community: 50 Years of the Welsh Group*, National Museums & Galleries of Wales

56 Group and 56 Group Wales: Chronological Chart of Full Membership over Fifty-Six years

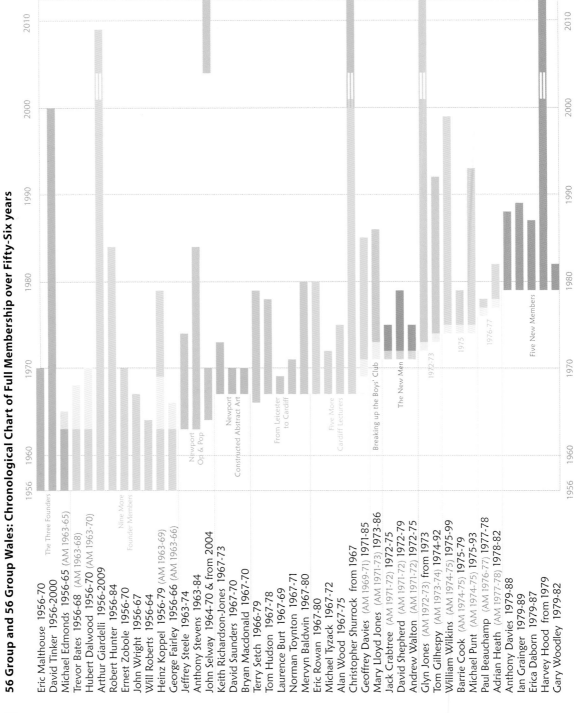

Eric Malthouse 1956-70
David Tinker 1956-2000
Michael Edmonds 1956-65 (AM 1963-65)
Trevor Bates 1956-68 (AM 1963-68)
Hubert Dalwood 1956-70 (AM 1963-70)
Arthur Giardelli 1956-2009
Robert Hunter 1956-84
Ernest Zobole 1956-70
John Wright 1956-67
Will Roberts 1956-64
Heinz Koppel 1956-79 (AM 1963-69)
George Fairley 1956-66 (AM 1963-66)
Jeffrey Steele 1963-74
Anthony Stevens 1963-84
John Selway 1964-70 & from 2004
Keith Richardson-Jones 1967-73
David Saunders 1967-70
Bryan Macdonald 1967-70
Terry Setch 1966-79
Tom Hudson 1967-78
Laurence Burt 1967-69
Norman Toynton 1967-71
Mervyn Baldwin 1967-80
Eric Rowan 1967-80
Michael Tyzack 1967-72
Alan Wood 1967-75
Christopher Shurrock from 1967
Geoffrey Davies (AM 1969-71) 1971-85
Mary Lloyd Jones (AM 1971-73) 1973-86
Jack Crabtree (AM 1971-72) 1972-75
David Shepherd (AM 1971-72) 1972-79
Andrew Walton (AM 1971-72) 1972-75
Glyn Jones (AM 1972-73) from 1973
Tom Gilhespy (AM 1973-74) 1974-92
William Wilkins (AM 1974-75) 1975-99
Barrie Cook (AM 1974-75) 1975-79
Michael Punt (AM 1974-75) 1975-93
Paul Beauchamp (AM 1976-77) 1977-78
Adrian Heath (AM 1977-78) 1978-82
Anthony Davies 1979-88
Ian Grainger 1979-89
Erica Daborn 1979-87
Harvey Hood from 1979
Gary Woodley 1979-82

1956 1960 1970 1980 1990 2000 2010

1956 1960 1970 1980 1990 2000 2010

Members North and South
1984
1981-82
1987-89
Return to the Continent
1990-91
What is the 56 Group Doing?
1995
1997
Fiftieth Anniversary and Beyond
2007
All of These Things
Marking 56 Years

Derek Southall 1981-83
Peter Ellis 1982-91
Peter Prendergast 1982-2007
Alain Ayers 1984-86
Philip Nicol 1984-91
Maggie James 1985-91
Paul Davies 1985-93
John Mitchell 1985-88
Kieran Lyons 1985-2000
Emrys Williams 1985-91 & from 2004
Michael Williams 1985-96
Tom Piper from 1987
Sue Williams 1988-2009
Josephine Coy 1989-97
Bryony Dalefield 1990-2000
David Gould 1991-2001
Helen Sear 1991-92
Richard Powell 1991-93
Carol Hiles from 1991
Artstation 1994-2001
Peter Bunting 1994-96
Shani Rhys James 1994-2001
Stephen West 1994-2001
Sue Hunt from 1994
Martyn Jones from 1995
Cherry Pickles 1995-2001
Brendan Stuart Burns 1995-2011
Dennis Gardiner from 1995
Peter Lewis 1995-2001
Peter Spriggs from 1997
Robert Harding from 1997
William Brown 1997-2001
Peter Seabourne from 2004
Clive Hicks-Jenkins from 2004
Christine Kinsey 2004-09
Dilys Jackson from 2004
Robert Alwyn Hughes from 2005
Richard Renshaw from 2007
Antonia Spowers from 2007
Ken Elias from 2007
Kevin Sinnott from 2009
Pete Williams from 2012
Alison Lochhead from 2012
Justine Johnson from 2012

The date of joining is the date of election, usually at the annual general meeting in the latter part of the year. The date of leaving is the date of resignation, ceasing to be recorded as a member or death. The broken line represents a period of uncertain membership when no exhibitions occurred. Those who did not continue their membership after this period are considered to have left in 2001. The two forms of associate membership (AM) are represented by a lighter shade. Some of the associates did not become full members. There is a full explanation on page 91.

56 Group and 56 Group Wales Officers

Chair
1956-61	•	see note below ‡
1961	•	Eric Malthouse
1961-98	•	Arthur Giardelli
1998-99	•	Carol Hiles
1999-2000	•	Bryony Dalefield
2003-06	•	Glyn Jones
2006-08	•	Peter Spriggs
2008-10*	•	Robert Alwyn Hughes
from 2010*	•	Dilys Jackson

Vice-Chair
1971-74	•	Mary Griffiths
1977-96	•	David Tinker
1996-97	•	Glyn Jones
1998-2001	•	Brendan Stuart Burns
2004-06	•	Peter Spriggs
2006-08	•	Robert Alwyn Hughes
2008-10*	•	Dilys Jackson
from 2011	•	John Selway

Past-Chair
2006-08	•	Glyn Jones
2008-10*	•	Peter Spriggs
from 2010*	•	Robert Alwyn Hughes

Secretary
1956-57	•	Malcolm Ford
1957-59	•	see note below ‡
1959-61	•	Robert Hunter
1961-63	•	Patricia Cross
1963-71	•	Mary Griffiths
1971-74	•	Elisabeth Elias
1974-91	•	Mary Griffiths
1991-96	•	Julian Sheppard
1996-2001	•	Robert Weir
2001-10*	•	Peter Seabourne
2010*-11	•	Rebecca Spooner
from 2011	•	Heledd Mair Griffiths

Assistant Secretary
1988-96	•	Betty Evans

Treasurer
1956-61	•	see note below ‡
1961-63	•	David Tinker
1963-65	•	Eric Malthouse
1965-96	•	David Tinker
1996-98	•	Sue Williams
1998-2006	•	Dennis Gardiner
2006-08	•	Harvey Hood
from 2008	•	Martyn Jones

Publicity or Press Officer
1962-63	•	Eric Malthouse
1963-67	•	John Wright
1974-77	•	Eric Rowan
1978-86	•	William Wilkins
1986-96	•	Michael Williams
1996-2000	•	Martyn Jones

Sponsorship Officer
1985-90	•	Peter Ellis

Exhibition Officer
1998-2000	•	William Brown

President
1998-2009

201 Arthur Giardelli in his studio at Warren, Pembrokeshire, 1996. A founder member, he was chair 1961-98 and president 1998-2009 and remained in the Group until he died in 2009.

202 Dilys Jackson working on a mould at the first US/UK Cast Iron Symposium held in Wales at the Berllanderi Sculpture Workshop, 2003. She is currently chair of the Group.

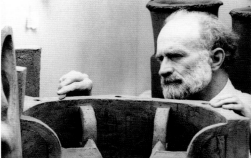

203 David Tinker working on a terra-cotta sculpture, 1983. One of the three founders of the Group, treasurer 1961-63 and 1965-96, and vice-chair 1977-96, he remained a member until he died in 2000.

‡ Between 1956 and 1961 there was a relatively loose committee. To 1957 this consisted of Edmonds, Malthouse, Tinker and Ford. From 1957, with Edmonds in London and Ford no longer secretary, Malthouse and Tinker carried out most of the administration until early 1959, when Hunter took over as secretary. Giardelli seems to have been actively supportive throughout.
* Appointed at the 2010 AGM which was postponed until January 2011.

Guests, Associates, Fellows and Honorary Members

Guests - Artists invited to exhibit with the Group for a single exhibition or for a short period.

1960s • **Glyn Jones, Jeffrey Steele, Anthony Stevens, John Selway, Terry Setch, Eric Rowan** and **David Saunders** exhibited as guests and were, later, invited to join the Group.

1962 • **Ronald Carlson** (*Paintings & Sculpture* tour)

1964-65 • **Peter Nicholas** (1964 and 1965 tours and *56/65 Contemporary Painting & Sculpture*)

1982 • **John Griffiths** (*Glasgow Group / 56 Group Wales*)

1989-90 • **Dmitri Kaminker** (Swansea)

1990 • **Kenneth Salins** (Glasgow and Derby)

1993 • **Paul Bevan** and **Eileen Little** (Bristol)

Associate Members - Artists more formally connected to the Group. There were two types:

1963-67 Those who were full members but who moved outside Wales.
 • **Michael Edmonds, Trevor Bates, Hubert Dalwood, George Fairley** and **Heinz Koppel.**

1969-77 Those who were elected for an initial period of one or two years.
 • **Geoffrey Davies, Mary Lloyd Jones, Jack Crabtree, David Shepherd, Andrew Walton, Glyn Jones, Tom Gilhespy, Barrie Cook, Michael Punt, William Wilkins, Paul Beauchamp** and **Adrian Heath** later became full members.

1969-70 • **Michael Granger** left Wales for London in 1970 and did not exhibit with the Group.

1969-71 • **William Featherston** exhibited in the *Two Foot Square Show* and, in 1971, at Newport and Swansea. He moved to Canada that year.

1969-71 • **Keith Arnatt** did not exhibit as his work in conceptual art had not fitted in with Group exhibitions.

1971-72 • **Chris Orr** did not exhibit with the Group although, confusingly, his name appears on several catalogues.

1974-75 • **Robert Mitchell** exhibited in Leeds and Cardiff in 1975.

1976-77 • **David Nash** exhibited in 1977 at Aberystwyth. He decided not to continue with the Group.

1977-78 • **Alistair Crawford** exhibited in *Art in the Making* and, in 1978, at Cardiff and Bristol.

Recent Graduate Fellowship Members - Graduates or postgraduates from any of the Welsh higher education institutions invited to exhibit with the Group for a year in order to gain professional experience.

2006 • **Beth Marsden** (Coleg Sir Gâr)

2007 • **Alison Harris** (University of Glamorgan)

2008 • **Christian John Olsen** (University of Wales Institute Cardiff)

2012 • **Kay Keogh** (University of Glamorgan) and **Victoria Malcolm** (Coleg Sir Gâr)

Life and Honorary Members - Artists and others associated with the Group honoured for their special contribution. There were inconsistencies between policy and practice before 1984. Life and honorary status were amalgamated that year and the clarified constitution indicated that the status was no longer automatic for members two years after they had left Wales.

1972-73 • **Michael Tyzack** was recorded, for one year only, as an honorary member. He had been living and working outside Wales for more than two years, therefore under the 1967 constitution became an honorary member.

1973 • **Elisabeth Elias** was made an honorary member in recognition of her role as secretary, 1971-74.

1974 • **Jeffrey Steele's** status as life member was formalised. In 1969, as he was no longer living in Wales, he had, uniquely, been designated a 'permanent member' in recognition of his Welsh birth and contribution.

1974-93 * • **Claude Souviron,** director of the Musée des Beaux-Arts, Nantes, was made an honorary member following the Group's exhibition in Nantes.

1978-97 * • **Tom Hudson** was made a life member when he moved to Canada.

1984-96 * • **Robert Hunter,** a founder member, was made an honorary member on his resignation.

1984-99 * • **Bruce Griffiths** was made an honorary member in recognition of his role in facilitating the Bologna exhibition and for unseen help over the years.

1985-2000 * • **Anthony Stevens** was made an honorary member after he had been living outside Wales for two years.

1986 • **Zdeněk Vaníček** was made an honorary member in recognition of his friendship and his role in arranging the Czechoslovak tour.

1991 • **Mary Griffiths** was made an honorary member in recognition of her role as secretary, 1963-71 & 1974-91.

1993 • **Michael Punt** was made an honorary member after committments overseas led to his resignation.

1996 • **Michael Estorick** was made an honorary member in recognition of his support for the Group.

 * The year in which the honorary member died.

56 Group and 56 Group Wales Exhibitions, 1957 - 2012

The exhibition title is the Group's name unless otherwise given in italic.

56 Group Exhibitions

1957 • Worcester Museum & Art Gallery; National Museum of Wales, Cardiff; Tenby Civic Centre

1958 • National Museum of Wales, Turner House, Penarth

1960 • Welsh Committee of the Arts Council of Great Britain tour (National Museum of Wales, Cardiff; Glynn Vivian Art Gallery, Swansea)

1962 • *Paintings & Sculpture* University College of North Wales, Bangor; University College of Wales, Aberystwyth; Howard Roberts Gallery, Cardiff; Glynn Vivian Art Gallery, Swansea; Victoria Street Gallery, Nottingham; Wakefield Art Gallery; Image Gallery, Leamington Spa; Cheltenham Museum & Art Gallery

1963-64 • *Drawings & Gouaches* Dillwyn Gallery, Swansea; National Library of Wales, Aberystwyth; Welshpool Art Room; National Museum of Wales, Cardiff; Hereford Art Gallery; Arts Council Gallery, Cardiff; Midlands Federation of Art Galleries (Lichfield Art Gallery; Northampton Museum & Art Gallery; Newark Museum; Worcester Museum & Art Gallery; Mansfield Art Gallery; Rugby Exhibition Gallery); Hambledon Gallery, Blandford Forum; Cheltenham Museum & Art Gallery; Victoria Art Gallery, Bath

1964 • *Oils & Constructions* Dillwyn Gallery, Swansea; Arts Council Gallery, Cardiff; University College of Wales, Aberystwyth; Newport Museum & Art Gallery; Arnolfini Gallery, Bristol

* 1965 • *Painting & Sculpture* Bear Lane Gallery, Oxford; Dillwyn Gallery, Swansea; Carmarthen Art Gallery; National Museum of Wales, Cardiff; Bangor Art Gallery

• *A Selection of Small Works* Exeter University

• *56 / 65: Contemporary Painting & Sculpture* (with ten young artists from Wales) Newtown Library (Welsh Committee of the Arts Council of Great Britain for the National Eisteddfod of Wales)

1966-67 • *Graphic Exhibition* Bangor Art Gallery; Temple Gallery, Llandrindod Wells; University College of Wales, Aberystwyth; Arts Council Gallery, Cardiff; Dillwyn Gallery, Swansea; Newport & Monmouthshire College of Technology; Midlands Federation of Art Galleries tour (Municipal Museum, Newark-on-Trent; Buxton Library & Museum; Usher Art Gallery, Lincoln; Burton-on-Trent Museum & Art Gallery; County Museum, Warwick; Alfred East Art Gallery, Kettering; Derby Museum & Art Gallery; Shrewsbury Museum & Art Gallery); University College of North Wales, Bangor (extended by six oils and constructions as *The Return of the 56 Group* for the College Arts Festival)

56 Group Wales Exhibitions

1967 • Bear Lane Gallery, Oxford; North Oxfordshire Technical College,Banbury; West Oxfordshire Technical College, Whitney; Whitworth Art Gallery, Manchester; City Art Gallery, Leeds; Herbert Art Gallery, Coventry; Welsh Arts Council tour (National Museum of Wales, Cardiff; Dolgellau Free Library; Bangor Art Gallery)

• *Graphics* Bols Taverne, Amsterdam

1968 • Newport Little Theatre & Arts Centre

1968-69 • *56 Group Wales 1968: An Exhibition of Work by Contemporary Welsh Artists* Republic of Ireland Arts Council tour (Municipal Gallery of Modern Art, Dublin; Municipal Gallery, Limerick; Cork School of Art); Arts Council of Northern Ireland tour (Arts Council Gallery, Belfast; Brooke Park Gallery, Londonderry; Coleraine University)

1969 • Grosvenor Gallery, London; Richard Demarco Gallery, Edinburgh; Aberdeen Art Gallery; Dundee City Art Gallery; Victoria Street Gallery, Nottingham

• *Breton Welsh Artists* University College Cardiff

• *Art in Wales: The 20th Century: Today - 56 Group Wales* Welsh Arts Council tour (National Museum of Wales, Cardiff; Tenby; Parc Howard, Llanelli; Glynn Vivian Art Gallery, Swansea; Memorial Gallery, Newtown)

1969-70 • Bear Lane Gallery, Oxford; Palmer Building, University of Reading; Ikon Gallery, Birmingham; Bluecoat Chambers, Liverpool

1970-71 • *The Two Foot Square Show* Ikon Gallery, Birmingham; Cyfarthfa Castle Museum & Art Gallery, Merthyr Tydfil; Haverfordwest Library; Memorial Gallery, Newtown; Bangor Art Gallery

1971 • Arnolfini Gallery, Bristol

• Newport Museum & Art Gallery; Glynn Vivian Art Gallery, Swansea

• National Museum of Wales, Cardiff

1972 • Newport Museum & Art Gallery

* See page 20 for discussion of *11 Painters from Wales* at Jefferson Place Gallery, Washington DC, 1965.

1972	• Bürgermeister-Ludwig-Reichert-Haus, Ludwigshafen am Rhein, West Germany

1972 • Bürgermeister-Ludwig-Reichert-Haus, Ludwigshafen am Rhein, West Germany
 • Midland Group Gallery, Nottingham
1973 • *Glasgow Group Wales* McLellan Galleries, Glasgow
 • *A Rainy Day* Welsh Arts Council tour (National Museum of Wales, Cardiff; University College of North Wales, Bangor; Newport Museum & Art Gallery)
1974 • Oriel, Welsh Arts Council, Cardiff
 • *Paintings & Drawings by Glyn Jones & Eric Rowan* University College Swansea
1974-75 • Musée des Beaux-Arts, Nantes
1975 • *Drawings by William Wilkins* University College Swansea
 • *Arthur Giardelli* University College Cardiff
 • *David Tinker, Mary Lloyd Jones* University College Swansea
 • *56 Group Wales 1975* University Gallery, Leeds
 • *Painting and Sculpture* National Museum of Wales, Cardiff
1976 • *Glyn Jones: Recent Paintings & Drawings* University College Cardiff
 • *56/20: Grŵp 56 Cymru/56 Group Wales. Twentieth Anniversary, 1956-1976:*
 • *56/20: Retrospective Exhibition* National Museum of Wales, Cardiff
 • *56/20: Graphic Work* Sherman Theatre, Cardiff
 • *56/20: Installation and other Large Works* Chapter Arts Centre, Cardiff
1976-77 • *56/20:* Arts Councils of Republic of Ireland and Northen Ireland tour (Bank of Ireland, Dublin; Crawford Municipal Art Gallery, Cork; Arts Council Gallery, Belfast); Aberystwyth Arts Centre
1977 • *David Shepherd* University College Cardiff
1978 • University College Cardiff
 • *Arthur Giardelli, Glyn Jones, Terry Setch: Paintings, Drawings &Constructions* University College Swansea; University College Cardiff
 • *Painting & Sculpture* Royal West of England Academy, Bristol
 • Wyeside Arts Centre, Builth Wells
1978-79 • *Art in the Making* Welsh Arts Council tour (Wrexham Arts Centre; Llanelli Library; The Cross Community Centre, Pontardawe; Aberystwyth Arts Centre; Haverfordwest Library; Alyn & Deeside Area Library, Buckley; Greenhill Further Education Centre, Tenby; Cathedral of St Woolos, Newport; Oriel Môn, Llangefni)
1979 • *Robert Hunter and David Tinker* University College Cardiff
 • Newport Museum & Art Gallery; Glynn Vivian Art Gallery, Swansea
 • *Groupe 56 Pays de Galles* Musée de la Poste, Amboise, France
1980 • Llantarnam Grange Arts Centre, Cwmbran
 • *Five New Members: Erica Daborn, Anthony Davies, Ian Grainger, Harvey Hood, Gary Woodley* University College Cardiff
1981 • *Exhibition of Graphic Work* Sherman Theatre, Cardiff
 • *56 Group Wales in Scotland* Perth Museum & Art Gallery; Livingston Art Foundation; Forebank Gallery, Dundee; Artspace Galleries, Aberdeen
1981-82 • *25th Anniversary Exhibition* National Museum of Wales, Cardiff; National Library of Wales, Aberystwyth; Mostyn Art Gallery, Llandudno
1982 • *Peter Ellis, Peter Prendergast, Derek Southall* University College Cardiff
 • *Artists Inc.* (with artists from Belfast, Dundee & Exeter) St Paul's Gallery, Leeds
 • *Glasgow Group / 56 Group Wales* City Art Centre, Edinburgh
 • John Owen Gallery, Cardiff
1983 • St David's Hall, Cardiff
 • *Drawn Together - New Work by Four Artists with the 56 Group Wales: Erica Daborn, Anthony Davies, Geoffrey Davies, Ian Grainger* University College Swansea; Howard Gardens Gallery, Cardiff
 • *Gruppo 56 Galles* Galleria d'Arte Moderna, Bologna
1984 • Haverfordwest Library
 • *A Birthday Celebration* Oriel, Welsh Arts Council, Cardiff
 • *Vale of Glamorgan Festival Exhibition: Alain Ayers, Harvey Hood, Philip Nicol* St Donat's Arts Centre
1985 • *Life and Landscape from Scotland and Wales* (with Glasgow Group) Newport Museum & Art Gallery

1986	•	*Eight New Members: Alain Ayers, Paul Davies, Maggie James, Kieran Lyons, John Mitchell, Philip Nicol, Emrys Williams, Michael Williams* Unibersity College Cardiff
1986	•	*Fishguard Music Festival* Fishguard Library
	•	*Czechoslovak Tour* Mirbachov Palace, Bratislava; Dům Umění, Brno; Galerie Umění, Karlovy Vary; Eastern Slovakia Gallery, Košice
1987	•	*30th Anniversary Exhibition* City Museum & Art Gallery, Worcester
1987-88	•	*Moving Pictures* Newport Centre; Ely Library; Abergavenny Drama Centre; Fairwater Comprehensive School, Cwmbran
1988	•	*56 in 88* Mostyn Art Gallery, Llandudno
	•	Pembroke Dock Library
1989	•	*Cardiff to Camden* Cardiff Old Library; Swiss Cottage Library, Camden
1989-90	•	Glynn Vivian Art Gallery, Swansea
1990	•	Glasgow Group Gallery, Glasgow; St Michael's Gallery, Derby Cathedral
	•	*Chepstow Festival Exhibition* Chepstow Museum
1991	•	*Czech Republic Tour* Úluv Gallery, Prague; Alšova Jihočeská Galerie, Hluboká nad Vltavou, České Budějovice; Západočeská Galerie v Plzni, Plzeň; Rabasova Galerie, Rakovník; Muzeum Beskyd, Frýdek-Místek
	•	Haverfordwest Library
	•	*Wales Art Fair* Old Library, Cardiff
1992	•	Oriel, Theatr Clwyd, Mold
	•	Rhondda Heritage Park, Trehafod
1993	•	Royal West of England Academy, Bristol
1993-94	•	*Works on Paper* Rhondda Heritage Park, Trehafod; Newport Museum & Art Gallery
1994	•	*Libr'art* Halle aux Foires, Libramont, Belgium
1995	•	Old Library, Cardiff
1996	•	*56 in 96* National Museums & Galleries of Wales, Turner House, Penarth
1996-97	•	*Raymond Eyquem: The Art of the Possible* University College Cardiff; Pembroke Dock Library; Oriel Bangor Museum & Art Gallery
1997	•	*40th Anniversary Exhibition* Worcester Museum & Art Gallery; Tenby Community Education Centre; St David's Hall, Cardiff
1999	•	*New Work* Oriel Henry Thomas, Carmarthen; Yale College Memorial Gallery Wrexham; Oriel Plasnewydd, Plasnewydd Primary School, Maesteg
1999-2000	•	Howard Gardens Gallery, Cardiff; Theatr Clwyd, Mold
2005	•	*Amongst Friends* Gate Arts Centre, Cardiff
	•	*56GW* Washington Gallery, Penarth; Oriel Henry Thomas, Carmarthen
2006	•	Kooywood Gallery, Cardiff
	•	*50 Years of 56 Group Wales* National Library of Wales, Aberystwyth
2007	•	Cynon Valley Museum, Aberdare; Llantarnam Grange Arts Centre, Cwmbran
	•	*New Work* St David's Hall, Cardiff
2007-08	•	The Gallery, Barry
2008	•	*Exhibiting at Home* Howard Gardens Gallery, Cardiff
	•	Art Shop, Abergavenny
	•	*Mixing West* Tenby Museum & Art Gallery
	•	*All of These Things* Oriel Myrddin Gallery, Carmarthen
2009	•	*Mix 56* Wyndham Arcade Gallery, Cardiff
	•	*Opening Show* Mumbles Road Gallery, Swansea
2010	•	Queens Hall Gallery, Narberth
2011	•	Oriel Canfas Gallery, Cardiff
* 2012	•	*Marking 56 Years* Bay Art, Cardiff
	•	MOMA Wales, Machynlleth

* See page 84 for discussion of historical exhibitions to mark fifty-six years of the Group, 2012.

Index of Key Individuals

Bold denotes full members' main entry.
Italic denotes image of the artist or the artist's work.

Acknowledgements

In addition to those acknowledged in the preface, we should like to thank all current and past members and their estates. All of them have been unfailingly supportive of this project. We are most grateful to the Group, for allowing us to draw upon its archive and to numerous individuals quoted from correspondence, documents and publications. The sources of these have been acknowledged in footnotes throughout.

The following have also been helpful with information and perspectives: John Crane · Betty and David Evans · Raymond Eyquem · Ruth Fowler · Heledd Mair Griffiths · Mary Griffiths · Isabel Hitchman · Louise Jones, Lemon Street Gallery, Truro · Barrie Maskell · Garston Phillips, Worcester City Museum Service · Roy Powell · David Redfern, The London Group · Nicholas Thornton, National Museum Wales · Noel Upfold · Zdeněk Vaníček · Valmai Ward · Islwyn Watkins

Picture Credits

The majority of images were obtained from the Group's archive. We are extremely grateful to all the artists, photographers and their estates who have provided images, copyright permission and checked details. Institutions, galleries and other individuals have also been an invaluable source of images. Copyright of artworks remains with the artists or with their estates. Copyright of photographs remains with the photographers. Every effort has been made to seek permission to reproduce the images although, for many, the photographers are unknown.

56 Group Wales Archive: Cover, 126 & 129 (reproduced by permission of MAMbo - Museo d'Arte Moderna di Bologna) · 2 · 10 · 21 · 23 · 24 · 25 · 26 · 28 · 29 · 33 · 35 · 36 · 37 · 38 · 39 · 40 · 41 · 42 · 44 · 51 · 53 · 54 · 55 · 56 · 58 · 60 · 61 · 63 · 64 · 66 · 67 · 68 · 69 · 70 · 71 · 72 · 73 · 75 · 76 · 77 · 78 · 79 · 80 · 81 · 82 · 84 · 85 · 86 · 87 · 88 · 90 · 91 · 93 · 94 · 95 · 96 · 97 · 98 · 100 · 101 · 102 · 103 · 104 · 106 · 107 · 108 · 109 · 110 · 111 · 112 · 114 · 115 · 117 · 119-124 (reproduced by permission of ITV Wales) · 125 · 127 · 132 · 133 · 134 · 136 · 137 · 138 · 140 · 142 · 143 · 144 · 145 · 146 · 150 · 151 · 152 · 153 · 154 · 155 · 157 · 158 · 161 · 162 · 163 · 164 · 165 · 166 · 167 · 170 · 171 · 172 · 173 · 174 · 175 · 176 · 177 · 181 · 185 · 186 · 188 · 193

Artists or their estates: 1 · 3 · 5 · 7 · 9 · 11 · 13 · 16 · 31 · 32 · 43 · 46 · 47 · 49 · 50 · 52 · 57 · 59 · 62 · 65 · 74 · 83 · 89 · 105 · 116 · 128 · 130 · 131 · 135 · 139 · 141 · 147 · 148 · 149 · 159 · 160 · 168 · 169 · 178 · 179 · 180 · 182 · 183 · 184 · 189 · 191 · 192 · 195 · 197 · 198 · 199 · 202 · 203

Galleries, Institutions & Individuals: Frontispiece Paul Malthouse · 4 William Gibbs · 6 © Trustees of the Methodist Church Collection of Modern Christian Art · 8 & 22 © Amgueddfa Cymru - National Museum Wales · 12, 113 & 201 Graham P Matthews · 14 University of Glamorgan Art Collection Museum · 15 & 190 David Moore · 17 & 18 © Heinz Koppel Picture Trust · 19 Aberystwyth University, School of Art Gallery & Museum · 20 Peter Johns · 27 Glyn Jones · 30 Islwyn Watkins · 34 Jeffrey Steele · 45 Bodelwyddan Castle Trust · 48 Mark Hudson · 92 Carmarthenshire County Museum · 99 Jonathan Clark Fine Art, London · 118 Bernard Mitchell · 156 Tracy Tinker · 187 & 194 Christopher Shurrock · 196 Robert Alwyn Hughes · 200 Bob Gelsthorpe

Known Photographers: 11, 113 & 201 Graham P. Matthews · 14 Geraint Jones · 15 & 190 David Moore · 19 Public Catalogue Foundation · 20 Peter Johns · 30 David Trace · 32 Peter Jones · 51 Ken Oaten · 73, 76 & 78-82 Hylton Warner & Co. Ltd · 86 Dorcas Brown · 87 Harry Holland · 92 Dara Jasumani · 106 Colin Molyneux · 117 Linton Lowe, Direct Photo · 118 Bernard Mitchell · 136-37 Peter Haveland · 138 Gary Kirkham · 156 Tracy Tinker · 175 Ralph Carpenter · 179 John Jones · 187 & 194 Christopher Shurrock · 195 Kevin Sinnott · 199 Steve Ray · 200 Bob Gelsthorpe · 202 Felicia Glidden

The following have been helpful in the search for images and in obtaining permissions: Dave Ball, Sheffield Hallam University · Gil Chambers · Keith Chapman, Keith Chapman Gallery, London · Gareth and Sonia Davies · Ivor Davies · Ann Dorsett, Carmarthenshire County Museum · Jane England, England and Co., London · Raymond Eyquem · John Gibbs · William Gibbs · James Gilberd, Gilberd Marriott Gallery, Wellington, New Zealand · Branwen Griffiths · Guardian Archives · Michael Harrison · Isabel Hitchman · David Hobden · Neil Holland, School of Art, Aberystwyth University · Jill Howorth, Silk Top Hat Gallery, Ludlow · Simon Hucker, Jonathan Clark Fine Art, London · David Juda, Annely Juda Fine Art, London · Karel Lek · Sue Lucy, Victoria Art Gallery, Bath · Morrigan Mason, Bodelwyddan Castle Trust · François Morin · Lisa Oliver, ITV Wales · Portland Gallery, London · Sabrina Samorì, MAMbo - Museo d'Arte Moderna di Bologna · Chana Schütz and Hermann Simon, Centrum Judaicum, Berlin · Valerie Shepherd · Derek Shiel · Sam Smith · Ceri Thomas, University of Glamorgan · Jaimie Thomas, The National Library of Wales, Aberystwyth · Melissa Munro and Kay Kays, National Museum Wales · Islwyn Watkins · Jill Webster

Text © David Moore 2012 Design Sue Hiley Harris

Published in 2012 by Crooked Window Printed in Wales by Gomer

ISBN 978 0 9563602 1 2

Crooked Window
90 Struet, Brecon
Powys, Wales LD3 7LS

www.crookedwindow.co.uk

56GroupWales
Grŵp56Cymru